Stolen

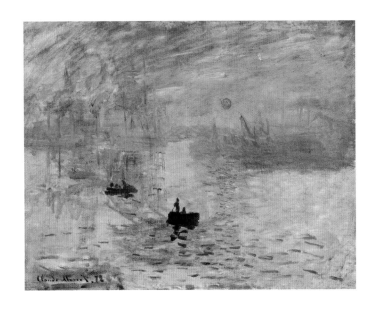

Stolen

The Gallery of Missing Masterpieces

JONATHAN WEBB

with The Art Loss Register

Introduction by Julian Radcliffe

BLACK WALNUT

This edition published in 2008 by Black Walnut Books, an imprint of
Madison Press Books.

ISBN-10: 1-897330-35-9

ISBN-13: 978-1-897330-35-7

For more information please contact

Madison Press Books
1000 Yonge Street, Suite 200
Toronto, Ontario
Canada M4W 2K2
madisonpressbooks.com

Printed in China

CONTENTS

INTRODUCTION

Crime and art make fascinating yet unsettling bedfellows. Besides the obvious questions of why art is stolen, who steals it, and how profit is realized from reselling it, is an underlying sense that art theft is a crime that should be preventable. Certainly, there are unscrupulous art market operators who make the trade in stolen art possible. If unethical dealers stopped buying stolen items, thieves would have no market in which to sell their goods and less incentive to get involved in this type of crime. But the market for the highest quality artworks is currently so rich that the allure of financial gain keeps dealers and thieves alike in the business of trading. How did the market for such artworks become so lucrative? And what can be done to make stolen art a less appealing commodity?

While stealing art is not exactly a novel idea, the widespread scale of the problem is recent. Art's appeal to thieves is a reflection of its commercialization, a process to which museums and auction houses have contributed. Since 1968, when the first blockbuster show featuring Florentine frescoes was brought to the Metropolitan Museum of Art in New York, museums have been known increasingly for their spectacular shows, ubiquitous gift shops, and, lately, even the structures in which they house their collections. Museums, in effect, add value to art by selecting and exhibiting it. Auction houses, engaged in the same competitive race to broaden public participation and push up prices, have also played a role in art's commercialization by turning their sales into glittering, formal affairs with the titillating promise of fabulous windfall profits.

There have been ups and downs in the art market since the 1960s, but the steady upward trend of prices is unmistakable and seemingly irreversible. New records in art values are reported almost every week. And, not incidentally, reports of major thefts around the world are just as frequent. The association between money and great works of art has become firmly fixed. Everybody makes this connection: art professionals, academic researchers, antique collectors, the general public, and, of course, thieves.

Unfortunately, for many police forces the pursuit of art thieves is treated as a low priority. While this is understandable, given the

Rembrandt Harmensz van Rijn (1606–1669), *self-portrait.* Oil on copper. Stolen in December 2000 from the National Museum in Stockholm.

often-limited resources and the many preoccupations of law enforcement agencies, it creates a vacuum to be filled by a cooperative public-private partnership, such as the Art Loss Register's with the British police. But while the combined technology, databases, and forensics provided by such partnerships provide some of the tools to suppress the international trade in stolen art, a fundamental change is required in the attitude of many dealers, auction houses, and collectors, who often choose not to investigate or disclose an artwork's questionable provenance where significant profits stand to be made.

While rates of art theft continue to grow, the market is gradually adapting to counteract illicit trade. Changes are evident in new acquisition practices (such as routinely consulting the Art Loss Register's database of stolen art), and the cooperation of nation states in restoring stolen art to its rightful owners (notably, in several legal cases involving art stolen during the Holocaust). Growth in the tourism industry is also prompting many countries to pay more attention to their heritage and their artifacts, particularly if they are of religious or cultural importance. As art values continue to rise, and

to attract more criminals, it is unlikely that these efforts will achieve their goals quickly. However, the chances of the thief, fraudster, fence, or handler getting away with their crimes are slowly but surely diminishing, even as the consequences for the dishonest dealer or auction house are growing more serious.

Change comes slowly, but in the interim we must treasure the works of art that are part of our common cultural heritage, whether they are privately or publicly held. *Stolen* presents some of the most beautiful and important works that have been lost, sold, and — sometimes — returned to their rightful owners. It tells the stories of the people who are working to stop the illicit trade in artifacts, and celebrates the vital cooperative spirit that is making the work of the Art Loss Register and its partners so worthwhile.

Julian Radcliffe,
Chairman, Art Loss Register

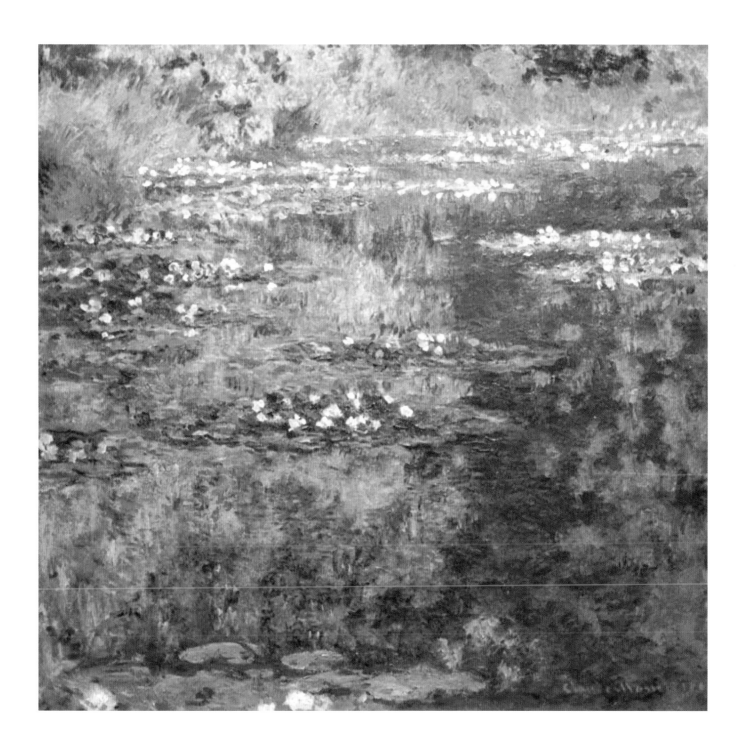

Claude Monet (1840–1926), *Water Lilies* (1904). Oil on canvas. This painting was stolen from a Jewish art dealer in France by the Nazis during World War II. In April 1999, the painting was returned to the heirs of the rightful owner.

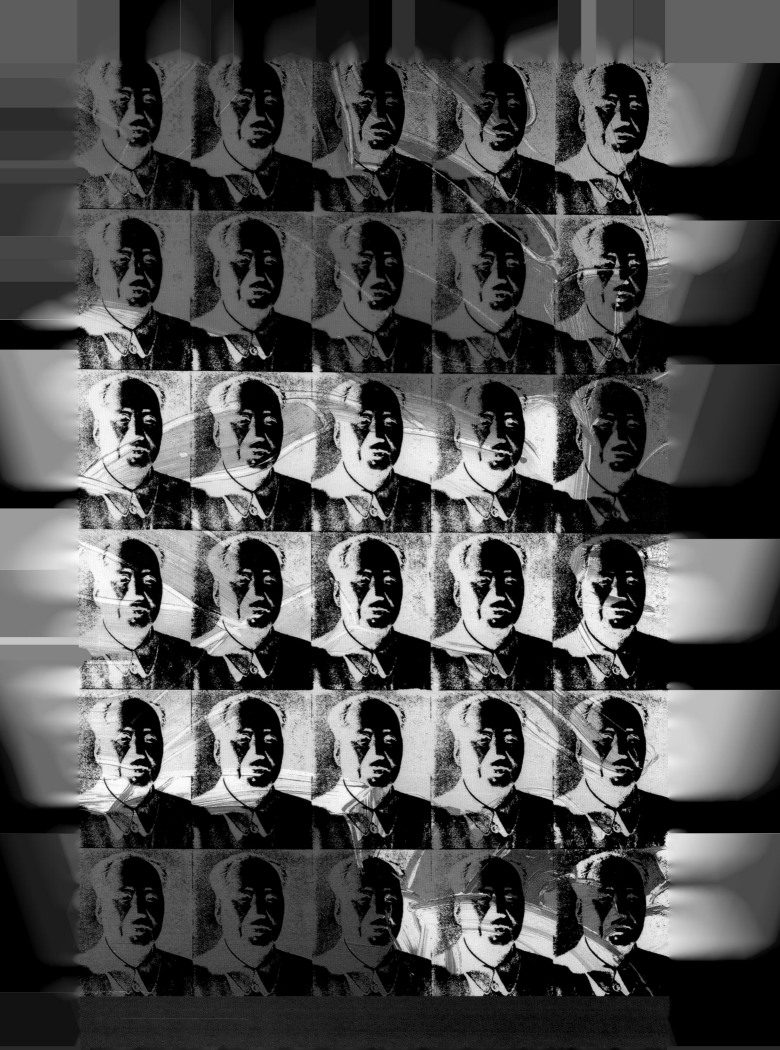

THE CASE OF THE MISSING WARHOL

"They're often not too bright.... Only later do they realize that they've taken something they can't really sell."

—Christopher Marinello, Art Loss Register

Andy Warhol (1928–1987), *30 Colored Maos (Reversal Series)*. Acrylic and screenprint. Warhol's exploration of the relationship between art, celebrity and commerce was reflected in his silkscreen prints of iconic figures like China's Mao Tse-tung. This print was created by the artist in 1980—and almost immediately stolen.

MR. CHEE'S SECRET

A daring theft, a gruesome murder, a lost work of art by a twentieth-century giant. These are the main elements in the narrative that Julian Radcliffe describes in the course of a journey across London one day in June 2007.

Radcliffe tracks down art thieves. His company, the Art Loss Register (ALR), maintains the most extensive database of stolen art available for searching. When a valuable, uniquely identifiable work of art disappears, the owner or insurance company adds its description to the database. When the police discover a cache of stolen goods, they check each item against these descriptions. Similarly, when an auction house, art gallery, museum or art dealer is offered an item for appraisal or sale, they too can find out if the database holds a match. The ALR was established in 1991 with backing from insurers, auction houses and a venture capital firm, among others. Over the years, its effectiveness has been well established. Radcliffe's staff routinely comes up with dozens of matches a year.

Radcliffe's work, like a lot of detective work, can be tedious, but it also has moments of high drama, and the results can be immensely satisfying. There is the obvious satisfaction of seeing a criminal brought to justice. There is the sense of fulfillment that comes from returning a spectacular work of art to its appreciative owner. And there is the chance sometimes to see a painting restored to the art market and, in the process, discover its current worth, which happens to be the case on this sunny day in June 2007. The stolen item, an eye-jarring acrylic-and-silkscreen print by the American Pop Art genius Andy Warhol, is to be sold at Sotheby's in an auction beginning at 8 PM.

Shortly before noon on the day of the Sotheby's auction, Radcliffe steps out of his office in London's Hatton Garden and waves down a taxi. As the vehicle makes its way through the lunchtime traffic, Radcliffe tells the story of the Warhol print. *30 Colored Maos (Reversal Series)* revisits a subject the artist first explored a decade earlier. It was commissioned by Warhol's agent, Bruno Bischofberger, in 1980 and included in an exhibition of works by the artist in a Paris gallery the same year. It was promptly stolen.

"It disappears off the wall close to the exit," says Radcliffe. "So everybody assumes it was taken by somebody visiting the gallery."

The loss was reported by the gallery owner and investigated by the Paris police, but the canvas had vanished without trace. The owner filed a claim against his insurance policy and was paid for the loss. Nothing more was heard about it for more than twenty years. It's not unusual for stolen artwork to disappear for a long time, especially when the work is by someone famous,

making it difficult to dispose of. The case is set aside, no action taken. No action really is possible until the thieves, their confederates, or someone close to them makes a move. In this case, nothing happened until the thief died.

In December 2006, Sotheby's sent a query to the ALR. The auction house had been offered a Warhol print. Was it stolen? The staff at the ALR checked their files and determined that it was.

It is the nature of these investigations that the story is revealed to the investigator in reverse sequence. Radcliffe's research took him first to the person at the end of the line, and his task was to work his way back to the beginning. At the end of this particular line was an English provincial art dealer who had taken the print into Sotheby's.

Every case is different. The person attempting to make the sale may be the original thief, but this is unlikely. It's especially unlikely when years or decades have elapsed since the crime was committed. The seller may be a naïve but genuine innocent who has obtained the item through purchase, inheritance or (least likely of all) chance discovery. It is also possible that the contact is a dupe, the unwitting emissary of the thief, or working with the thief in some kind of scam. Radcliffe's first concern is to get the artwork back safely in conjunction with the police. He approaches the people who may lead him to it with an open, if skeptical, mind.

Radcliffe met with the art dealer. "He said, look, if this is stolen, we want nothing to do with it," says Radcliffe. "In fact, he was much more cooperative than is normally the case. Normally, the consignor says, I bought it, I want it given back to me. But he said, if it's stolen, we don't want to have anything to do with it." And he gave Radcliffe the name of the person he was acting for, a British lawyer who lives in northern Cyprus. He even rang the man and set up a meeting.

As it happens, this part of Cyprus is a sanctuary for people who wish to elude the law. It was seized by Turkey in an act of international brigandage that has been punished by the refusal of virtually all Western nations to recognize it. Consequently, no extradition treaties apply. Of course, there can be many reasons why a man or woman might want to avoid the laws of his or her own country. And Cyprus has other attractions that make it an agreeable place to live.

Radcliffe traveled to Cyprus and met the British lawyer who had instructed the art appraiser to consign the Warhol print to Sotheby's. The lawyer never touched the piece, which was sent directly from Paris to London. Like the art dealer, the lawyer is helpful. He makes it clear that he wants nothing to do with stolen art. And neither, he says, does the woman he's acting for — who lives in Paris. Which brings Radcliffe at last to the scene of the original theft.

He meets the woman in Paris. She is middle-aged, cultured and as anxious as her friends to disassociate herself from the proceeds of crime. She suspected that the artwork had been stolen, she said. She came into possession of the piece because she was the only surviving relative of her brother, a film producer, who died in the mid-1990s of complications associated with AIDS. The deceased film producer, in turn, was the beneficiary of the will of a man named Mr. Chee. Chee apparently never changed the terms of his will after the film producer died.

Somehow *30 Colored Maos (Reversal Series)* ended up with Chee. Maybe he stole it himself, or maybe he knew the person who did. "This is what we believe," says Radcliffe. "We know or were told that it was held by this man Chee, a Chinese Frenchman living in Paris, who worked in the demi-monde of the art world…buying and selling, always short of money, and who was a homosexual partner, friend or whatever of a French film producer."

Chee died in 2004 or 2005, when he was struck on the back of the head by a murderer wielding some kind of club. The murderer may only have meant to rob him, but Chee's skull was thin and easily crushed, and the blow was fatal. As his friend, and as the closest surviving relative of her brother, it was the Parisienne who went through Chee's belongings. And it was she who found the Warhol.

"The film producer's sister cleans out his flat, finds the painting and then wants to find out what it is," says Radcliffe. "She suspects there's something wrong with it…maybe it's a fake, maybe it's a copy, whatever. And she then has it authenticated." That's when she discovers it's the real thing.

Not everyone in Paris with artwork to sell asks a friend in Cyprus, with its tricky jurisdictional issues, to represent them. "The reason they brought him in," says Radcliffe, referring to the man in Cyprus, "may be because he's a lawyer and he's helping to wind up the estate…that would be a nice interpretation." It's not, perhaps, the most obvious route to take. But, as soon as the Parisienne, her lawyer and the art dealer were made aware the print was stolen, they all cooperated fully with the ALR's investigation. The dealer stands to receive a commission for his helpfulness.

Their cooperation is significant for a practical reason: the ALR makes a point of never rewarding criminals. Only those who had no part in the theft and freely offer information leading to recovery of the stolen object can hope to be paid for their trouble. "We were in favor of the dealer getting his original commission," says Radcliffe. "We want it to be known in the art world that if there's a stolen picture, we will try to honor the arrangement that has already been made, because we want cooperation in the future."

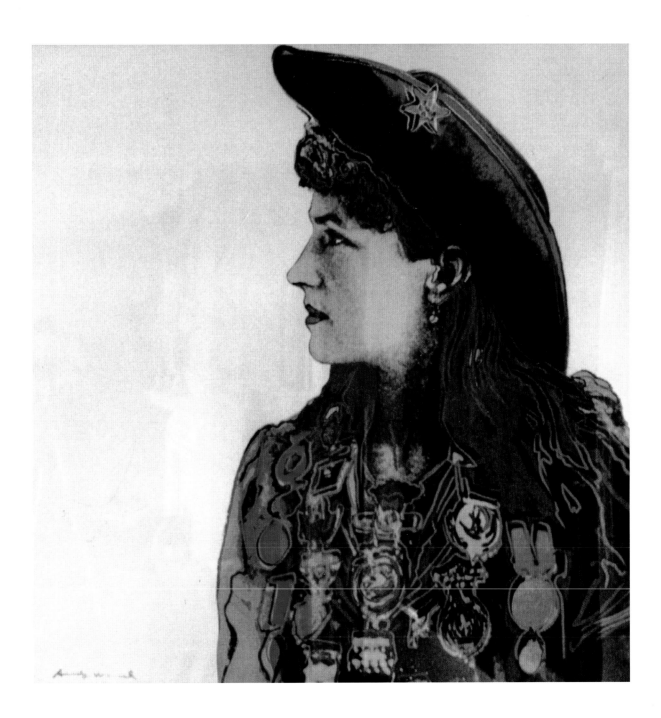

Andy Warhol (1928–1987), *Annie Oakley*. Warhol was prolific and his work apparently is as much in demand in the illicit art market as in the legitimate. This screenprint was stolen from a residence in Los Angeles in 1997.

In some ways, the story is typical of the most common art thefts. Chee eked out a difficult existence on the margins of the Parisian art world. Somehow, he came into possession of the stolen Warhol. No doubt he intended to dispose of it somehow, but it was impossible to dispose of. Warhol's work is too well known for anyone to touch it. So it sat in a cupboard in his flat until the film producer's sister found it. It was almost certainly the only item of any value in Chee's possession. It became the only fortune he ever possessed, one he could never enjoy.

CHAIRMAN MAO ON BOND STREET

Sotheby's occupies a refurbished complex of Georgian buildings near one end of Bond Street in London's Mayfair shopping district. There are expensive jewelers and art galleries opposite and on either side. Their exteriors are painted in different shades of cream and antique white. The signage is discreet.

There is no sign at all to advertise the restaurant on the ground floor of the auction house. Radcliffe exchanges greetings with some of the establishment's patrons as he makes his way toward the staircase at the back of the building. Works by some of the world's most celebrated contemporary artists hang from the walls on the landings and in the first-floor galleries: Tracey Emin, Francis Bacon, Tom Wesselmann, Roy Lichtenstein, Jean-Michel Basquiat, Joseph Beuys, Lucien Freud. All are on the block at this evening's sale. Radcliffe, intent on finding the Warhol, makes a brisk circuit of the gallery before he spots it hanging in a well-lit corner at the back of the main salesroom.

Warhol's *30 Colored Maos (Reversal Series)*, some three feet wide by five feet tall, takes up more space than its catalogue picture leads the viewer to expect. The repeated images of the Chinese tyrant are like black smudges, grainy and indistinct. The splashes of blue, red and beige paint that the artist laid beneath them have a disturbing, almost violent effect.

The original owner of the print was compensated for its loss by the insurance company long ago. Radcliffe and the insurance company have agreed to split the proceeds. The ALR's share is around 20 percent. A windfall like this—if all goes well—makes a significant difference to the company's balance sheet. Radcliffe is cautiously optimistic. "We had a very disappointing sale of a Picasso last autumn," he says. "There were some very good Picassos in the sale, and our Picasso was not a very good one. But people think this is quite a good Warhol." Sotheby's estimate is between £1 million and £1.5 million.

There are actually eight other Warhols in the sale, including one of his massive dollar signs.

It's not the American Pop artist's work that is attracting the most interest, however. Damien Hirst, the provocative British artist famous for pickled sharks in glass cases, is the subject of knowing speculation. His *Lullaby Spring*, a large steel cabinet in which thousands of pills are displayed, carries an estimated sale price of between £3 million and £4 million and is featured on the wraparound cover of the catalogue. A Francis Bacon self-portrait, estimated at between £8 million and £12 million, also draws its share of admirers. The works themselves are striking, but the soaring prices they command are stimulating extraordinary interest in London's art community. The buzz in the building is palpable.

After a quick review of the other works on display, Radcliffe descends again to the ground floor and makes his way to the exit. He pauses for a moment on the pavement, while his eyes adjust to the hot, bright world outside. Builders' scaffolding has been erected out front—the Sotheby's façade is getting a makeover—and a poster of *30 Colored Maos* has been tacked up there, just above head height. The image of the Communist tyrant on Bond Street at a time when London has never seemed more prosperous is an odd juxtaposition. But in Warhol's art, even Communist icons are turned into commodities. Looked at this way, the irony is perfect.

Sotheby's, London, is located on Bond Street, one of the world's most exclusive shopping precincts.

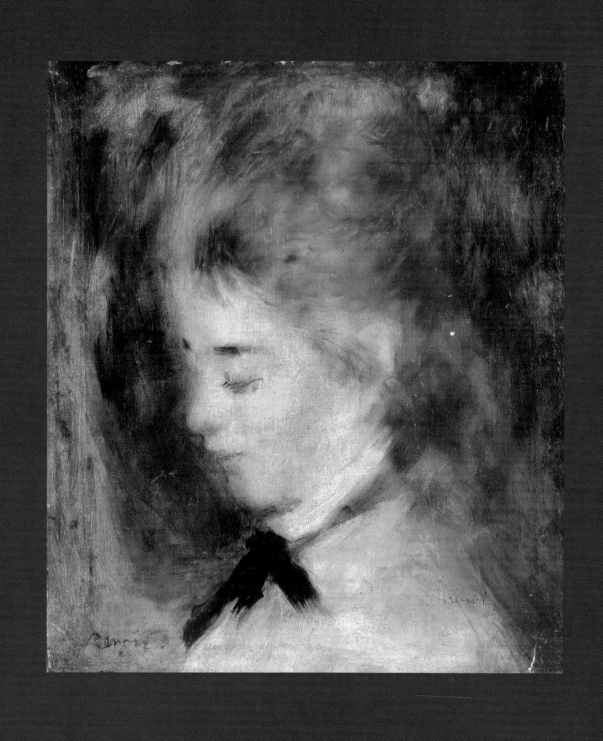

ART CRIMES

"Fewer than half of our cases are art crimes in isolation with no other crimes connected to them. The great majority of the cases involve money laundering, tax evasion, illegal exports."

— Julian Radcliffe

Pierre-Auguste Renoir (1841–1919), *Tête de jeune fille au ruban bleu*. An expert from Sotheby's examined this and other works stolen from the Argentine museum in Taiwan in 2001. The oil-on-canvas painting had been removed from its stretcher but was in good condition.

BETWEEN FRIENDS

One morning, an antiques dealer arrives at his shop to find the front door ajar. His heart sinks: the glass is broken, and the wood around the lock is splintered. He has been robbed. He notifies the police. They investigate but have no useful leads, and the file is set aside. The dealer's insurance company pays him for the loss of a Georgian silver tea set, a seventeenth-century British clock and a handful of other valuable but smallish items.

Some time later, a shifty individual turns up at the dealer's door, shows him photographs of the objects that were stolen and offers to sell them back. The dealer considers for a moment and then makes a very low offer — perhaps 5 percent of what they're worth. The crook is offended, walks out and sells them up the street.

The dealer makes no report of the incident, either to the police or to his insurance company. Failure to notify the police undermines their purpose and failure to notify the insurance company is almost certainly fraud. But the dealer is unperturbed: he dines out on the story for years.

The story may be apocryphal, but its underlying themes have an authentic ring. Antiques shops are robbed from time to time, and their owners are sometimes offered the opportunity to buy stolen goods. It stands to reason that they may be offered their own goods back occasionally by fences who don't know where they came from. There's no doubt that the antiques trade, like the art and antiquities business in general, has its share of dodgy operators.

Sarah Jackson had been with the Art Loss Register for a relatively short time when she happened to glance in the window of a London antiques dealer and recognized a pair of side chairs. The chair backs had a unique configuration. "Like this," she explained, sketching it on a notepad. She had listed the chairs herself when they were reported as stolen. The police were notified, and the antiques dealer was confronted. He said the person he bought them from had owned them for years. The dealer was out of luck: the grain of the wood and a nick on one of the seats nailed the identification. The original owner had died, but the housekeeper remembered them distinctly. It makes sense that she would, says Jackson. She was the one who had dusted and polished them for all those years.

The kinds of art thefts that attract media attention are of a different order from these. The daring theft from the Gardner Museum in Boston in March 1990 of more than a dozen great paintings, including a priceless Vermeer, three Rembrandts and a Govaert Flinck, still unsolved at the time of writing, has been the subject of endless newspaper articles and a handful of

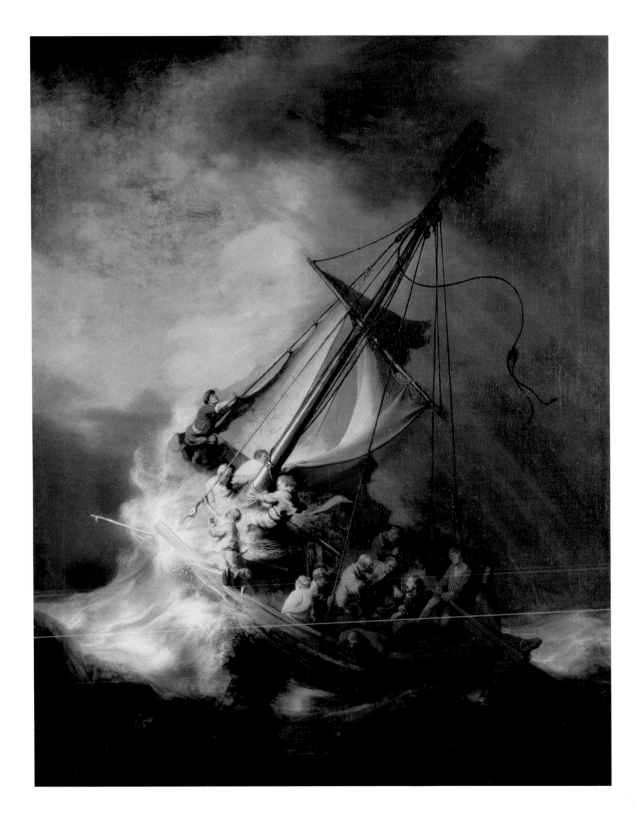

Rembrandt Harmensz van Rijn (1606–1669), *Storm on the Sea of Galilee*.
Oil on canvas. One of eleven paintings stolen from the Isabella Stewart
Gardner Museum in Boston on St. Patrick's Day in 1990.

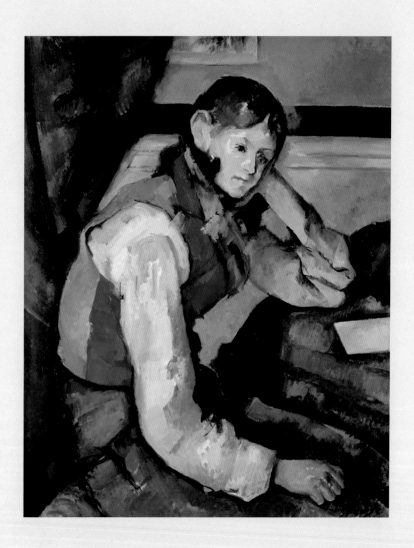

ZURICH ART HEIST

The Buehrle Collection, housed in a private gallery in Zurich, Switzerland, is controversial. It contains a number of art works said to have been seized illegally from their original owners by the Nazis and then purchased by Swiss arms manufacturer Emil Buehrle through intermediaries.

In February 2008, the Buehrle gallery was itself the target of thieves. Four fabulous Impressionist paintings were taken: Paul Cezanne's *The Boy in the Red Vest* (left); Claude Monet's *Poppies Near Vetheuil* (right); Vincent van Gogh's *Blossoming Chestnut Branches;* and Edgar Degas's *Viscount Lepic and His Daughters.* The four paintings were valued at $164,000.

Swiss police recovered two of the four paintings (the van Gogh and the Monet) within ten days of the robbery. The thieves remained at large.

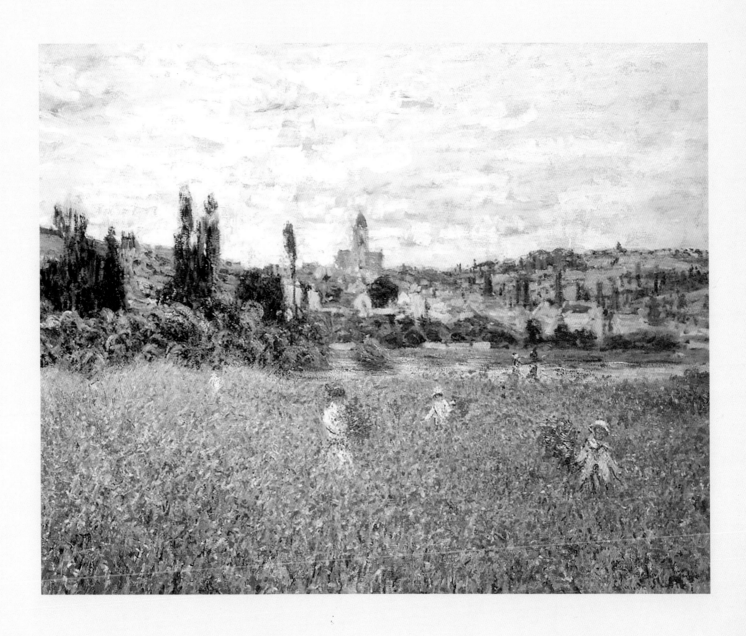

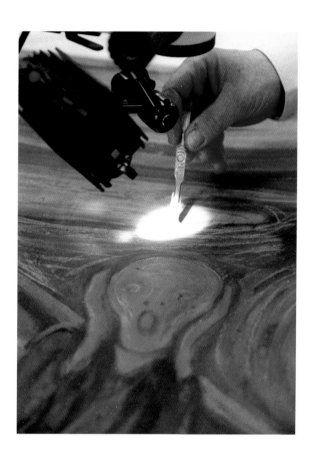

Owners always worry when a work of art is stolen, that, even if it is recovered, it will have been damaged. Conservation staff looked very carefully at Edvard Munch's *The Scream* after it was returned to the National Gallery in Oslo in May 1994.

books. The disappearance (twice) and recovery (twice) of Edvard Munch's *The Scream* drew similarly comprehensive coverage. Robberies like these, of paintings whose worth runs to the tens and even hundreds of millions of dollars, cause police forces to set aside resources that would not normally be given to art. The cultural and historical importance of the objects stolen in these instances may be different but, from an investigator's point of view, they share common features. They belong to a separate sheltered and moneyed world, a world not easily penetrated by outsiders. The art world, for one thing, is secretive. Even used-car dealers in most Western countries are subjected to more comprehensive regulation. Art dealers prefer not to expose either the sources of their inventory or their preferred client lists. Museum curators keep mum in their hunt for both acquisitions and donors. Collectors also can be secretive. Discretion is rated a virtue in this rarified world.

Another story illustrates the point. A gallery owner admitted that he was fooled into purchasing a stolen painting. He can't sell it now he knows it was stolen, and the person he bought it from has disappeared. But you know how this business is, he says. You work with the people you know. The seller was a friend of a friend. The dealer thinks for a moment and then says wryly, it's kind of like catching a sexually transmitted disease.

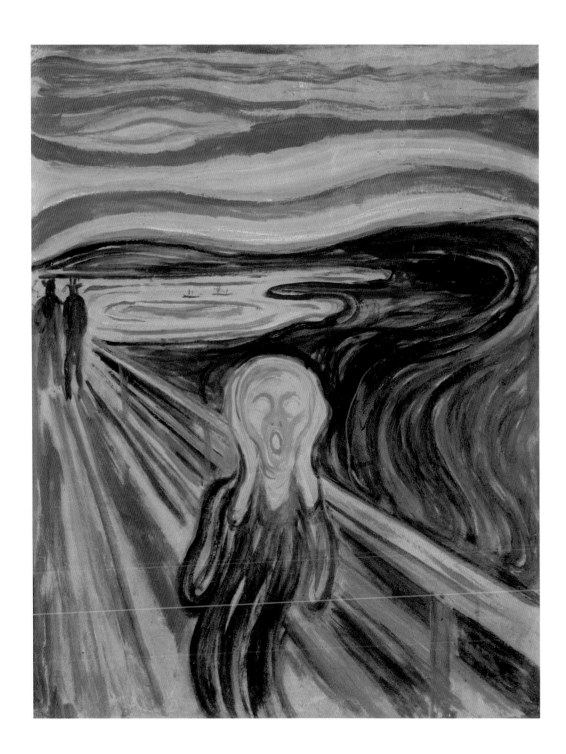

Edvard Munch (1863–1944), *The Scream*. Oil on board. The priceless painting was stolen in February 1994 and recovered a few months later. A different version of the same work was stolen from the Munch Museum in 2004.

You know your friends, but you don't really know your friends' friends, do you?

Police officers in general have little patience with the secrecy and what some see as the pretentiousness of the art world. Charley Hill was a detective inspector with Scotland Yard's Art and Antiquities Unit in the mid-1990s. He says that many police officers find it hard to take art theft seriously. Why one piece of paint-daubed canvas is worth millions while another is more or less worthless strikes many of them (and many laypeople, for that matter) as a mystery hardly worth thinking about. The police have other preoccupations: terrorism, the drug trade, biker gangs and organized crime, not to mention everyday occurrences such as armed robbery, sexual assault and murder. In this context, the disappearance of a painting, sculpture or old desk can seem trifling. At best, says Hill, in his time there anyway, Scotland Yard was mainly interested in the kinds of investigations that resulted in arrests leading to prosecutions. They wanted quantifiable outcomes. An elaborate operation to catch up with a piece of stolen art that may have slipped across several national borders and passed through several pairs of hands was hardly worth the effort when the cabinet minister to whom the police chief reported was mainly interested in the tally of villains who had been sent to jail. "But when it comes to great works of art," says Hill,

"the important thing is to get them back." Police officers, in his view, don't always see it this way.

Scotland Yard's Art and Antiquities Unit has been through both good times and bad. It was actually disbanded for a few years in the mid-1980s. Some of the good times coincided with the period when Charley Hill was detective chief inspector at Scotland Yard and Dick Ellis headed the art and antiquities unit. Together with other officers, including Graham Saltmarsh, they scored some notable successes. Hill famously went undercover, posing as a representative of the Getty, to recover Munch's *The Scream* the first time it was stolen from the National Gallery in Oslo.

Even then, Ellis says, he was fighting constant skirmishes with a bureaucracy that was not particularly sympathetic to his activities. Ellis retired from Scotland Yard in 1999.

Ellis, Hill and Saltmarsh all went private. Ellis's phone number is now one of the first ones dialed when the media want expertise on stolen art. Among his coups was the sensational exposure of a ring that smuggled Egyptian antiquities into London. Hill is another who reporters often call. Since leaving the force, he has worked as an insurance company investigator, and he subsequently entered into a partnership with Saltmarsh. He now works on his own. His great success in private practice was the recovery of Titian's *The Rest on the*

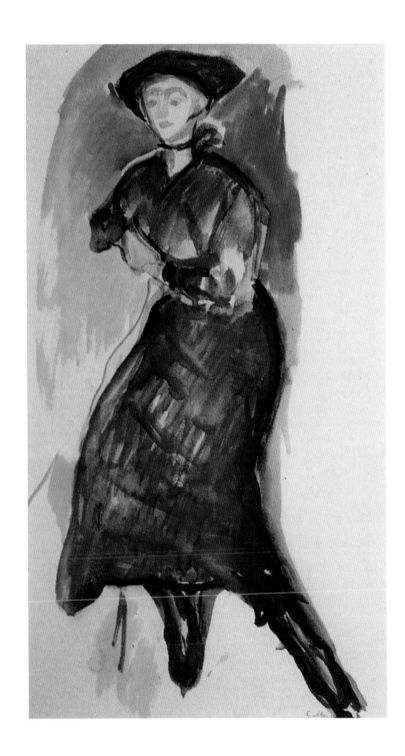

Edvard Munch, *Blue Dress*. Stolen 6 March 2005 from the
Hotel Refsnes God in Moss, Norway, the 1915 watercolor was
recovered less than 24 hours later during a police raid in Oslo.

Two paintings by Pablo Picasso, *Maya with Doll* (1938) and *Portrait of Jacqueline* (1961), were stolen in February 2007 from the Paris home (above) of his granddaughter, Diana Widmaier-Picasso. The paintings were recovered by French police a few months later.

Flight into Egypt, stolen from a private estate in 2002. Saltmarsh joined an American-based security company.

Nowadays the Art and Antiquities Unit has a full-time staff of four and a budget under constant threat. It has been recruiting volunteers from the art industry to serve as special constables and is being encouraged to enter into public-private partnerships, though no one seems to know quite what that means. Police cars sporting auction-house logos? The head of the unit, Detective Sergeant Vernon Rapley, reports that they investigate around 120 incidents a year.

Art crime is taken very seriously in France and Italy. It may not be a stretch to suggest that both countries place greater importance on protecting their culture than their Anglo-Saxon counterparts do. In any event, the Carabinieri and the Gendarmerie nationale (the latter through L'Office Central de lutte contre le trafic des Biens Culturels or OCBC) have long maintained active art-theft departments. In the United States, the FBI's art-crime unit has only recently come into existence: it was created in response to political pressure in 2004.

The previous summer, the United States had been embarrassed by the looting of the Iraqi national museum in Baghdad. A hostile international press accused the American invaders

of having planned for the protection of the oil ministry in Iraq, while neglecting entirely the country's magnificent cultural heritage. Rumor had it that American tanks had taken potshots at the museum. Now, supposedly, thousands of antiquities would flood the illicit market, and the FBI lacked the resources to deal with them. In the event, the Pentagon threw together a joint task force led by a marine colonel who happened to have a combined degree in classics and law. The colonel, Matthew Bogdanos, had the situation in Baghdad under control by the summer of 2003. But the FBI went ahead and organized the art-crime unit anyway.

The unit is made up of a dozen specially trained officers, each of whom is assigned to a specific region within the United States. They spend a week each year in Washington attending training sessions on subjects such as the conservation and handling of artworks, as well as lectures by auctioneers, art dealers and other experts. "This kind of material requires special expertise," says Bonnie Magness-Gardiner, the program manager. "It has special qualities. For example, there are no serial numbers on pieces of art, so they have to be categorized in other ways." Officers are not expected to be art connoisseurs, but they have to understand the qualities that distinguish one work of art from another. They need to know who they can call on for advice.

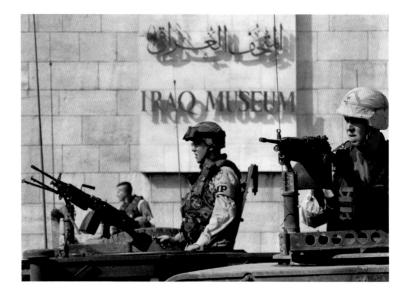

U.S. soldiers secure the area around the Iraq Museum in Baghdad in November 2003. The looting of the museum led to the creation of the FBI's art-crime unit.

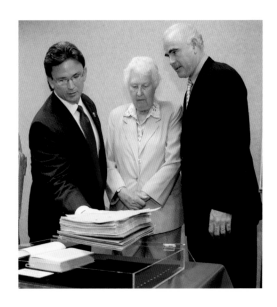

Janice Walsh, daughter of the novelist Pearl S. Buck, is flanked by FBI agents (top) at a press conference held in Philadelphia to announce the recovery of the original typewritten manuscript of *The Good Earth*. It had been missing for decades.

"The business of art," says Magness-Gardiner emphatically, "is unique."

The kinds of items that fall within the art unit's purview range widely—"anything that is uniquely identifiable that has cultural value," according to Magness-Gardiner. A recent case is typical of the FBI's art investigations, first because the stolen item was worth thousands rather than millions of dollars, and second because the theft occurred so long ago that it may never be solved. It's also typical because the item itself was irreplaceable and virtually impossible to sell in the legitimate market, which doubtless is why it was kept out of sight for so long.

Pearl S. Buck won a Pulitzer Prize for her novel *The Good Earth* in 1938. Some years later, a straw suitcase containing the original typewritten manuscript together with a number of other documents was loaned to a museum in New York City. Buck was unsure what happened to it after the exhibition. She died in 1973 without finding out.

The art-crime unit recovered the manuscript in 2007 when an auction house in Philadelphia reported that it had been offered for appraisal. The police had done their best work in the case long before they got the auctioneer's phone call. "We've worked hard," said Special Agent Robert Wittman, "to establish a good relationship with this auction house—one of many we work with

THE MARKET IS CLOSED

In medieval Britain, purchasers could obtain title to stolen goods if the transaction occurred in certain street markets during daylight hours. The tradition was known as market overt. In modern times, the notion has offered incautious buyers dubious protection at best, and in 1995 it was abolished formally. Still, villains and incurable optimists cling to the notion for what comfort it brings.

In March 2001, a diffident young man with a Liverpool accent and a picture tucked under his arm walked into Sotheby's London premises. The painting was a small Edward Landseer landscape, which he wanted appraised. While the Sotheby's representative was making notes and asking questions, the young man suddenly picked up the picture and left. Sotheby's contacted the Art Loss Register with a description of the work and was informed, as it suspected, that the painting had been stolen long ago—in 1985. The ALR contacted police, and dealers and auction houses were alerted to watch for it.

One day later, the staff of Hall's Auctioneers in Shropshire called the ALR: the man with the Liverpool accent had turned up at their door, this time with two paintings in hand. One was the Landseer landscape, the other a painting of game birds, *A Cock and Hen Pheasant*, by Archibald Thorburn. The ALR discovered that this, too, had been stolen, not from a dealer as the Landseer had been but from an art fair in 1986. When the man from Liverpool returned to the auction house later in the day, he was greeted by police officers. He said that he had bought both paintings from a "car boot" sale—a private sale in a public place. He claimed that he had title because of market overt but he didn't. He was taken into custody.

in this city and around the country. They call us if they come across something iffy." No one was charged for the decades-old theft.

A manuscript gone missing from a museum years ago is a single, seemingly anomalous incident. It hardly constitutes a crime wave. But when there are many similar, seemingly anomalous incidents, they add up.

Scotland Yard's Vernon Rapley says the number of items that are recovered varies wildly from one year to the next. "We quantify recovered stolen works of art by value," he says. In 2006, the Art and Antiquities Unit recovered items worth an estimated £3 million but, some years, "the unit has recovered *single objects* valued in excess of £3 million." The FBI's Bonnie Magness-Gardiner is similarly wary of supplying year-to-year statistics. The uniform crime report compiled each year by the federal agency "does not break down crime by categories that we could find useful," she says. Overall, in the first three years of its existence, the unit claims to have recovered some 850 items; roughly 700 of these were part of a single haul of pre-Columbian artifacts. The total value of the unit's recoveries in the same period was around $65 million.

The statistics relating to losses are similarly elusive in most Western countries but, by almost every estimate, the real numbers are considerable. One source suggests that thirty thousand works of art are stolen each year in Italy—a figure that includes antiquities looted from archaeological sites. Six thousand artworks reportedly are taken annually in France. The numbers spiral out of control when thefts in the East and the developing world are taken into account. An inventory undertaken in Russia revealed that 160,000 artifacts had gone missing from Russian museums during a period of eighty years. In just one case that came to light in 2005, a married couple—a curator with medical bills to pay and her husband—were found to have stolen more than two hundred items from the State Hermitage Museum in St. Petersburg. The losses from museums in other weakened or war-ravaged countries are unknown, while the numbers of antiquities stolen from archaeological sites worldwide are uncountable. Interpol, the international police organization based in Lyon, France, has reckoned that the illegal trade in art and antiquities is the fourth most lucrative criminal activity. And it's not infrequently connected to the crimes it competes with in importance.

DEEP WATERS

The features that make an Old Masters drawing or an antique armoire unique are significant to

GRAND THEFT AUTO

The Austin car company made just seven hundred of these pedal cars in the 1950s and 1960s. In pristine condition, they might be quite valuable, but the one stolen from the garage of a private house in Surrey in the summer of 1998 showed signs of hard wear. It might have fetched £2,000 at auction. So it was surprising that the thieves thought it worthwhile to send it to Australia.

ALR staff, running a routine check, saw it in the Christie's Melbourne decorative arts catalogue in July 1999. The owners supplied a photograph taken just a month before the car went missing. This revealed a pattern of rust spots and scratches which, with the license plate number, proved the items were identical. The ALR researchers then looked more closely at the rest of the catalogue and found listed a number of other items that had been stolen in the south of England at around the same time—in particular, pieces from a collection of porcelain that was part of a £200,000 burglary in Oxford.

On its own, the car probably would not have made it to Australia, but consolidated as part of a larger shipment of stolen goods, it helped fill a container. Thieves, like more scrupulous businesspeople, also look for efficiencies to streamline their operations.

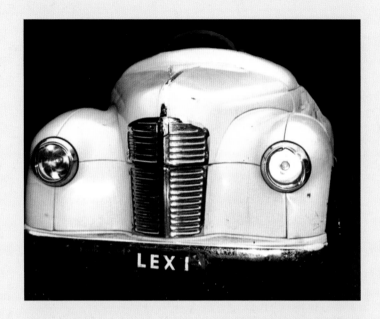

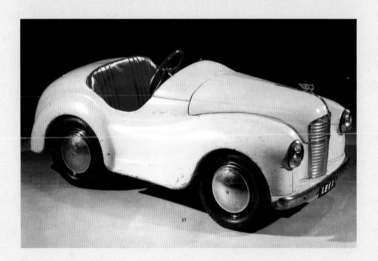

33

the collectors and connoisseurs who catalogue and appreciate them. They may be thrilled by the purity of the artist's line or the perfection of the cabinet-maker's craftsmanship — characteristics that allow them both to describe the pieces accurately and, when necessary, to gauge their price. Thieves don't care about these distinctions; they just care about the price. Police investigators are unanimous about this. A painting by Cézanne is not stolen because of the painter's sublime brushwork, nor is a Warhol taken because of the artist's innovative printmaking technique. There are no master criminals of refined taste indulging a hankering to hang their very own Matisse on the walls of their secret lair. Art in a criminal context is currency. Its value resides in what it can be used for. This most often means cash, but it can also mean leverage or, more rarely, status. Criminals use stolen art to achieve criminal ends.

In one of the most spectacular art thefts in modern times, an Irish gang based in Dublin and headed by Martin Cahill, an unusually brazen and devious thug, robbed Russborough House, an Irish country estate, of eighteen paintings, including a priceless Vermeer, two Rubens, a Gainsborough and a Goya. Some of the paintings subsequently turned up in London in connection with a drug investigation, during which it became apparent that they were being used, as Charley Hill puts it, "as

negotiable instruments to provide venture capital for [drug] trafficking." Another painting was put to more creative use. The gang used it to secure a loan from a crooked diamond merchant based in Antwerp to whom it had been selling stolen diamonds. The gang used the loan to set up a Caribbean "brass-plate" bank through which it intended to launder its drug profits. As it turned out, the gang got badly out of its depth when it entered Caribbean waters. The financial adviser who helped set up the dummy bank turned around and used the painting for fraudulent purposes of his own. His fraud was uncovered and, in the ensuing litigation, the Irish thugs lost their original stake.

The financial ineptitude of Cahill and his gang might be put down to inexperience. Other cases suggest that the use of artwork as surety for loans or as currency to be exchanged at some fraction of its legitimate value for drugs, guns or other contraband has become routine. The fact that art secures the money is incidental. What matters is the price it can fetch.

It might be thought that Interpol would have a role to play in addressing the problem. But Interpol has no independent power to pursue criminal investigations. It exists primarily as a clearinghouse for information. In this capacity, it has for several years issued posters, CDs and bulletins alerting other police agencies and the general

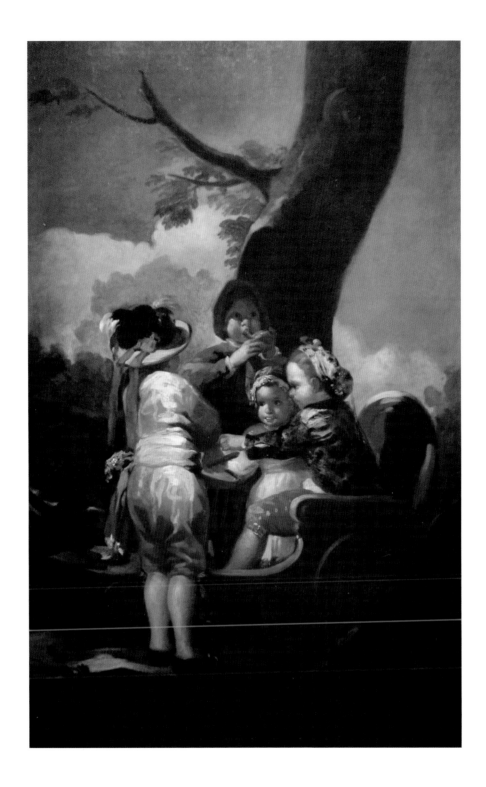

Francisco de Goya, *Children with Cart* (1778). This painting, owned by the Toledo (Ohio) Museum of Art was sent on loan to New York's Guggenheim Museum in November 2006. The truck carrying the painting stopped overnight at a hotel in Pennsylvania and in the morning, the picture was gone. The FBI, acting on a tip, recovered the painting and its journey to New York, so rudely interrupted, was completed in February 2007. The truck driver was arrested.

public to look out for certain items that have been stolen. It also maintains a database of more than twenty thousand stolen artworks, complete with thumbnail-sized photographs and written descriptions. This work is valuable as far as it goes.

But the number of thefts continues to mount, while the number of arrests and recoveries remains small. Police officers in national art-theft units do what they do best. They develop a relationship with people in the arts community, cultivate informants and deploy the customary crime-scene tools when a theft occurs. But certain features peculiar to art theft make it almost impervious to these familiar approaches. First, works of art usually are whisked out of the country within a day or two of being stolen. Second, they often don't emerge again for years. Third, as often as not, when the items do reappear, they have changed hands at least once and often several times. Fourth, the value of art, unlike electronic goods, for example, typically increases. There is no police organization anywhere that can address these problems effectively, except in the rare cases where the value of the stolen items justifies the resources. Nor can the police cope in a comprehensive way with the legal issues that arise, because laws vary widely from one country to the next, and the criminal fraternity is just wily enough to exploit the differences.

GONE FISHING

The Wildenstein Gallery on London's New Bond Street was closed as usual on a Friday evening in April 1987. In the window was *Bouquet d'anemones dans une vase verre*, a painting by the French Impressionist Auguste Renoir. It was valued at close to three-quarters of a million dollars. The doors were securely locked, and the alarms were switched on.

On Saturday the painting was gone. Thieves had extracted it through a hole in the display window. Police speculated that they had used fishing gear to hook the painting and lift it up and out, past the infrared beams that, if they had been broken, would have tripped the alarm. The incident became known as the "Fishing-Line Theft."

More than four years later, in September 1991, a man walked into the Wildenstein Gallery in Tokyo with the Renoir tucked under his arm. He said he was the legitimate owner, and he offered it up for sale. The gallery called the police.

The case was not as simple as it might at first appear. The Japanese gentleman who offered the painting to Wildenstein in Tokyo claimed to have bought it in the belief that the transaction was aboveboard and honest. His assertion carried some weight in Japanese law, and Wildenstein ultimately had to negotiate a settlement in order to get the painting back.

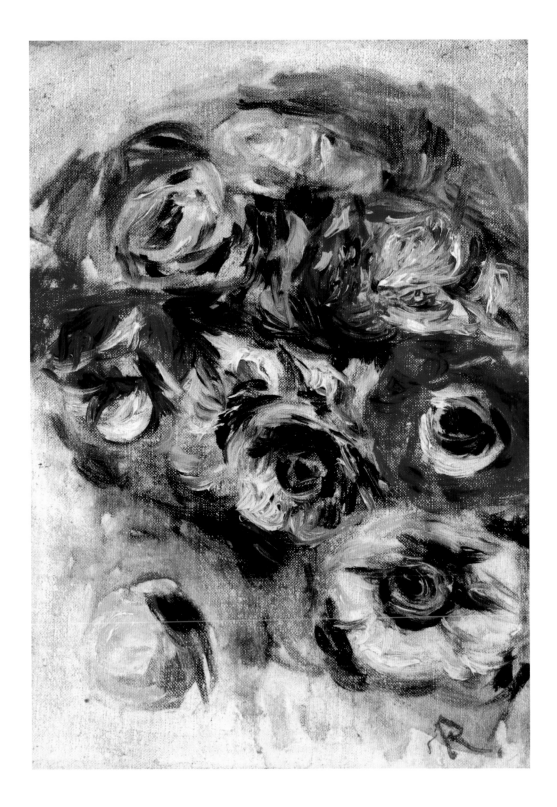

Pierre-Auguste Renoir (1841–1919), *Bouquet d'anemones dans une vase verre*. Police speculated that the thieves used fishing gear to haul the painting out of the display window. Newspapers fell for the story, hook, line and sinker.

Simon Bening, *Apostle Petrus.* This is one of seven miniatures (each measuring about five by seven inches) that were hidden in a mineshaft in Germany after World War II. They were pilfered in 1945 by an American working for an aircraft manufacturer who was going through technical records also concealed in the mineshaft. The paintings were worth about half a million dollars, but he sold them for only $100. They were returned to Germany in 1998 following an investigation into the affairs of a rug dealer who had purchased, and then tried to flog them.

According to the common-law tradition that has evolved in Britain and its former colonies and dominions, a thief can never really own or possess title to something he or she has stolen. And because the thief can't possess title, he or she can't pass it on, either. Even a "good faith" purchaser, who truly believes that the seller has the right to offer an item for sale and pays an appropriate sum of money for it, can't own it unless six years have passed since it was stolen.

Historically, there was an odd exception to the rule. By the tradition of market overt, if a stolen item was taken to an open-air market between sunrise and sunset, a buyer could purchase that item and assume title in the process. When the original owner discovered the theft, according to this tradition, he or she would know enough to visit the market and reclaim the article that had been stolen. In effect, this meant that the original owner had an obligation to make the theft known and to take appropriate steps to recover it. Market overt survives as an urban myth that has no legal validity today. The idea that the original owners of stolen pieces have an obligation to make known their losses and to take steps to recover them, however, remains true.

The civil codes of most European and Eastern countries are generally less helpful than the Common Law systems to the original owner of stolen goods. Under civil law, for example, a "good faith" purchaser can, in some circumstances, assume title to an object that has been stolen. And limitation periods in both civil and common law jurisdictions also can assist thieves. "Limitation" means the original owner's claim to title expires after a stipulated period has elapsed after a good faith sale. In civil-code countries, the limitation period typically ranges from three to six years. In common-law countries, the period is usually six years but can be considerably longer. So, in theory, the bad guys have only to shift their ill-gotten art to a favorable jurisdiction and hang on to it for a few years to make it theirs. A sweet deal. But there are impediments.

One famous legal case reveals the sometimes conditional nature of limitation. In *Autocephalous Greek Orthodox Church of Cyprus v. Goldberg & Feldman Fine Arts Inc.*, a church in Kanakariá, Cyprus, was robbed of rare and ancient mosaics — they were actually ripped from the apse — in the late 1970s. The church, with the support of the government of Cyprus, contacted every agency and institution it could think of to let them know of the theft. This included UNESCO, the press, museums and leading scholars. Surprisingly, it did not occur to anyone to contact Interpol, an omission that was raised in the later court action. As so often happens, however, the mosaics just disappeared. It was not until 1988, after more than

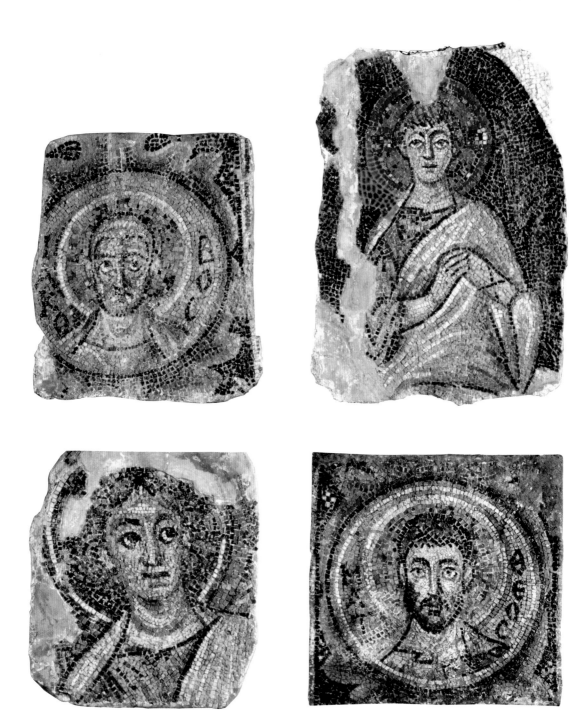

Following the Turkish occupation of northern Cyprus in 1974, thousands of icons and other works of art were looted from the island's churches. Among the items stolen were these sixth-century mosaics from the Church of the Panagía Kanakariá at Lythrankomí. The mosaics were purchased in 1988 by an American art dealer who tried to sell them to the Getty Museum in Los Angeles. The Getty declined the offer and notified Cypriot authorities of the approach. The church sued the dealer and the mosaics finally were sent back to the island in 1991. Fifty-thousand people reportedly were on hand to celebrate their return. The mosaics depict (clockwise from top left) St. James, Christ as a child, St. Matthew and Archangel Michael.

a decade had passed, that Peg Goldberg, an art dealer from Indiana, was offered the opportunity to purchase them. She paid someone in Cyprus just over $1 million for the mosaics (reportedly in crisp one-hundred-dollar bills) and then hauled them back to the United States, where she offered them to Marion True, the curator of antiquities at the Getty, for $20 million. True prudently declined and reported the offer to the International Foundation for Art Research. When the church learned of the transaction, it sued for the mosaics' return.

The case, which was heard before the Seventh Circuit Court of Indiana in 1990, turned on the question of when the limitation period started. If the court held that time started "running" when the theft occurred, then the church was out of luck. But the court came to a different conclusion. It noted that authorities acting for the church had exerted themselves in raising the alarm around the world. Even though they did not contact Interpol, they did reach out in a concerted campaign to let the world know of their loss. In the judge's estimation, their actions sufficed to constitute due diligence. Accordingly, the limitation period did not start to run until the whereabouts of the mosaics came to light when Goldberg offered them for sale. As the limitation period had not expired, the church got its art back.

This case does not exhaust the possible legal complications. Courts in different jurisdictions

The Kanakariá mosaics were badly damaged, both by their initial removal from the church, and by subsequent efforts to restore them in the United States. They were returned, not to the church itself, but to a museum in Cyprus.

have focused on other aspects of the limitation laws. In some jurisdictions, the notion of due diligence may be weighed differently against the notion of discovery, the moment when the stolen item comes to light. In others, the concept of demand and refusal is crucial. That is to say, the limitation period starts to run when the original owner of a piece demands its return from the current holder and is refused. These issues do not lend themselves to easy generalization. They do demonstrate, however, why art law is emerging as a recognized specialty within the legal profession.

A DANGEROUS PLACE
TO DO BUSINESS

"Most developments in the modern world favor the criminal," says Raymond Kendall, a former director of Interpol. "Cell phones and the internet reduce the need for the criminal to travel. Deals can be struck without face-to-face meetings. When he or she does travel, the same facilities designed to make business easy for legitimate businesspeople work for the criminal, too. Now that there are almost thirty countries in the European Union, border controls have become virtually nonexistent. It is very difficult now for police to trace either the criminals themselves or their unlawfully obtained goods."

Kendall and others have argued that the art world has to muster at least some of the resources needed to meet the challenge posed by globalized crime. It does not require a great leap of imagination to see how this might work. Police forces, with the exception of Interpol, are not international, but auction houses are. Insurance companies specializing in art, such as AXA Art and Hiscox, serve clients all over the world. The legal profession also has an international dimension. All have an interest in protecting their clients' property and ensuring that their business is clean.

Auction houses employ experts who can tell the difference between genuine and fake works of art (or they know someone else who can). The same experts also explore an artwork's history to ensure that it has been legitimately acquired. Insurance companies encourage policy holders to install some kind of security and to keep a detailed description of valuable artworks. An increasing number of lawyers specializing in art advise clients on a variety of issues. Activist lawyers bring about incremental changes in the law, by developing new approaches and by talking among themselves at conferences and symposia, a process especially evident in the evolution of the law relating to Holocaust art. "Art law as a discipline doesn't really exist,"

Daniel Wooster (1963–), *Music to My Ears*. This oil-on-canvas
painting by the contemporary American artist was stolen from
an art fair in Los Angeles in 2001.

Julian Radcliffe drew on his experience with a Lloyd's of London insurance syndicate when he launched the Art Loss Register in 1991.

says Pierre Valentin, head of the art division of Withers LLP, a law firm with branches in London and New York. "There is only a small body of law aimed specifically at the art world." But there are a number of complex legal issues that affect the art industry, ranging from acquisition, maintenance and security to intellectual property rights. Lawyers, along with others in the private sphere, have become part of the solution to the problem of art theft.

Julian Radcliffe and the Art Loss Register have provided another part of the solution. Radcliffe got his start in the insurance industry, which may seem a surprising background for a crime fighter. But insurance is all about risk management and Radcliffe developed innovative forms of insurance specifically aimed at securing investment in dangerous places. Then, in the early 1970s, he wrote a memorandum in which he argued that political subversion was a growing threat to business stability, and that there were established links between subversives and criminals. This paper provided the conceptual underpinning for the creation of a new company, Control Risks.

Control Risks offered advice to firms whose international operations made them vulnerable to a variety of threats, ranging from industrial espionage and employee sabotage to kidnapping. Radcliffe hired executives and staff from the British special forces — a tough crowd engaged in

dangerous work—and the company flourished. In 1986, he initiated the study that later would lead to the creation of the ALR.

The ALR's database of stolen works of art has grown steadily over the years. It started in 1991 with a card index that had been maintained by the International Foundation for Art Research in New York. This list, when the ALR took it over, had about thirty thousand entries. Information supplied by the Carabinieri, Interpol and UNESCO have been added, along with lists of artwork stolen during World War II. The ALR routinely logs items reported stolen by the police, art dealers, museums and individuals. It also logs items reported lost to fire or otherwise destroyed so it can detect insurance fraud if these items turn up on the market later. Although the rate has slowed somewhat, the ALR continues to add about 7,000 to 8,000 entries to the list per annum. By 2007, there were roughly 180,000 items altogether. Slightly less than half were paintings. The balance included a substantial number of clocks and watches, sculptures, silver, jewelry, furniture and objets d'art. There were also, in smaller numbers, such items as textiles (tapestries, carpets and the like), musical instruments, arms and armor, memorabilia, toys, medals, coins, stamps and even vintage cars.

The ALR was supported from its inception by the leading auction houses and by the insurance industry. Radcliffe and his staff have worked hard on their behalf to cultivate good relations with the police forces with which they deal on a daily basis. In this, as in some of Radcliffe's other enterprises, the organization negotiates with dexterity the narrow path that separates public and private interests. Control Risks also offered services—including, for example, negotiation with criminals and terrorists—that might be considered law-enforcement issues, which is to say, police business. "There is no question," says Radcliffe, "that if I had not been involved in Control Risks, I would not be so familiar with the techniques and public policy issues that underlie the Art Loss Register." Clarity of purpose, cooperation and sophisticated legal advice all are essential to the ALR's operations.

Tenacity and persistence are needed, too, along with a pugnacity that can come as a surprise to anyone who mistakes Radcliffe for just another clubbable Englishman. The novelist Mordecai Richler once warned that the British could not be trusted because they're never what they seem. With an American or Canadian, what you see is what you get. But the comfortable British gent who apparently is something in the city, as Radcliffe was, and who retires to the country on weekends (in Radcliffe's case, to a farm in Shropshire), is another matter entirely. Radcliffe's appearance gives no obvious hint of

Paul Cézanne (1839–1906), *La Route*. This pencil-and-watercolor sketch by the French Impressionist was among the items stolen from the National Art Museum in Buenos Aires in 1980.

his service with the British Territorial Army, his short stint with military intelligence in Northern Ireland or the time he spent in the strife-torn Middle East. He has devoted his career to thwarting villains of one sort or another, and he gets a steely glint in his eye when he assures a visitor that it wasn't a love of art that got him involved in this business. It was a hatred of crime.

Radcliffe has had ample opportunity over the years to act on his convictions. The two cases described below are similar in some ways. In both, the art that was stolen disappeared for a long time. In both, it was moved a long way from the site of the original robbery. And in both, the person who stood to profit most from the sale of the stolen items hid behind intermediaries who may or may not have known what was going on. But these are, in a sense, the usual similarities. This is what happens to stolen art.

In other ways, the stories are different. The first has elements of international intrigue. The second is about old-fashioned greed.

ARMS AND THE CÉZANNE

The junta that held power in Argentina from 1976 to 1983 was among the most brutal and corrupt

of modern times. Thousands of dissidents were arrested, tortured and killed. Many were kidnapped by police and paramilitary organizations, giving rise, in time, to the terrible spectacle of the vigil mounted by the mothers of the disappeared who came to be known as the "Mothers of the Plaza de Mayo." The published confession by an air force officer that he and his fellow officers had thrown hundreds of prisoners, naked, drugged, but still alive from aircraft flying high over the south Atlantic was just one among many subsequent, horrifying revelations. This was Argentina's dirty war, and its aftermath still unsettles the conscience of the nation.

The same junta that mounted a vicious campaign against supposed subversives at home tried to consolidate popular support by going to war with Great Britain over the Falkland Islands. The military campaign proved to be tougher and more protracted than the generals anticipated, and allies they had counted on faded away. Consequently, they were forced to look for arms and supplies from unconventional sources — in a losing cause, as it turned out.

The revelation that the murderers who had carried out the regime's dirty work were given concessions that included, among other things, a free pass to loot Argentina's cultural institutions may seem bizarre. But this was the story told by crooked police officers in the years after the

regime had crumbled. The theft from the National Museum of Fine Arts in Buenos Aires was just one of several similar robberies said to have been commissioned or countenanced by the notorious head of a paramilitary unit, Anibal Gordon.

The robbery took place on Christmas Eve, 1980. No doubt, security was lax that night, and parts of the museum were also in a mess because of renovations. The thieves had a shopping list: they took only items that had been donated to the state by the family of a rich estancia owner, Antonio Santa Marina. It was an odd list because it ignored many of the museum's more valuable works, but the Santa Marina collection still contained some fine pieces. The thieves helped themselves to sixteen paintings and drawings, including three by Renoir, two each by Cézanne, Degas and Rodin, and others by Matisse, Gauguin and Daumier. They took seven valuable artifacts as well.

The stolen art vanished. None of these items emerged from its hiding place for more than twenty years. The first intimation that their recovery might be imminent was a routine communication between Sotheby's and the ALR at the end of April 2001.

Some weeks earlier, an American woman had walked into the Bond Street branch of the auction house with glossy photographs of Impressionist paintings. The people at Sotheby's

GARDEN-VARIETY THEFT

Sometimes thieves lead investigators down the garden path.

Police acting on a tip intercepted a truck at a rest stop on the M3, the major highway linking London and the port city of Southampton, in March 2000. The driver and passenger were headed for the ferry to Holland. Their cargo, concealed by innocent-looking boxes, included the antique Japanese water carrier (above left) and the stone eagle (center), both stolen from private residences.

Another garden-variety theft was the seizure of the statue of Hygeia, Greek goddess of health (below left), from a stately home in Dorset. The thieves tipped her over and carted her away on a trolley, which left well-defined tracks in the ground. These also led to the Netherlands, but it wasn't until two years later that police picked up the trail. They were alerted when a dealer in London conducted a routine check with the ALR before purchasing the statue from a specialist on the other side of the Channel.

liked what they saw. Indeed, they liked the photographs so much that they sent Winnie Cheng, one of their representatives, along with a junior staff member, to see the original paintings in Taiwan. There, at the beginning of May, on the other side of the world, Cheng and her associate examined the artwork properly. They determined that the paintings, although stripped of their frames and stretchers, were authentic and in good condition. Cheng valued them tentatively at about £2 million. Sotheby's only required confirmation that the owner's claim to title was legitimate in order to proceed.

It fell to the ALR to break the bad news. The paintings were part of the decades-old haul from Argentina's national museum. The art was hot.

After consultations with Scotland Yard and the legal staff at Sotheby's, Julian Radcliffe flew to Málaga, Spain, to meet the woman who had tried to raffle off the artwork. Gabriella Williams and her husband were Texans.

Alan Williams was an engineer, aged sixty-four, understated and businesslike. His wife was seventeen years younger and, according to Radcliffe's notes, wore "massive amounts of gold jewelry on her hands, heavy makeup, artificial eyelashes, nails, and [was] … quite plump." Gabriella Williams did most of the talking. She explained to Radcliffe that she and her husband presided over Humana Way International, a charitable organization based in Texas. It was properly registered and all set to alleviate the world's miseries. It hadn't actually undertaken any charitable projects to date, but she assured him that it "was looking to do so." She and her husband had planned to use the paintings in an elaborate scheme to raise money for Humana Way's prospective good works.

The names of many people were introduced into the conversation, and Radcliffe duly noted their addresses, telephone numbers, citizenship, even passport numbers. The paintings were said to have belonged to a Brazilian senator, Pedro Mansueto de Lavor, who may or may not have passed away. An organization, the De Lavor Trust, had been set up in the senator's name, and the trust had entered into some kind of agreement with one Arthur Lung, who was managing director of a logging company in Suriname. The Williamses had been introduced to Lung by John Thorpe, an American who claimed to have been employed by the U.S. Drug Enforcement Agency. Gabriella Williams didn't trust Thorpe, she said, but it emerged that he had been made president of Humana Way International's Korean branches (in both North and South Korea). Since North Korea is a totalitarian state that is all but impenetrable by outsiders, and South Korea is one of the most prosperous of Asian nations and both are a long

way from Texas, this revelation caused Radcliffe to add to his notes a rare, ironical exclamation mark.

There were other names and contacts: bankers, accountants and intermediaries. It was apparent that the art itself had been shifted over vast distances: from Argentina, through Brazil and Suriname, to Hong Kong and Taiwan, putting literal distance between the paintings and the scene of the crime. The innumerable names served a similar purpose. The complex, dubious and sometimes unverifiable relationships among them created a kind of maze that was meant to baffle pursuit.

Gabriella Williams presented herself as a kind of knowing innocent. On the one hand, she was prepared to work with people she didn't trust while, on the other hand, she insisted on the purity of her purpose. She even offered, doubtless in a charitable spirit, to assist the ALR in its work of art recovery. (She did wonder aloud, however, what sort of finder's fees the ALR was paid.) Her scheme, as far as the paintings were concerned, "was to obtain a valuation from Sotheby's and Lloyd's and then take these and the fine art to a bank, borrow part of the value of the assets and invest this in order to provide income for the participants." She was certainly in it for the money, whether the money was intended for charity or (more likely) not.

Discussions were initiated with the Argentine government in the weeks that followed Radcliffe's encounter with the two enterprising Texans.

It was a difficult time in the South American nation: the military junta was long gone, but the economy was in a parlous state with inflation running rampant. There wasn't any money in the arts budget to subsidize the ALR's detective work. Fortunately, an Argentine philanthropist was found who agreed to pay the ALR's fee. This allowed Radcliffe to follow the trail to Taipei.

There, in January 2002, Radcliffe came up against the brother of Arthur Lung, the one who was the managing director of the logging company and a director of the De Lavor Trust. They met in a hotel room. Radcliffe took a tough line with Yunhei Lung. He told him that the paintings were stolen, that he would never be able to sell them on the open market and that he would have to give them up. Lung — stocky, belligerent and a chain-smoker — was unmoved. He confirmed Radcliffe's mostly unspoken suspicion — it being a delicate topic for Argentina — that the theft of the art was tied, in some way, to an illicit arms deal back in the time of the Falklands War.

"I remember exactly what Lung said," reported Radcliffe. "He said, you get the Ministry of Defence to instruct me to release them, and I will do so. And I thought to myself, why is the Ministry of Defence interested in this.... Well, we know that South Africa, Israel, Taiwan and so on were the sort of countries that didn't pay much

attention to arms embargoes. So when there was an arms embargo on Argentina, during the military dictatorship and/or the war, they may well have breached it. Taiwan feels under threat. They have to have a very strong arms industry.... So they'll sell arms to anybody."

Taiwan is essentially untouchable for most legal purposes. China regards Taiwan as Chinese territory and takes a dim view of nations that recognize Taiwanese sovereignty. Consequently, out of deference to China, most Western nations have declined to establish full diplomatic ties with Taipei. So there was no way to bring diplomatic pressure to bear on Yunhei Lung and his associates in the Ministry of Defence. It appeared that the Argentine haul had been found only to be lost again.

But Lung, the posturing tough guy, may have been annoyed by Radcliffe's assertion that he could never sell the paintings — so annoyed, in fact, that he took it as a personal challenge. Just a few months after their meeting in May 2002, three of the stolen paintings were offered for sale to one of Paris's chic galleries on rue de Seine. These were a Renoir portrait, *Tête de jeune fille au ruban bleu*, a Cézanne watercolor and a Gauguin pencil sketch. The seller turned out to be a nephew of the Lung brothers, Yeh Yeo Huan. The gallery contacted the ALR, and Radcliffe promptly set in motion the legal machinery to have the artwork seized.

Paul Gauguin (1848–1903), *The Call*. This was among sixteen Impressionist paintings and drawings taken from the Argentine museum. The thieves appeared to know what they wanted, but they left many other, more valuable works behind.

Chaim Soutine (1893–1943), *Portrait d'une jeune fille* (above right) and *Portrait d'un jeune homme* (right). Michael Bakwin's parents put together their collection of Impressionist art over the course of a lifetime. Seven of the paintings he inherited were stolen fom his house in May 1978.

The end was not swift — in France the wheels of justice grind slowly — but the case took one or two more strange turns. Alan and Gabriella Williams and their unlikely charity faded out of the picture. The Argentine ambassador to France made an entrance, taking an active interest in the case, and making strong representations for the return of Argentine property. A French solicitor also made what turned out to be a cameo appearance as the representative of the Lungs and the Taiwanese government. His contribution to proceedings was positive and constructive and, for a while, it seemed possible that the paintings that were squirreled away in Taiwan might be brought into play. Unhappily, at this precise juncture, the French solicitor was arrested on charges of smuggling gold into France. The solicitor withdrew.

In November 2005, Buenos Aires got back the three pictures that had been smuggled into France. Radcliffe was among the observers on hand to witness the ceremony. The Argentine press rejoiced at the pictures' return but made scant mention of the bleak circumstances in which they had been taken. Thirteen pictures remain in a warehouse in Taipei. "I believe that one day they will try to sell them," says Radcliffe, taking the long view, "and we know that we'll get them back." In the pursuit of stolen art, patience is not just a virtue, it's indispensable.

A FISHY BEQUEST

Three paintings were stolen from a private residence in Wiltshire, England, in 1985. Two were by John Frederick Herring, an eighteenth-century British artist of Dutch descent who specialized in hunting scenes. The third painting was by E. Holiday, a minor British artist who favored rural scenes (right). All three turned up in December 1998 in the estate of an American living in Florida. According to the terms of the will, the paintings should have been turned over to a charity, but the dealers whose job it was to appraise the paintings checked first with the ALR. It turned out that these were just three of several stolen paintings in the dead man's possession. His widow cooperated fully with the ALR in returning the works to their original owners.

Peter Paul Rubens, *Unidentified Man Wearing a Ruff.* This painting, valued at more than $3 million, had been in the Van Wylinck family since 1927. Dirck Van Wylinck offered it as collateral for a loan to two men who then smuggled it to the United States and sold it to a collector in New Jersey in 1992. The collector had no notion that the painting was stolen and cooperated fully when the FBI, alerted by Belgian authorities, knocked on his door. The painting was returned to its owner in 1996.

SOME THINGS DON'T LOOK GOOD HERE

Patience helps when you're building an art collection, too. The Bakwins bought their first Impressionist painting, a Renoir still life, in Paris in 1925. They were newly married and were just finishing their medical studies, both specializing in pediatrics. They took their profession seriously. Each went on to head the pediatric department in their respective hospitals: in Ruth's case, the New York Infirmary, and in Harry's, Bellevue, also in New York City. Both later taught at the City University of New York. But the art-collecting habit was established when they were young and in love and free to act on a whim, and it was repeatedly reinforced over the years. Whenever they could get away from work, they headed for Paris and indulged their passion for Impressionist paintings.

In the early years, they mingled with the expatriate Americans who clustered at the Dome in Montparnasse. They counted the writer Gertrude Stein, the composer Virgil Thomson and the poet Ezra Pound among their friends. The Lithuanian-born American painter Ben Shahn guided them through the Parisian art world, introducing them to Chaim Soutine and others. Harry, an excellent chess player, acquired the knack of losing when he played with Maurice de Vlaminck. The painter,

cheered by victory, invariably lowered the price of his latest work. Over five decades, from the 1920s to the 1960s, the Bakwins purchased a formidable number of important paintings by van Gogh, Renoir, Cézanne, Soutine, de Vlaminck, Rouault, Matisse, Gauguin, Derain, Duchamp and Utrillo. It was a museum-standard collection: they were frequently asked to loan pieces to the Museum of Modern Art and other major institutions, which they cheerfully did. When they died, however, it wasn't the museums that benefited, but their four children.

One of the four, Michael Bakwin, settled his family in a modest house in Stockbridge, Massachusetts. He opened a restaurant in the town, which is not far from Boston, and prospered as Stockbridge became a destination for harried urbanites in search of a rustic break. The family's life was quiet but not, perhaps, quite as far removed from the evils of city life as Bakwin might have imagined.

The robbery was almost certainly carried out by David T. Colvin, a sometime carpenter and laborer who had been arrested once for selling guns illegally. He weighed around three hundred pounds and had a reputation for violence. He had been investigated on suspicion of dealing in drugs, and the police were keeping an eye on him. When he boasted to an FBI undercover agent that he was going to steal a valuable painting, the

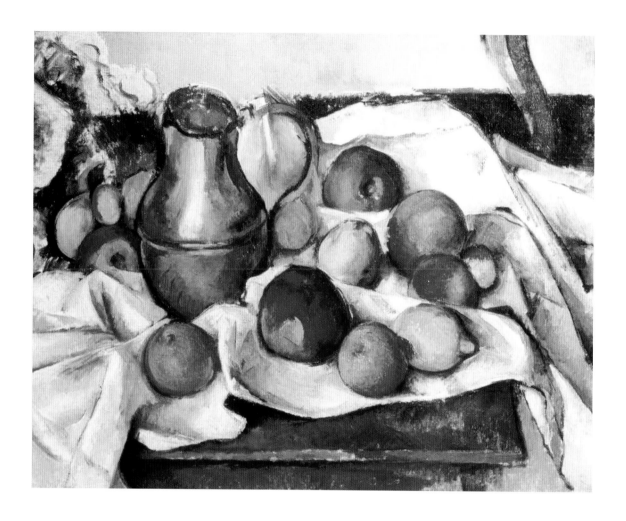

Paul Cézanne (1839–1906), *Bouilloire et fruits*. This was by far the most valuable of the paintings stolen by David Colvin from Michael Bakwin. Recovered and offered at auction in 1999, it sold for £18.15 million—well above its estimated sale price.

agent made a note but took no action. The agent was intent on making a drug bust. He remembered the comment later.

Rarely has a robbery been easier. Everyone knew about the Bakwins' art collection. And everyone apparently knew that the Bakwins were casual about security. The house was empty, and the door was probably left unlocked on the Memorial Day weekend in May 1978 when Colvin sauntered into the dining room and helped himself to seven paintings. They were the paintings that Michael loved best: *Bouilloire et fruits* by Paul Cézanne, *Portrait d'une jeune fille* and *Portrait d'un jeune homme* by Chaim Soutine, *Maison rouge* by Maurice Utrillo, *Fleurs* by Maurice de Vlaminck and two figure paintings by the Armenian artist Jean Jansem. It was and remains the biggest (that is, most valuable) art theft from a private collection in the United States. The Bakwins didn't discover their loss until the Tuesday after the holiday.

The FBI's report pointed to Colvin. Further investigation led to one of Colvin's associates, who said that plans had been made to pass the paintings on to a local fence who, in turn, had connections to another fence in Florida. There were phone calls from someone who hinted that the paintings might be returned for a ransom. The paintings weren't insured (in any case, insurance companies won't pay if the money goes to enrich

the thieves), but Michael Bakwin made arrangements for a local lawyer to conduct negotiations. Nothing happened. A grand jury was convened and Colvin was called on to give evidence. He cited the Fifth Amendment and declined to testify. The police had leads and a likely perpetrator but not enough evidence to solve the case. Massachusetts State Police Major Jack Flaherty later recalled: "It was not your run-of-the-mill, everyday theft. Every once in a while, a new piece of information would come up, and it would be a dead end."

Bakwin, in frustration, hired a private detective, who tracked down the fence in Miami—but this, too, turned out to be a dead end. And then David T. Colvin came to his own dead end. He was murdered in a dispute over a gambling debt on February 19, 1979.

Nothing more was heard about the missing paintings for twenty years.

Simon White, a Lloyd's underwriter, phoned Julian Radcliffe on January 19, 1999, with an odd story. He had been contacted by an English businessman, Anthony George Westbrook, who wanted, or so he said, to ship a Cézanne and other valuable paintings from Moscow to London, where he proposed to have them sold at auction. White wanted to know if the transaction was on the up-and-up. On the basis of the

information White supplied, Radcliffe ascertained that the Cézanne, if it wasn't a forgery, was one of Michael Bakwin's long-lost masterpieces. Here was a chance, perhaps, to coax it back into the light.

Radcliffe set up a meeting in London. This, as it turned out, was the first step on a journey that would last, with timeouts and detours, for more than half a dozen years. At every step Radcliffe consulted Bakwin, for whom he was acting, and where appropriate, the police. His goal always was to get the artwork back without rewarding the criminals. The holder of the artwork, for his part, wanted anonymity and a reward. Both used guile and the law to secure an advantage. The outcome was in doubt right up to the end.

Westbrook showed up for the meeting in March 1999 with photographs that revealed details proving that the paintings were the real thing. He claimed that he was acting for people who had approached him in Russia. When Radcliffe told him that the paintings had been stolen in the United States, Westbrook "appeared surprised, but not very surprised." He said that he would have to get instruction from his "principals" before discussions could resume.

There were more talks in the weeks that followed. At about the same time, another painting by Cézanne, quite similar to Bakwin's, was sold at auction for a record price. This inspired Westbrook to demand £10 million, arguing that this figure represented 10 percent of the paintings' market value and so constituted a suitable finder's fee. Radcliffe rejected the suggestion out of hand. The price was too high and, besides, no money would change hands without a full and true account of the paintings' recent history. The thieves would have to be identified and prosecuted. Westbrook went back to his principals and then handed over negotiations to a legal counsel in Zurich. His withdrawal was temporary.

Dr. Bernard Vischer, the Swiss counsel, first made the surprising proposal that his client purchase the paintings. He offered £18 million. There's no way of knowing whether this offer was serious or exploratory: it may have been an attempt to establish the artworks' market value. In any event, it was followed by another offer that definitely was meant to be taken seriously: a trade. Vischer's client would hand over the Cézanne. In exchange, Bakwin would sign over title to the remaining six pictures to the client. The client was identified only as Erie International Trading Company, a dummy company based in Panama where the laws permit a company's officers to remain anonymous. This was a key moment in the negotiations. The Cézanne was by far the most valuable of the stolen paintings, and this appeared to be a real chance to get it back.

Maurice de Vlaminck (1876–1958), *Fleurs*. The Bakwins came
to know many of the artists whose work they collected. Harry
Bakwin let de Vlaminck beat him at chess.

Maurice Utrillo (1883–1955), *Maison rouge*. This oil-on-panel painting was one of seven taken from Michael Bakwins' dining room.

Radcliffe and Bakwin consulted with the police and took legal advice.

And then they said yes.

There would be documents to sign. Vischer wanted Bakwin's formal agreement to give up any claim to the remaining six paintings. Any dispute between the parties to the agreement would be settled by arbitration in Switzerland. Radcliffe added a proviso of his own. Vischer's client would have to sign an affidavit declaring that he had nothing to do with the original robbery. This affidavit would be sealed and handed over to a British lawyer. It could be opened only by order of a British court.

The deal was done in a Geneva law office on October 25, 1999. After the formalities were completed, Vischer produced a plastic garbage bag from which he withdrew the painting wrapped in a towel. The Impressionist specialist from Sotheby's was on hand to confirm its authenticity and attest to its condition. He declared that the painting was real and its condition excellent. Hands were shaken all round.

Bakwin wasted no time in putting the painting up for auction. He wasn't about to risk hanging it in his home again. It was the star turn at Sotheby's on the night of December 7, 1999, bringing in £18.15 million against an estimate of between £9 and £12 million. There was applause in the salesroom.

And then the negotiations resumed.

Radcliffe got in touch again with Westbrook and reminded him that the paintings in Erie's possession were still stolen. If Erie wanted to part with them, they had no choice but to talk to the ALR. Westbrook balked. Radcliffe gave a detailed account of the negotiations leading up to the Geneva handover to journalist Peter Watson, and the story appeared under Watson's byline in the London *Sunday Times* on December 17, 2000. The intended effect of publication was to make it impossible to sell any of the stolen pictures on the open market: now everyone knew their history. Erie's front men fell silent.

Four years later, a Boston-area real estate developer, Paul Palandjian, contacted Sotheby's in London. He had four paintings he wanted to sell: they were Michael Bakwin's two Soutines, the de Vlaminck and the Utrillo. The period that had elapsed since the paintings were signed over to Erie was just over five years. It is probable that the people behind Erie believed that the elapsed time meant that the limitation period could be invoked under Swiss law and that the paintings would no longer be regarded as stolen. They were shipped from Switzerland to London in April 2005. Sotheby's promptly notified the ALR, Radcliffe took steps to have the pictures legally sequestered and a series of court actions kicked in.

From Radcliffe and Bakwin's point of view, there were three legal issues to be decided. The first was whether or not British courts would accept the contractual stipulation that any dispute would be settled by Swiss arbitration. The second was whether or not the signing over of the six paintings was valid. And the third was whether or not they could persuade a British court to open the sealed envelope that would, if the agreement had been honored, expose the identity of the person behind the Erie International Trading Company.

There was talk of further negotiation between Bakwin and Erie. The litigation was expensive and the outcome uncertain. Radcliffe took the position that the contract with Erie was unenforceable because it had been entered into under duress. "If I wanted to get the Cézanne back, I had to sign the agreement — and I told them so at the time," Radcliffe said. He told a reporter for *The Art Newspaper* that "these were still stolen works and this was a case of extortion." Bakwin elected to fight on. In November 2005, a court in London unambiguously rejected the argument for referring the case to Switzerland and affirmed that the six paintings were still contraband. Erie appealed the case and lost again. And then, in late January 2006, Bakwin and the ALR persuaded the High Court of Justice to open the sealed envelope.

It was well and truly sealed. Seven layers of paper, card and tinfoil had to be stripped away before the two-page document was exposed. It was dated October 20, 1999, five days before the Cézanne had changed hands in Geneva. Under the heading "Declaration," its author made a number of statements intended to deflect blame or prosecution. He said that he had no part in the original robbery and that he had never participated in any criminal activity. He claimed to have taken possession of the paintings eighteen years ago — more than two years after the robbery occurred — and to have moved the paintings out of the United States before 1988. But, most importantly, he signed his name: Robert K. Mardirosian.

"I know some things don't look good here, but I believe I have a legitimate case to make," Mardirosian told Stephen Kurkjian of *The Boston Globe* a day after his name was revealed. "I could have sold these a dozen times, but never did. My whole intent was to find a way to get them back to their original owner in return for a 10 percent commission."

Mardirosian, it turned out, had been David T. Colvin's lawyer. Colvin told him that he had the paintings when Mardirosian was advising him on another legal matter. Mardirosian urged him not to try to fence them, that with his other troubles, he would just make things worse. Colvin, according to Mardirosian, stayed the night at his house. It was not until months later, after Colvin was

murdered, that he discovered that the paintings had been stashed in his attic. This, in any event, is the story he told Kurkjian. In 2007, Mardirosian was arrested for handling stolen goods.

It's likely that the police would have caught up to Colvin if he hadn't been killed. As it was, the case went cold and remained unsolved for decades. The ALR took advice from the police — the FBI, Scotland Yard and the Swiss police all were involved at different stages — and the police, in turn, supported the course that the ALR followed. But the Bakwin case, like the Argentine case before it, showed that the ALR's database and hard-nosed negotiating protocols are effective tools for recovering stolen art.

While the private sector and agencies other than the police have worked to solve some old-fashioned art thefts, the courts, pressure groups and crusading lawyers have led the way in addressing the long-unresolved art crimes committed by the Nazis in World War II.

Robert K. Mardirosian, a lawyer, believed that he was entitled to a finder's fee for returning the paintings stolen by David T. Colvin.

TAINTED LEGACY

"There is little of the Mannerist chiaroscuro to be expected

in the world of art contraband, more a prevailing gloom."

—Mr. Justice C.J. Moses, *City of Gotha v. Cobert*

Some Allied soldiers in Germany after hostilities ended found
themselves engaged in an operation to collect and secure the
enormous number of artworks that had been stolen and then
dispersed by the Nazi leaders.

THE NAZI THIEVES

It was August 1944. Alexandre Rosenberg, an officer in the Free French forces led by General Leclerc, was engaged in fighting on the outskirts of Paris when he was ordered to seize a train in the marshaling yard at Aulnay-sous-Bois. It was a freight train, fully loaded and on the point of departing for Germany. When Rosenberg and his men pulled open the doors and pried open the crates that were packed inside, they were stunned by what they discovered. In crate after crate, they turned up spectacular works of art: Old Masters, Impressionists, twentieth-century moderns. Among them were paintings that Alexandre knew intimately. He had grown up with some of them; others he had helped to catalogue. They belonged to his father.

It was an astonishing coincidence. But much of what happened in the desperate, dying days of the war in Europe was so unlikely that it amounted to madness. Hitler had ordered that Paris be burned—an order his commandant disobeyed—while, in the streets, shopkeepers brandishing antique rifles crouched behind improvised barricades and tried to pick off the last grimly determined German snipers. Amid the confusion, as collaborators fled from vengeful neighbors, resistance fighters gave up their lives and the scales of war tipped decisively in the Allies' favor, Hitler turned his attention to another urgent issue. Locomotives were diverted, and troops were withdrawn from the front. The Führer was using the last trains out of the city to retrieve his stolen art.

Alexandre's father, Paul Rosenberg, was among the most important art dealers in Paris in the years between World War I and World War II. Art was something of a family affair: both Alexandre's grandfather and his uncle Léonce were dealers as well. Léonce, who was older than Paul, was something of an eccentric, apt to send hectoring circulars to his artists, expounding his views on business and art. In contrast, Paul had an eye for new trends and a shrewd instinct for sales opportunities, and he soon opened his own shop.

His timing could hardly have been better. Paris, between the wars, was the center of the art world. The Impressionists were finding acceptance among adventurous collectors in North America, and the modern artists who followed them were beginning to make their mark. In 1918, Paul offered Pablo Picasso a guaranteed income in exchange for the exclusive right to represent him. They became and remained close friends. In 1921, Paul signed a similar agreement with Picasso's sometime collaborator and rival for recognition as the inventor of cubism, Georges Braque. And in 1927, Paul became Fernand Léger's dealer on similar terms.

Paul Rosenberg added to his art inventory at a famous series of auctions following World War I. The opportunity, as often happens, was the result of another man's misfortune. Germany was required by the terms of the Treaty of Versailles to pay reparations to those of its neighbors that were among the victims of its aggression, but the country was an economic basket case at the time, with neither the resources nor the desire to turn over the funds. France forced the issue by seizing German assets where it could find them. Among the pickings was the art collection of a German dealer in Paris, Daniel-Henri Kahnweiler. His rival, Léonce Rosenberg, was given the task of appraising the art and organizing the auctions in which the collection would be dispersed. Four auctions were held between 1921 and 1923. The first was a modest success, while the next three were unmitigated disasters. Paintings were knocked down for prices that were a tenth of what they would have fetched a few years earlier. By the end of the proceedings, demoralized observers no longer bothered to object when artists' names were mispronounced or when paintings were shown upside down. The auctioneer openly sneered at his own offerings. And a fine collection of de Vlamincks, Braques, Picassos, Légers and Derains was added to Paul Rosenberg's storeroom on rue La Boétie. In the years that followed, his art holdings grew and his

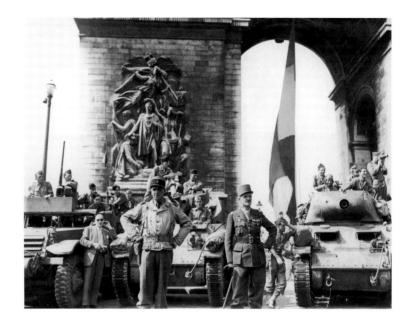

The Allies stood back to allow soldiers of the Free French army to liberate Paris in August 1944. The liberation of the city was not without bloodshed but the reception given to them by their compatriots after five years of German occupation was ecstatic.

Henri Matisse (1869–1954), *Odalisque,* or *Oriental Woman Seated on Floor.* Oil. The long-lost painting was rediscovered by the Rosenberg family when it was given to the Seattle Art Museum in Seattle, Washington.

business thrived. He entered into a partnership with another dealer in London and explored the possibility of opening a gallery in New York. The gallery in Paris, meanwhile, was a linchpin in the international art circuit.

He was not oblivious to the rising international tensions that characterized the later 1930s, but until the end of the decade, France was seen as a sanctuary for refugees, not as their point of departure. Few envisioned the scale of the catastrophe that lay ahead. Once war was declared between France and Germany, but before hostilities began—in the period of the *drôle de guerre,* or Phony War—Rosenberg took precautions that seemed to be both prudent and sufficient. His collection was already somewhat dispersed. According to Hector Feliciano's account in *The Lost Museum,* Rosenberg had several paintings on show in the London gallery, and others had been loaned to an exhibition touring the United States. In May 1940, when the Wehrmacht was demonstrating the irrelevance of France's defensive Maginot Line and driving full-tilt toward the heart of the republic, Rosenberg shipped more paintings from Paris to the relative safety of a warehouse in Tours. Others he stashed in a bank vault in Libourne, near a villa he had rented a few miles from Bordeaux. In a move that proved to be fortunate, he registered the holdings in Tours in the name of his assistant's brother-in-law.

But the bank vault, listed in his own name, contained 162 paintings, including such masterpieces as *Odalisque*, or *Oriental Woman Seated on Floor*, by Henri Matisse.

Rosenberg was by no means the only one who underestimated the nature and extent of the Nazi onslaught. Still, there had been signs of what was to come. From the time Hitler became chancellor in 1933, Jewish families in Germany had suffered state-sanctioned harassment, beatings and worse. Many fled the country even before the Kristallnacht pogrom on November 9, 1938, when mobs looted and destroyed thousands of Jewish businesses and homes. "At long last, Berlin's man in the street had an opportunity to fill himself up again," Joseph Goebbels, Hitler's propagandist, exulted in his diary. "Fur coats, carpets, valuable textiles were to be had for nothing. The people were enraptured." In the aftermath of Kristallnacht, the terrible death-dealing machinery of the Holocaust was set in motion. That same machinery was also a cover for theft.

The massive scale of the theft and the methods by which it was achieved—ranging from quasi-legal edicts to extortion and muggings—were thoroughly chronicled by the historian Lynn Nicholas. As the Third Reich expanded across occupied Europe, Jewish families lost their homes, their furnishings, their valuables and their cash. In subsequent years, vast quantities of gold, some

American soldiers examine candlesticks that were part of a hoard believed to have been hidden on the order of Reichmarshall Hermann Göring. Göring's collection of seized and stolen art was second only to Hitler's.

obtained horribly from the death camps, found its way into Nazi bank accounts in Switzerland. And staggering numbers of artworks, far surpassing that looted in any previous war, were seized as part of Hitler's perverted Aryanization scheme.

Hitler wanted to rid the Reich of the "degenerate" modern and Jewish art that he regarded as inferior, while building an encyclopedic collection of the "Aryan" art of which he approved. The latter was intended for a planned museum in Linz, Austria, the city of his birth. His ideological henchman, Alfred Rosenberg (unrelated to Paul) provided logistical support for the endeavor by creating the Einsatzstab Reichsleiter Rosenberg (ERR) to collect, catalogue and transport the looted property to Germany. All of Europe was plundered by the Nazis but, following the invasion of France, Rosenberg installed the ERR in the Jeu de Paume, a museum on Place de la Concorde in Paris. There, in the museum's ample halls, Rosenberg's curators scrambled to keep up with the incoming truckloads of appropriated valuables. Hitler never visited the museum, but he was supplied regularly with portfolios illustrating the seizures, from which he selected his trophies. Meanwhile, Reichmarshall Hermann Göring visited the gallery often, helping himself to items that the Führer had declined.

Göring's collection had more than 1,300 items by the end of the war. Hitler's was vastly bigger. By the time he took cover in his Berlin bunker—where he sometimes brooded over an architect's model of the projected complex at Linz—Hitler had amassed some 8,000 works of art. Tens of thousands more were earmarked for consideration. More than 22,000 items were sent by train from the Jeu de Paume to Germany. The shipments included more than 5,000 paintings, almost 2,500 pieces of antique furniture and more than 500 Gobelin tapestries. One hundred and thirty-seven freight cars were diverted for the operation—and all this time, there was a war going on.

In June 1940, Paul Rosenberg and his family fled before the advancing Germans. They were stopped at the Spanish border, where French police denied Paul's son, Alexandre, permission to leave the country. At nineteen, they said, he was eligible for the draft, and his parents had to leave him behind. The boy ultimately made it to England, where he was asked, on landing, if he knew anyone who could vouch for him. He said yes, Winston Churchill. His questioners took him for a wise guy, but it was true. Churchill, an amateur painter, had visited his father's gallery. Alexandre was admitted to Britain, and his ambition to fight the Germans was achieved when he joined the Free French forces that were formed under the direction of the French government-in-exile.

Fernand Léger (1881–1955), *Femme en rouge et vert*. Oil on canvas. This was among the paintings looted by the Nazis from the Rosenberg family—there was some question whether it had been Paul's or Léonce's. After the war, it found its way into the collection exhibited in the Pompidou Centre in Paris. It was returned to the family in 1999.

Hector Feliciano has described how the ERR located the different caches of Paul Rosenberg's art collection in France. Unscrupulous dealers in Paris, anxious to appease the occupying forces and pleased by the prospect of financial gain for themselves, betrayed Rosenberg. Artworks left in his home, his Paris gallery and the rented villa near Bordeaux were all seized in short order. The Germans then discovered the existence of the bank vault in Libourne. The contents were taken under the spurious authority of the new regime and shipped to the Jeu de Paume. Of all the works of art that Rosenberg had left in France, only those that were hidden in Tours were left alone.

Five years would pass before Alexandre would halt the last shipment of art from Paris to Germany. In that time, many other families besides his would suffer from the remorseless depredations of the Nazi thieves. Obtaining redress for the losses would turn out to be a much longer process, one that is still far from complete.

FINDERS, KEEPERS

In 1945, in an attempt to save his collection from the advancing Allied armies, Göring sent a trainload of art from his estate in Prussia to Hitler's mountain retreat, Berchtesgaden, in Bavaria. The most important items were moved into an air-raid shelter, but much remained on the train. Rumors spread throughout the countryside that the train was loaded with schnapps, and soon it was swarmed by nearby residents bent on finding free liquor. There was booze on board, and the locals' larceny was rewarded accordingly, but what many found and liberated instead were small masterpieces by Dutch masters, late-Gothic wood statues and thirteenth-century Limoges reliquaries. According to Bernard Taper, who was among those who were later called upon to clean up the mess, matters occasionally took an unfortunate turn. A group of women fighting over a priceless Aubusson carpet, for example, resolved the dispute by carving it into pieces. Some parts became bedspreads; others, curtains.

Taper was with the Monuments, Fine Arts and Archives (MFA&A) section of the U.S. Office of Military Government in Germany after the war. When the sheer scale of the looting was understood, as the victorious armies stumbled upon caches of art in railway sidings, warehouses and underground shelters, it became obvious that something had to be done. The three Western allies—the British, French and Americans—each set up a separate organization in their own administrative zone to deal with the problem. These ad hoc art units, with their

art-historians-in-uniform, performed admirable service by salvaging, conserving and listing the artworks they found. In theory, they were also charged with the task of returning the art to its owners. In practice, items were returned to their country of origin rather than to individuals: the task of private restitution was just too big and too legally complex to take on.

The issue was handled differently in the Soviet zone. The Nazis had been moderately circumspect in their looting of Western European museums: a veneer of legality covered their depredations. Nazi ideology acknowledged a shared cultural history with the West. The invasion of the Soviet Union, in contrast, was savage. Museums, galleries and palaces were occupied, emptied and frequently destroyed. The destruction was intentionally wanton, reflecting the self-described master race's contempt for its supposed inferiors in the East. Horses were stabled in palaces, chapels were turned into garages, great buildings were gutted and burned to the ground. Anything that had value in the estimation of the ERR's assessors was seized. When the tables were turned at the end of the war, Stalin adopted a policy of enforced reparations. Soviet trophy brigades emptied Soviet-occupied Germany as efficiently as the Germans had emptied Soviet Russia. The official policy was finders, keepers. Neither apology nor restitution was in the cards.

An enlisted man guards an oversized *Venus and Adonis*, once part of Göring's collection, later recovered near Berchtesgaden, Bavaria.

In this famous photograph taken by Soviet cameraman Yevgeny Khaldei, a Soviet soldier—his leg reassuringly clasped by a comrade—hoists the red flag over Berlin while the Reichstag smolders.

Salomon van Ruysdael, *River Landscape with Ferry.* Widely acknowledged as one of the masterworks in Goudstikker's collection, this painting occupied a prominent place in Amsterdam's Rijksmuseum before it was returned, belatedly, to the widow of Goudstikker's son.

BELATED RESTITUTION

Dutch art dealer Jacques Goudstikker owned the most important collection of Dutch and Italian Old Masters in the Netherlands between the two great wars. He lost it all—some 1,400 paintings—to the Nazis. He also lost his life when he was fleeing the advancing German armies in 1940. Most of his collection has disappeared, but some 267 paintings were returned to the Netherlands after the war. The government distributed them among its various galleries and museums.

The Nazis had paid for the works they took, albeit meanly and under duress, and after the war Desirée, Goudstikker's widow, renounced her claim to a portion of the works for which she had taken cash. It was not until after Desirée's death in 1996 that her son's widow, Marei von Saher, took up the family's case for restitution with the Dutch authorities.

In 1998, after a Dutch court had declared itself incompetent to rule in the matter, a government commission, likely inspired by the Washington Conference, set up a restitution committee. The committee decided to return to Goudstikker's descendants some 202 paintings—all those in public hands except those to which Desirée had renounced her claim. It was a momentous decision that removed masterworks from the walls of more than a few museums, including Amsterdam's finest. "Yes," observed the curator the Netherlands Institute for Cultural Heritage, "they would be missed. They are already. These were well-known paintings."

The work of the postwar art commissions was wound up by 1950. The efforts made by Western nations since then to trace the original owners of Nazi-era looted art (or "Holocaust art") have lacked vigor. Mostly, it was left up to the owners of private collections, or their heirs, to take the lead by tracking down and reclaiming their lost possessions. Some claims were resolved promptly and properly; many others met with an indifferent bureaucracy or worse. The manner in which the French disposed of Holocaust art was indicative of the broader trend. After the work of the French equivalent of the MFA&A, the Commission de récupération artistique (CRA), was completed in 1949, 14,265 items were turned over to the French state. Of these, most were sold at auction and the proceeds quietly added to general revenue. The remainder, 1,333 items, was judged to have significant artistic value and was taken into public collections. Technically, these works came under the care of their adoptive institutions while remaining the property of their original owners, who were free to file a claim at any time. But few of the works' new guardians drew attention to the pieces that had come into their care, and most of them have remained for decades as unobtrusive adornments to public collections. The matter of ownership was discreetly ignored.

Between about 1950 and the mid-1990s, Holocaust art was simply not an issue. A few individuals — Alexandre Rosenberg among them — actively sought the return of what they had lost. It also sometimes happened that a work of art turned up at auction, was recognized by the family from which it had been stolen and steps were taken to get it back. These actions and occasions were isolated, however, and settled (or not settled) with comparatively little public notice. Some Jewish survivors may have felt that it was unseemly or trivial to pursue lost artwork when so much more had been lost by so many. They also may have felt that the task was futile: the various postwar commissions had done their work, and the disposition of the artworks was settled. The Cold War was a factor, too, because the Soviet Union and its satellites were secretive, and their collections and archives were closed to outside investigators. As more time passed, many survivors may have assumed that the limitation laws nullified their claims. In addition to these considerations, it takes time, money (for lawyers' fees) and courage to challenge an individual — let alone an institution — over title to property. For all these and perhaps other reasons, nothing much happened. Thousands of injustices, both large and small, were left unresolved.

When a pebble is shifted, an avalanche gets its start. In 1989, the Berlin Wall was dismantled. At about the same time, libraries and archives in the former Soviet Union and in Warsaw Pact

countries gradually were opened. This led, in time, to scholarly excavations of the previously hidden documentation—and to some surprising revelations. East Germany was reunited with its western half in 1990. And after forty years, a movement began on a number of fronts to redress the looting that had taken place during World War II.

In April and September 1991, an investigative journalist and a Russian academic collaborated in writing two landmark articles in *Art News* magazine. Konstantin Akinsha and Grigorii Kozlov revealed for the first time the existence of secret art repositories in the Soviet Union and the rediscovery of tens of thousands of "trophies" that were thought to have been lost. It turned out, for example, that a Degas masterpiece, *Place de la Concorde*, which was thought to have been destroyed during the war, was displayed in the Hermitage Museum in St. Petersburg in the late 1940s. Hundreds of Old Masters drawings that had been taken in a forced sale to the Nazis from Franz Koenigs, a Jewish art collector in the Netherlands, were hidden in Russian storerooms. Most spectacularly, "Schliemann's Gold," a magnificent archaeological treasure, was hidden in Moscow. The list of rediscovered prizes was a long one.

The *Art News* revelations led Professor Elizabeth Simpson and others to organize a symposium that was held at the Bard Graduate Center in Manhattan in 1995 to address the issue of

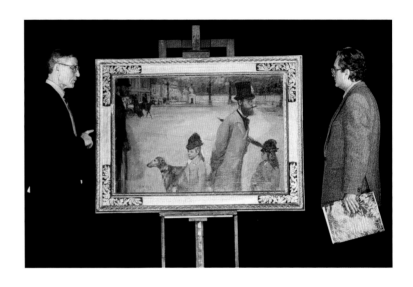

Place de la Concorde by Edgar Degas disappeared from Berlin at the end of the war. It turned up years later in the Hermitage, St. Petersburg, a trophy of Stalin's art brigade.

Gustave Courbet (1819–1877), *Rock at Hautepierre*. Oil on canvas. Max Silberberg, a Jewish collector, was forced by the Nazis to sell his collection, including this oil painting, to a Berlin gallery in 1935. It passed through a number of different hands in Germany and Switzerland before finding its way to a New York dealer and finally, in 1967, to the Art Institute of Chicago. Silberberg's daughter-in-law made a claim for restitution that was settled in 2001. The institute retains possession and title to the painting.

stolen cultural property in the aftermath of World War II. The Bard symposium brought together representatives from most of the nations involved in the war—including scholars from former East Bloc countries—along with men and women who had been involved with the military commissions afterward. An important contributor to the symposium was Lynn Nicholas, whose book *The Rape of Europa*, published in 1994, focused renewed attention on the issue. Nicholas brought academic rigor to the subject; Hector Feliciano's *The Lost Museum*, published the following year, added muckraking fervor; both were inspired by a sense of outrage. The push by the World Jewish Congress (WJC) to resolve the problem of the Nazi gold also served to advance the cause.

Tens of thousands of Jews had placed their savings in Swiss bank accounts before the war. For years afterward, when survivors of the Holocaust, or the families of those who had died, applied to the banks for reimbursement they encountered a wall. Sometimes, absurdly, applicants were asked to provide a death certificate, as if the concentration camp crematoria had issued chits to the families of their victims. Efforts to elicit a proper accounting failed repeatedly. The bankers claimed either that their promise of secrecy to clients was inviolable or that their records had been lost. Besides the issue of individuals' savings, there was a bigger issue of state-to-state transactions.

During the course of the war, Switzerland had taken in vast quantities of Nazi gold bullion, a significant portion of which had been stolen from Germany's Jews. Again, the Swiss refused to provide an accounting. Enquiries met the familiar blank wall. Finally, Edgar Bronfman, the heir to the Seagram liquor fortune and president of the WJC, took up the issue. His concerted campaign, backed up by hearings in the United States Congress and the threat of an international boycott, led to the momentous billion-dollar settlement of 1997. Old wrongs, it turned out, could be set right after all.

The tumbling pebbles turned into an avalanche in 1998. This was the year of the Washington Conference on Holocaust-Era Assets. To critics, it was just another talking shop—"Holocaust Lite"—this time set up by President Clinton and actively supported by the WJC. Lynn Nicholas made a presentation. So did the Art Loss Register. *The Art Newspaper*'s correspondent complained that the victims weren't heard. "It's basically one of those sex education guides that tells you everything that's related to sex, but doesn't talk about what actually goes on," one observer said. The outcome was a set of eleven principles that encouraged participating nations to give back the art the Nazis had confiscated. It was just a piece of paper, and yet it had an effect.

DUBIOUS PROVENANCE

In 1998, British museum directors undertook to conduct a survey of their holdings to identify works acquired in the period between 1933 and 1945 whose provenance was either dubious or uncertain. Two years later, they announced that some 350 paintings hanging in ten British galleries had incomplete provenance. Included on the list were (shown here, from left to right): Alfred Sisley's *View of the Village of Moret* (1892), currently held by the National Museum Wales; Gerard van Honthorst's *Portrait of Charles I* (1628), in the National Portrait Gallery.; and Jean-François Detroy's *Time Unveiling Truth* (1733), in the National Gallery.

81

There were congressional hearings that year as well. James Cuno, director of the Art Institute of Chicago and spokesperson for his professional association, told the senators that his members would take whatever steps were necessary to purge their collections of Holocaust art. He noted that Americans had not been the recipients of recovered artwork in the aftermath of the war, as many of their European counterparts had been. He estimated that the 120 museums that belonged to his organization had collections totaling some 18 million works of art, of which fewer than 200,000 came from Europe. Many of these had been acquired before the war. But there remained, he said, tens of thousands of artworks whose provenance would have to be explored—and he undertook to do that work. His announcement was echoed by museum directors in Europe. At about the same time, the National Museum Directors' Conference in Great Britain adopted a statement of principles not dissimilar to Washington's and agreed to conduct the required research. Close to a decade later, the organization had identified approximately 6,500 items whose history for the Nazi period was incomplete.

The Art Dealers Association of America adopted new guidelines. Its spokesperson Gilbert Edelson's comments were both principled and practical. "No responsible dealer wants to be a defendant in a lawsuit in which it is alleged that he or she sold a stolen work of art," he said.

There was scarcely a discordant note as voices were raised in support of the victims of Nazi theft. A few nations took concrete steps. In 2000, the government of the United Kingdom set up the Spoliation Advisory Panel under the administrative umbrella of the Ministry for Culture, Media and Sport. Its task was to recommend appropriate solutions when Holocaust-related claims were made against publicly funded museums. Similar panels were set up in Austria, Germany, the Netherlands and France. The idea was to develop a mechanism that avoided litigation and, in some cases, the panel's work has borne admirable results. Litigation, of course, continues to provide an alternative avenue for those in search of redress. Down this path surprises are always possible. Kick a small stone, and it's liable to take others with it. Before you know it, the entire prospect has changed.

BIG MAMMA AND THE SMUGGLERS

The painting *The Holy Family with Saints John and Elizabeth and Angels* by Joachim Wtewael measures just 8¼ by 6¼ inches. The colors are vivid and the composition, with its blushing putti and distant ruins, is not, as the judge noted in his

Jacopo Zucchi (1540–1596), *The Bath of Bathsheba*. Oil on panel. This painting was the property of the Italian government, which had loaned it to the embassy in Berlin. It was thought to have been destroyed in the course of the battle for Berlin in 1945. Twenty years later, it was sold by a Parisian dealer to the Wadsworth Atheneum Museum of Art in Hartford, Connecticut. The museum and the Italian government came to an agreement in 1998 that led to the return of the painting to Italy. It is now part of the collection of the Galeria Nazionale d'Arte Antica in Rome.

Lucas Cranach the Elder (1472–1553), *Madonna and Child in a Landscape*. The painting was confiscated by the Nazis from a Jewish industrialist in Vienna in 1940. The North Carolina Museum of Art purchased it in good faith in 1984, but soon found itself facing a claim from the industrialist's descendants. The issue was settled in June 2000 when his great-nieces took possession of the masterpiece.

concluding remarks, to everyone's taste. However, the seventeenth-century painter is counted among the Masters, and *The Holy Family* was valued at roughly three-quarters of a million pounds at the time of the trial. That is to say, it might have achieved that sum at auction, if only it hadn't been loot.

Its original owner was a publicly funded institution, the Duke of Saxe-Cobourg-Gotha Foundation for Art and Science, in Gotha, Thuringia. Like so much valuable art in Germany, it had gone missing after World War II, and the City of Gotha, the plaintiff, wanted it back. The defendant was a Panamanian front company, Cobert Finance SA. The English high court judge who presided in the case, C.J. Moses, heard evidence about SMERSH (the counterintelligence departments of the Soviet Army before the creation of the KGB), the Soviet art brigades, Russian art thieves, a smuggling ring operating out of Germany and an agent acting for the defendant who apparently attempted to bribe a witness in the lobby of London's Savoy Hotel.

Although the Americans liberated Thuringia in 1945, they turned the province over to the Red Army after Stalin met Churchill at Yalta. Then the trophy brigades moved in. Experts testified to the thoroughness with which the Soviet Union went about sacking Germany after the war. The judge determined that the Gotha

THE PROBLEM OF PROVENANCE

Gilbert Edelson addressed a congressional sub-committee looking into the problem of Holocaust art on behalf of the Art Dealers Association of America in July 2006. He wanted his listeners to understand that while the members of his organization were committed to redressing the wrongs committed by the Nazis—indeed, more than a few of them had been victims of Nazi persecution—the pursuit of provenance was not invariably a simple matter.

Provenance, he noted, is not routinely recorded for works of modest value. Works by contemporary, relatively unknown artists frequently change hands cheaply and informally. Only as the artist's reputation grows and the monetary worth of their work increases is the history of their artworks carefully tracked. Often the early gaps are never filled in.

Some collectors insist on anonymity. Consequently, provenances not infrequently refer only to a "private collection" and a city rather than to a person's name and address. And while dealers' invoices can be useful in tracking down provenance, such documentation can be ephemeral and frequently is lost over the years.

Other sources of information may include auction catalogues, scholarly studies, family histories, photographs and the paperwork pertaining to sale. Even dealers' labels on the backs of paintings (such as that shown above right from the back of a stolen Landseer sketch) can provide useful clues. But tracing an artwork's passage through numerous hands can be a challenge. Sometimes, said Edelson, it is just not possible to establish a complete and accurate record of the prior ownership of a particular work.

Jacopo Robusti (Tintoretto), *Lot and His Daughters.* Hitler appropriated tens of thousands of works of art for his projected museum in Linz, Austria. Vast numbers of these works were catalogued and returned to their country of origin in the aftermath of World War II, but thousands more remained unclaimed. In April 2000, a German government department put detailed descriptions of the unclaimed objects online. The database includes both masterpieces and relatively minor items such as coins and *objets d'art.* Among the masterpieces is this painting, which was purchased from a Berlin dealer by the Nazis in 1941. Institutions and the descendants of families who suffered from Nazi depredations can search for and identify their lost artworks at www.lostart.de.

collection was hauled away in early 1946. It is almost certain that *The Holy Family* went with it. The two parties to the dispute each had a different interpretation of the painting's subsequent history. Both versions claimed that the painting fell into the hands of a senior Soviet Army officer and found its way to Moscow. In almost every other respect they diverged.

The court concurred with and elaborated on the story suggested by the City of Gotha. The Soviet officer had to be senior, the court determined, because of SMERSH. Stalin's security agency watched over the work of the trophy brigades. Such was its terrifying reputation, the court was told, that no soldier would be foolish enough to steal a painting from under its malignant eye. It followed that the officer who appropriated the painting was either a SMERSH operative himself or powerful enough to enjoy its patronage. Either way, the painting disappeared for more than thirty years.

It surfaced in Moscow in the mid-1980s when the Soviet officer (his identity remains unknown) or someone acting for him approached two Russians, Makhin and Greshnikov, who had experience in moving stolen art. Makhin, in turn, contacted a German national, Helmut Fürst, who ran a business taking tourists to St. Petersburg and, it was suggested, packed stolen icons on the trip back. Fürst did a little research and identified the original owner of the painting. He said it would be difficult to sell in the West but agreed to give it a try. Next, the Russians contacted "Big Mamma" Dikeni. She was more properly known as Mrs. Mariouena Dikeni, wife of the Togo ambassador in Moscow. According to the judgment delivered by Justice Moses, Big Mamma had used her diplomatic immunity to carry illicit artwork to the West before. Fürst met Big Mamma in the embassy limousine. Fürst testified that he asked her to put up DM50,000, with the promise that he would pay her DM80,000 when she turned over the painting to him in Berlin. Effectively, he was offering her a commission of DM30,000. She declined the offer and, according to Fürst's testimony, took a straight payment of DM10,000 instead. She picked up the painting in February 1987.

Big Mamma apparently double-crossed Fürst. She called him a couple of times, once to tell him she was sick and had to delay her travels, and later to say that she had left the painting with a relative in Berlin. She did the job she was asked to do. She took the painting to Berlin in March. Instead of handing it over to Fürst, however, she gave it to a dealer named Rohde, who in turn handed it on to another dealer. Dikeni was later to submit to the court a statement in which she admitted that she had, indeed, taken the painting to Berlin at Fürst's request. She claimed that she had given it to Rohde for examination and had never seen it again. In

effect, she said she was robbed. The court didn't buy this story. In his judgment, Justice Moses declared that he believed Fürst "when he [said] that he gave the painting to Mrs. Dikeni and, contrary to his instructions, that it was never returned to him." He found, accordingly, "that the painting was handed to Mrs. Dikeni...and misappropriated by her." It was Fürst, and not Dikeni, who had been taken for a ride.

Meanwhile, the painting passed through a couple of pairs of hands before it was acquired by a Mina Breslav sometime in 1988. She consigned it to Sotheby's and then sold it to Cobert Finance SA.

Cobert's explanation of how the painting wound up in Breslav's hands bears no resemblance to this account. In Cobert's version, the painting was given to a Soviet colonel in exchange for food, back in the dying days of the war. The colonel, Adolf Kozlenkov, gave it to another family, who returned it to Kozlenkov's son when the colonel died. It was the son who sold it in 1987 to Breslav. At no point, in this account, was the painting stolen: it was always a gift until it was purchased, legitimately, by Breslav, and then by Cobert from her. The documented history of the Gotha art collection and the activities of Stalin's trophy troops lent absolutely no support to the Cobert version, however, and no record of a Colonel Kozlenkov could be found. Cobert abandoned the story on the day the trial began.

Cobert's recantation went farther. Its legal counsel told the court that the company had not purchased the painting in good faith. It either knew or suspected that it was stolen. Its claim to title of the painting rested, therefore, on the contention that the limitation period had expired.

Cobert attempted to sell *The Holy Family* in an Old Masters sale at Sotheby's in 1992. It was withdrawn after media reports drew attention to its doubtful provenance. *The City of Gotha and the Federal Republic of Germany v. Sotheby's and Cobert Finance SA* was the result.

There was some funny business in the early days of the trial. The Russian art smuggler, Makhin, was offered $10,000 by Solomon Breslav, Mina's son, in the foyer of the Savoy Hotel. With the money came a document headed "Queries Breslav should put to Makhin," apparently an attempt to influence Makhin's testimony. Another person, Douglas Montgomery, who had "some involvement in the activities of Cobert" according to the judgment, was also seen in the hotel at the time. Montgomery, declared Justice Moses, "was present during part of the hearing but left, not to return, after evidence was given as to his presence at a time when money was offered to one of the plaintiff's witnesses."

This development, however, was simply a bit of entertaining byplay in a case that had more than its share of unexpected turns. It was also a case with some legal significance. In Germany,

Edgar Degas (1834–1917), *Harlequin and Colombine*. A U.S. State Department document written in 1950, but not made public until 1998, described Austria's principal auction house as the most important European conduit for art plundered by the Nazis. Hundreds of paintings acquired by Austrian museums in the war years may be tainted. This Degas pastel, for example, long in the possession of Austria's Belvedere Gallery, was acquired in a forced "aryanization" sale in 1942.

Egon Schiele, *View of Krumau* (1916). The original owner, Willy Hellmann, purchased this painting directly from the artist. It was looted by Nazis in 1938 and sold to a dealer who sold it to a museum in the Austrian city of Linz. There it remained until members of the Jewish community in Austria, having been informed of the painting's history by researchers working for Sotheby's, brought pressure to bear on the museum to restore it to the Hellmann family. The museum yielded and Hellmann's heirs sold the canvas at auction in London in June 2003. It made $12.6 million—well above the estimated sale price.

the limitation period for theft runs for thirty years. Cobert, an admitted bad-faith purchaser, was testing the law in a British court. If the court found in its favor, then observers guessed that a great many stolen artworks would be winkled out of the woodwork. Even though the Wtewael wasn't Holocaust art—it was taken from a German museum rather than a Jewish owner—it shared its essential characteristics, given how and when it disappeared. If the sale to Cobert was allowed, then hope for restitution in a great many Holocaust cases would grow suddenly faint.

The judge found in favor of the City of Gotha. His reasoning was complicated: there were numerous points of law to be sorted out. He decided, among other things, that both German and British law applied in the case. Under German law, he found that the limitation period had not expired because it started to run only when Dikeni misappropriated the painting. Under British law, he determined that the period of limitation didn't matter. Because Cobert had not made the purchase in good faith, it could never assume title to the work. This, he suggested, was a matter both of law and of public policy. "To allow Cobert to succeed, when, on its own admission it knew or suspected that the painting might be stolen … does touch the conscience of the court."

Some lawyers argue that morality plays no part in litigation; that it's all about power. They give short shrift to the notion that the court has a conscience. They may be right, but the City of Gotha still got its diminutive masterpiece back.

LOST IN TRANSIT

Another two court cases were initiated in 1998, both of which had relevance to Holocaust art. The first pitted the Museum of Modern Art (MOMA) in New York against a crusading United States attorney. The second found a curator in New Zealand who had not been keeping up with the news.

Lea Bondi Jaray, the Jewish owner of a Viennese gallery, purchased Egon Schiele's portrait of his mistress Valerie "Wally" Neuzil in 1925. Bondi Jaray treated the painting as her personal property rather than a gallery asset and hung it on a wall in her apartment. In 1938, shortly after the *Anschluss* in which the Nazis took over Austria, Friedrich Welz acquired Bondi Jaray's gallery in a forced sale. The following year, he saw *Wally* hanging in her apartment and demanded that it be added to the gallery's inventory. Bondi Jaray handed it over reluctantly—getting nothing in return—and sought refuge in England.

After the war, Welz was held for a time by American forces on suspicion of having

committed war crimes. His art collection was seized and sorted out by the MFA&A. *Wally* somehow got mixed up with another collection owned by an Austrian dentist, Heinrich Rieger, who had perished with his wife in the Nazi death camps. Rieger's heirs subsequently sold several of his paintings — including *Wally* — to the Austrian National Gallery. Dr. Rudolf Leopold acquired *Wally* a few years later in an exchange of paintings with the National Gallery. Leopold, a Schiele enthusiast, built up a formidable collection of the Austrian expressionist's paintings. He also built up a formidable collection of debts and fell seriously in arrears on his taxes. In 1994, a complicated agreement was worked out with the Austrian government and the National Gallery that led to the creation of the Leopold Foundation, of which Rudolf Leopold was appointed director for life.

Bondi Jaray survived the war and tried repeatedly, in the years that followed, to reclaim her property. She told Leopold that *Wally* was hers even before he acquired it. There is documentary evidence that Leopold informed the Austrian National Gallery of this claim. Bondi Jaray also confronted Leopold in person. He was self-conscious and muttered that matters "must be solved in some way," but took no action. Austrian authorities turned aside all enquiries, claiming that the acquisition of the Rieger paintings was legitimate and aboveboard. *Wally* remained in the Austrian museum.

This changed in 1997, decades after Bondi Jaray's death, when the Leopold Foundation agreed to contribute about 150 paintings and other artworks to a three-year-long, worldwide touring exhibition of Egon Schiele's work. *Wally* was included in the show, as was *Dead City III*, which the heirs of Holocaust victims also claimed. The paintings were on display at MOMA when the New York County District Attorney Robert Morgenthau issued a subpoena to have them seized as stolen goods.

Two laws offered some measure of legal protection to the MOMA and, by extension, the Leopold Foundation. Immunity from seizure legislation was enacted into United States federal law in 1965. The legislators weren't thinking of Holocaust art when they passed it. Rather, the law was meant to protect a work of art on loan from one jurisdiction to another from being seized in a civil action (over an unpaid debt, for example). The other law potentially available to the museum was a New York State antiseizure statute passed in 1968. Unlike the federal law, under the state legislation exhibitors didn't have to apply for coverage: the protection was extended automatically. The MOMA fought Morgenthau's seizure under the terms of the New York statute, and the outcome hinged on whether or not the law was meant to protect art on loan from criminal charges, such as theft, as well as from civil actions.

Egon Schiele (1890–1918), *Portrait of Wally*. Oil on wood.
The painting was seized from its owner's apartment by a
Nazi collaborator.

Egon Schiele (1890–1918), *Dead City III (City on the Blue River III)*. Oil and gouache on wood. This painting, together with *Portrait of Wally*, became the center of a controversy that pitted the Museum of Modern Art in New York against the family of a Holocaust survivor.

The case attracted a lot of attention. Few galleries have a higher international profile than the MOMA, and the Schiele retrospective was a major, widely attended event. In the circumstances, any legal imbroglio would have excited comment. The particular circumstances in this instance, however, made the public debate a passionate one. The museum chose to defend the sanctity of a loan in order to ensure that there would be more loans in the future. In so doing, it found itself defending the entirely legal but morally questionable acquisition by a third party of a Holocaust-era trophy. That the MOMA's chairman was philanthropist Ronald S. Lauder, a prominent participant in the World Jewish Congress campaign to recover art plundered by the Nazis, made the museum's position even more awkward. The MOMA dug in.

The museum won an initial legal victory. An appeal went against it, and then a subsequent appeal ended in its favor. Further appeals and an attempted negotiated settlement still had not resolved the issue in late 2007. "Aspects of this case have been through four courts, have taken four years, consumed unknown costs and generated untold anguish," wrote the eminent legal scholar Norman Palmer back in 2001. He added, "For a statute designed to deflect litigation, this was no mean record." The implication was that a victory in court would have much the same result as a loss. Museums everywhere would become apprehensive at the prospect of letting out of their sight artwork whose provenance was even remotely dubious. Of course, many observers considered this to be a constructive development.

In 1994, the Dunedin Public Art Gallery in New Zealand purchased seven small oil paintings from the widow of a New Zealand citizen, Arthur Fraser, who had fought in Italy in World War II. The paintings were by artists belonging to the Macchiaioli movement, a group of nineteenth-century Italian artists whose work anticipated the work of the French Impressionists by emphasizing natural light, outdoor scenes and everyday activities. The gallery circulated information about the paintings' acquisition among other galleries, as usual, and invited information about their provenance. (It did not, however, check the new purchases with the Art Loss Register.) In response to the announcement, the Dunedin was invited to loan five of the paintings to the Pananti Gallery in Florence, where they would be part of a larger exhibition of Macchiaioli painters. It was to be a notable cultural exchange between Italy and New Zealand. The New Zealand Embassy was delighted: it would sponsor an opening-day party. The Dunedin conveyed its acceptance to the Pananti and made preparations for the safe passage of the art.

YOU CAN'T JUST SAY THIS IS LOOTED

Sarah Jackson spent three and a half years pursuing the true history of Picasso's *Woman in White*. She traveled to Geneva, Berlin, Paris, Los Angeles and New York before matters were finally resolved. The story illustrates how tortuous the investigation of provenance can be and how difficult it sometimes is to resolve old cases.

Jackson, the Research and Historic Claims director of the Art Loss Register, became involved in January 2002 when a Paris art dealer asked for a provenance search for a painting that was being offered for sale by a Los Angeles gallery. The Paris dealer provided a photograph of the work, Picasso's *Woman in White*, which Jackson quickly matched against a fuzzy image in a list of artworks looted by the Nazis. The list, *Répertoire des biens spoliés durant la guerre 1939–1945*, had been compiled after the war by the French equivalent of the Monuments, Fine Art and Archives unit. The painting was loot and, according to the French, had been stolen from the Paris home of a well-known Jewish art dealer, Justin Thannhauser. Jackson reported this news to the French dealer, who passed it on to the Los Angeles gallery and to the current holder of the work, Marilynn Alsdorf. Alsdorf and her late husband, James, both prominent collectors and philanthropists, had purchased the painting in good faith from a New York dealer, Stephen Hahn, in 1975 for $357,000.

The discovery that the painting was listed, however, was just the starting point for Jackson. "You can't just say, this is looted, give it back," she explained. You need a thoroughly documented

history. Jackson accordingly flew to Berlin. There, in the Wiedergutmachungsamt—the government compensation office—she came up with a surprising find. A letter from Thannhauser's lawyer indicated that the Picasso painting should be struck from Thannhauser's claim for losses because he had been holding it on consignment for someone else. Carlota Landsberg was fleeing from Berlin in 1938 or 1939 when she left the picture with Thannhauser. Another document indicated that she had taken refuge subsequently in New York.

A photograph found in the Thannhauser archive in Geneva reinforced the finding. It showed the Picasso painting hanging on the wall in Thannhauser's Paris residence. On the back of the photo Thannhauser had written "Stolen by the Germans" and, in a corner, the name "Landsberg." Other documents revealed that Carlota's husband, Robert Landsberg, had purchased the painting from a Berlin dealer in 1926 or 1927, and he, in turn, had acquired it from one of Picasso's dealers in 1922. With this piece of information, Jackson established the chain of ownership from the painting's creation up to the first years of the war.

The postwar history is murkier. The Alsdorfs bought the painting from Stephen Hahn, who had acquired it from a Paris gallery that had been investigated for its collaboration with the Nazis. The Paris gallery did not explain how the painting came into its hands.

Jackson's next task was to track down Carlota Landsberg, whose last known address was a hotel in New York. A representative from the ALR's New York office was dispatched and, miraculously, discovered a receptionist who remembered the woman. Landsberg had died in 1994, but the receptionist

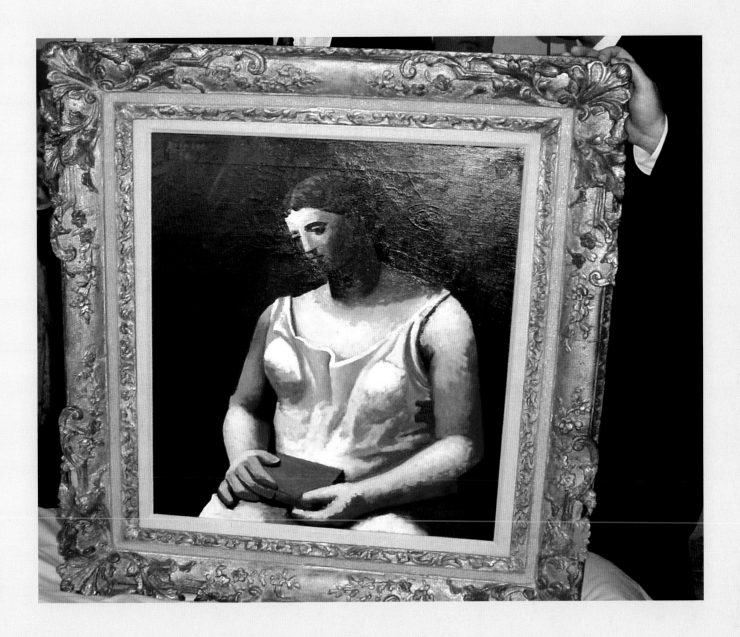

remembered the visits Carlota's grandson, Tom, had paid to her. Jackson found Thomas Bennigson in Oakland, California, where he was studying law. He had never heard of the lost Picasso.

Negotiations between the ALR and Alsdorf were inconclusive, and the matter was turned over to lawyers. The litigation, which included a dispute over jurisdiction when the painting was moved from Los Angeles to Chicago, was protracted. In the end, there was a negotiated settlement by which Bennigson accepted payment of $6.5 million, and Alsdorf received uncontested title to the painting.

Edgar Degas, *Landscape with Smokestack.* In 1939, Friedrich and Louise Gutmann, a German-Jewish couple, shipped this picture to France for safekeeping. The couple both were lost in the Holocaust. Friedrich was beaten to death at Theresienstadt concentration camp and Louise perished at Auschwitz. Their son Bernard devoted much of his life in the years after the war to tracking down items from his parent's art collection. He found a great many pieces before he died, but not the Degas. It was left to his son, Nick, to carry on the quest. In 1996, Nick stumbled upon a reference to the picture in a catalogue. The picture had found its way through Switzerland to the United States, where it had been purchased in 1987 by a retired pharmaceutical executive, Daniel Searle. Searle, who had no inkling of the artwork's tainted history, ultimately agreed to a settlement by which he and the surviving members of the Gutmann family split title to the picture equally between them. Searle donated his share to the Art Institute of Chicago. The museum gained full title when it purchased the Gutmann's half.

The pictures were sent to Italy by courier in September 1998. Two weeks later, John Timmins, the Dunedin collection manager, was still anxiously awaiting word from the Pananti Gallery that the paintings had arrived. What he finally learned instead was that they were being held by the police. The staff at the New Zealand Embassy in Rome, whose linguistic skills he would come to rely on, followed up the report. All five of the Macchiaioli pictures were being held as stolen goods, they were told. Customs officials had noticed that they were listed in a recent publication, *Treasures Untraced: An Inventory of the Italian Art Treasures Lost During the Second World War*. The Italian Ministry of Culture was in the process of contacting the heirs of the family from whom the paintings had been stolen. No doubt the family would launch a lawsuit, said the ministry helpfully, and the gallery was advised to be prepared to go to court.

The purchase had been made in good faith. It was the Dunedin's understanding that Arthur Fraser bought the pictures from a legitimate commercial dealer. No one at the gallery had been following developments in the art world regarding the recovery of Holocaust art. The Dunedin was not being especially careful, as other galleries were beginning to be, of works that might have changed hands in the period from 1933 to 1945. Italian officials were understanding and tactful.

The show at the Pananti in Florence went ahead as scheduled, with the Dunedin's paintings on the walls. The art just wouldn't leave the country until the dispute over title was resolved.

The claimants were the grandsons of a Jewish professor who had gone into hiding during the war, leaving his home exposed to the depredations of looters. As expected, the grandsons sued for the paintings' return.

John Timmins's account of the proceedings has a rueful note. In Florence and Rome, civil and criminal proceedings began against the gallery. This meant that two sets of lawyers were needed. When the exhibition at the Pananti ended, the Dunedin had to pay for extended insurance coverage. At every stage, documents had to be translated. Gallery officials had to travel at intervals from New Zealand to Italy and back again. The cost of their innocent transaction was adding up. After about a year had passed with no resolution in sight, the Dunedin was advised that its continued defense could keep it trapped in Italian courts for another seven or eight years. At this point, the gallery blinked and agreed to accept a settlement proposed by a Florentine judge. The heirs of the professor got to keep two paintings, and the Dunedin took home three.

Timmins and his colleagues embarked on a campaign of reform after the Macchiaioli affair was over. The Dunedin had canceled its subscription

to several art publications in the early 1990s as a cost-saving measure. Among the magazines that were cut off was *The Art Newspaper*, which has tracked the Holocaust art issue assiduously. The subscriptions were renewed and now are read attentively by all staff.

LOST IN TRANSLATION

The Schiele litigation and the Dunedin's bruising Florentine escapade served as a warning that, beginning in the late 1990s, the legal environment had changed. Museums and galleries took note. Another case that had been percolating through French courts for nigh on a decade came to a head in 2001. Now it was the dealers' turn to be afraid.

Paul Rosenberg's collection was just one of several that were sought by Nazi art thieves in France. The Schloss collection was another. Adolphe Schloss had acquired 333 Dutch and Flemish masters in the early years of the twentieth century. His was a fabulous collection: Rembrandt, Rubens, Cranach, Velázquez, Van Der Heyden, Ruisdael and Frans Hals were among the artists whose work Schloss possessed. As Rosenberg had done, the Schloss family did its best to conceal the paintings at the onset of the war. It hid them in a chateau in the Dordogne in the south of France, where they eluded the professional looters of Alfred Rosenberg's ERR until 1943. Then French collaborators turned in two of the Schloss brothers, who, under pressure, revealed the secret. There was some backing and forthing, as the Vichy government hesitated to surrender a part of the French patrimony to the Nazi invader, but presently it capitulated. The Louvre got first crack at the seized art and appropriated forty-nine paintings to add to its vast holdings. Most of the rest were shipped to Berlin, where they were widely dispersed.

The Schloss family got back the Louvre's 49 paintings immediately after the war. Altogether, 162 paintings were recovered and returned to the family, leaving 171 unaccounted for. These have been turning up at intervals ever since.

A couple of factors complicate the history of the Schloss collection in the years after the war. First, the family sold almost every painting that was returned to it, which means that a great many paintings that once were stolen are now in public and private collections and may be offered legitimately for sale. Second, in 1961, one of the Schloss heirs accepted a financial settlement of nearly Fr 4 million from the German government, leading casual observers to believe erroneously that the issue was settled and no further claims would be made. Other complications are

Frans van Mieris (1635–1681), *La Marchand d'etoffes*. Oil. This painting by the Dutch genre painter was among more than 300 paintings from the collection of Adolphe Schloss that were seized by the Nazis and catalogued at the Musée du Jeu de Paume before being dispersed.

illustrated by the surprising history of one of Frans Hals's portraits.

Adolphe Schloss bought *Portrait of Pastor Adrianus Tegularius* in 1901. It was passed on first to his widow, and then to his heirs, along with the rest of the collection. It was among the paintings that disappeared during the war, but then it turned up again, repeatedly. It was offered at auction by Parke-Bernet in New York in 1967 as part of the estate of a princess, and sold for $32,500. The catalogue stated the connection to Schloss, but no claimant came forward. It appeared at auction again at Christie's in London in 1972, where it went unsold, and at Sotheby's in London in 1979, where it sold for £21,000. It was later revealed that the French government, through its embassy in London, had attempted to stop the sale in 1972, but the auction house shrugged off the intervention.

The 1980s art market was hot, and many dealers found their stock depleted. A New York dealer, Adam Williams, attended Christie's sale of Old Masters' work in April 1989 with a view to rectifying the gap. Williams was then a director of the Newhouse Galleries and a respected specialist in European fourteenth- to seventeenth-century paintings. He had his eye on the Hals portrait. Bidding was fierce: Williams was not the only dealer who had no qualms about the painting's past. When the gavel was struck,

however, he had won with an offer of £121,000. He took the painting back to New York, gave it a thorough cleaning and put it on show a few months later. And then, in September 1990, he took it to France.

The painting was seized by two gendarmes and a court official acting on information supplied by a member of the Schloss family who claimed that the painting was theirs. The legal action initiated on that day involved criminal charges against Williams; he could go to jail. The case dragged on for years.

The painting was on a list published in 1947 by the French postwar art commission, a list almost impossible to obtain. A three-volume academic study of Hals's work published in 1974 also noted that it was stolen. Williams, however, said that he had undertaken no research before buying the portrait. He knew that it had changed hands several times—legally, he assumed—and he took it for granted that Christie's would vouch for its legitimacy. He claimed, in short, to have made the purchase in good faith.

Twice he was hauled before French courts, and twice he won. The judgment was appealed in 1998 and then referred to the French equivalent of the Supreme Court. A number of individuals appeared on Williams's behalf. Julian Radcliffe, for example, testified that when he was investigating the viability of a privately operated stolen-art

database between 1986 and 1991, which is the period in which Williams made the purchase, not a single case related to the Holocaust was brought to his attention. It just wasn't on anyone's radar. Williams himself, under cross-examination, insisted that if he had known the painting was stolen, he never would have touched it. Christie's had given him no clue.

Observers later noted that Williams and some of his witnesses all testified in English and were poorly served by the court translator. Whether or not this was the case, the decision brought down in July 2001 was devastating. The court said that Williams should have known better. "The gaps in the history of the painting should have prompted Mr. Williams to undertake research," it said. As a dealer specializing in the period, he should have been aware of the Schloss collection's wartime history. The court, in fact, refused to believe that he was unaware that the work was stolen. It declared that he had acted in bad faith and found him guilty of possession of stolen property.

The sentence, perhaps taking into account more than a decade of litigation and the expenses entailed, was light: a modest fine and a suspended prison sentence of eight months. Adam Williams and the auction house already had agreed to hand over the painting. But in the aftermath of the Williams case, all dealers understood that they could not lightly dismiss anomalies in a painting's history. They would be held to account.

THE WASHINGTON EFFECT

The sense that countries, cultural institutions and individuals have a moral obligation to respond positively to Holocaust claims has taken hold—in some quarters at least. More than a few defendants have chosen to abandon litigation and settle with claimants just because it's the right thing to do. Not all of these cases can be attributed to the Washington Principles, but their effect has sometimes been explicitly acknowledged. Even when not mentioned, it's clear that 1998 marks a watershed. Holocaust cases are handled differently now.

The United Kingdom's Spoliation Advisory Panel took on its first case soon after the panel was established in 2000. *View of Hampton Court Palace* by the Dutch master Jan Griffier the Elder had attracted appreciative visitors to the Tate Gallery in London ever since it was first hung there in 1961. The picture was a gift of the Friends of the Tate volunteer organization, which had purchased it from London art dealers, Roland, Browse and Delbanco, a few months earlier. The Tate made the kind of checks

Jan Griffier the Elder (1652–1718), *View of Hampton Court Palace*. Oil. In its first case, Britain's Spoliation Advisory Panel recommended that the British government make a financial settlement to the heirs of the painting's pre-war owner.

that were usual at the time. It asked Roland, Browse and Delbanco for an account of how the painting was acquired and was told that the dealers had purchased it—wrongly identified as the work of another Dutch artist—from an auction house in Cologne. The auction house, when contacted, could tell the Tate only that the painting had been the property of "a serious private collector in southern Germany." The war had erased all other traces of the painting's history.

No one challenged the Tate's ownership of the painting for about thirty years. Then, on January 15, 1991, a Tate staff member made a note of a conversation she had had with a visitor to the gallery. He had explained to her that the Griffier had once hung on the dining room wall of his parents' house in Germany. The information was filed away. It wasn't until 1999 that the same man approached the Tate again, this time to make a formal claim for compensation. The Tate referred the matter to the Spoliation Advisory Panel.

The story the claimant told was, in its tragic outline, familiar. His father, a partner in a private bank, had purchased the painting in Düsseldorf in 1932. After Hitler's assumption of power the following year, the claimant's father was persecuted, as were almost all German Jews. He was deprived of his position, his rights as a citizen and much of what he owned. Finally, he was arrested and taken to a concentration camp, where he perished. The claimant's mother escaped across the border to Belgium with her three children and what remained of their possessions. She sent the children on to England but stayed behind herself and was hidden by friends. Her situation was grim, however, and bit by bit she had to sell off everything of value that she owned. The Griffier, according to the claimant, went to a gallery in Brussels for just enough money to purchase "an apple and an egg."

The son who subsequently found his father's picture in the Tate Gallery had changed his name and fought with British forces during the war. To back up his claim he had only the story, which remained consistent in repeated telling and was not disputed by the Tate, and a single photographic negative of the picture which, he said, his father had taken for insurance purposes. Experts at the Victoria and Albert Museum, with assistance from the Kodak photographic supplies company, confirmed that the negative was authentic.

The Spoliation Advisory Panel found that the sale of the painting to Roland, Browse and Delbanco was legitimate. The painting was purchased in good faith, and the limitation period (thirty years under German law) had expired. Similarly, the Friends of the Tate and the Tate itself had acquired good title to the

work: it was theirs to keep. In law, no further action was required. But the panel had been convened to address the less tangible issue of moral obligation. Stahl, in the panel's opinion, "as a Jew struggling to survive in a hostile environment, and faced with the threat of starvation," had been forced to sell the painting at much less than its true worth. In her absence, her descendants were entitled to redress.

Dealers and experts from auction houses estimated the present value of the painting at between £100,000 and £250,000. The panel recommended that the British government pay £125,000 to the claimant. The Tate got to keep the picture but was asked to post a notice beside it giving an account of the painting's history and provenance. The Tate complied.

The various conferences, symposia, congressional hearings and court cases have made Holocaust claimants bolder and governments and galleries more open to their claims than they once were. When Holocaust art is identified, and the moral case for redress is established, the current holder frequently is more likely to negotiate than fight.

Items keep turning up. Feliciano related how one of Paul Rosenberg's lost paintings came to light. Matisse's *Odalisque*, or *Oriental Woman Seated on Floor*, was among the 162 paintings stashed in the bank vault in Libourne. The ERR seized it in 1941 and shipped it to the Jeu de Paume, where it fell into the clutches of Gustav Rochlitz, an opportunistic dealer who sold it to another dealer in Paris. It was purchased after the war by Knoedler and Co., a New York art dealer, which sold it to Canadian timber magnate Prentice Bloedel. For more than thirty years, the painting was seen only by family and friends of the Bloedels and, consequently, was nearly untraceable. Only when it was donated to the Seattle Art Museum (SAM) in 1991 was it possible for investigators to pick up the trail. Rosenberg's heirs made their claim known to the museum in 1997. The SAM's first instinct was to fight the matter in court. Both the Bloedel family and the gallery had acted in good faith, and many years had elapsed since the vault in Libourne had been emptied. But after they had done some research, and perhaps gauged the effect of events in Switzerland, Washington and elsewhere, the SAM conceded the justice of the Rosenbergs' cause. It gave up the painting in 1999 and took up the legal quarrel on behalf of the Bloedels with Knoedler instead. The Rosenbergs sold *Odalisque* to casino king Steven Wynn. Knoedler and the SAM have reportedly settled their differences.

A RIGHTEOUS WIND

The German Senate declined to do battle with the heir of another Jewish family in 2006. Indeed, the haste with which the issue was settled in favor of the claimant has drawn criticism: some observers feel that the argument for restitution was weak and that Germany gave up a painting it should have fought to keep.

Berlin Street Scene by the German expressionist Ernst Ludwig Kirchner was purchased at great expense by the Brücke Museum in Berlin in 1980. It is regarded as an important work, both because of its significance to the expressionist movement and as a portrayal of the city in the period just before World War I. Its departure from the Berlin museum likely would have been controversial under almost any circumstances.

It had belonged to Alfred Hess, a Jewish shoe manufacturer living in Germany, whose company ran into trouble during the Great Depression. For financial reasons, Hess was obliged to sell some of the paintings from his collection years before Hitler's assumption of power. He died in 1931. His widow, Thekla, was able to move some of the remaining paintings to Switzerland, where Kirchner's *Berlin Street Scene* was displayed in galleries in Basel in 1933 and in Zurich in 1934. It was listed for sale at RM2,500.

In 1936, the Zurich gallery sent the painting to Cologne, where it was sold to businessman and art collector Carl Hagerman for RM3,000.

The argument over restitution turned on the question of whether the painting was given up for financial reasons unrelated to the Nazi rise to power and sold at a fair market price or whether it was returned to Germany in 1936 under pressure and without suitable compensation. Hess had made no claim for the return of the painting in her lifetime. Her granddaughter, however, produced an affidavit signed by Hess in which she declared that the Gestapo had coerced her into returning the painting to Germany by threatening violence against her and members of her family.

A German legal scholar, Matthias Weller, pointed out the apparent weaknesses in the Hess case. He noted that Carl Hagerman, who kept his distance from the Nazis, was an unlikely beneficiary of Gestapo favor; that the price paid for the Kirchner appeared to have been fair; and that the artist himself (whose art was regarded as "degenerate" by the Nazis) congratulated Hagerman on his acquisition. The Berlin Senate, in coming down on the side of the Hess heirs, explicitly relied on the Washington Principles, giving considerable weight to the presumption that the Jewish family suffered from Nazi persecution by virtue of its situation during the years of Nazi hegemony—even though both Hess,

Ernst Ludwig Kirchner (1880–1938), *Berlin Street Scene*.
Oil on canvas. Some observers have argued that the German
Senate conceded too easily to the claim made by the pre-war
owner's family.

who traveled freely to Switzerland, and her son, who had fled to Britain, were outside Germany at the time.

Weller suggests that the German politicians may have been so determined to live up to the moral obligations enunciated in Washington that they neglected to vigorously press the case for retaining the art. The implication is that they were swept too easily before a righteous wind.

The Nazi thieves are long gone. Even the opportunists who connived to enrich themselves in the immediate aftermath of the Nazi era are mostly beyond the reach of the law. Holocaust art is a criminal matter now only when a new crime is committed, when the art is stolen again or smuggled across a national border, as Wtewael's *The Holy Family* was. Resolving outstanding cases may depend on the actions taken, sooner rather than later, by the present holders of the art. Even when institutions, acting in good faith, determine that a painting was wrongly taken from its owner by the Nazis, it may be no easy matter to find the descendants of the original victim. And as one generation gives way to the next, it may become impractical, and seem increasingly futile, to restore what was taken to the descendants of the original owners.

Virtually every Western nation embraced the Washington Principles. Without question, there has been a massive shift of opinion in support of those claiming restitution on behalf of the victims of the Holocaust. Major museums in Western countries are committed to investigating their own collections and are disposed to respond favorably to legitimate claims. And the pressure on private collectors to avoid the taint of art once stolen by the Nazis is compelling. The moment is ripe for action.

Haste is needed: the moment will pass. Limitation laws were invented because all acts, even the most evil, eventually become history.

THE ART COMMANDOS

Some 15,000 Jews lived in the Polish town of Drohobycz before World War II. Only about 400 survived. Bruno Schulz was one of those who died.

Schulz's genius as a storyteller and artist has slowly been recognized in the West, thanks in part to his promotion by other writers, including the American novelist Philip Roth. Schulz wrote slim novels of magic realism. In the town where he lived, however, he was known for the invented fairy tales he told schoolchildren and which he illustrated with images reminiscent of the work of Marc Chagall. When the Germans occupied Drohobycz in 1939, a Gestapo officer, Felix Landau, ordered Schulz to paint pictures on the walls of the children's nursery in his home. Schulz complied, accepting as he did so the implied protection of the Nazi thug. The protection proved to be inadequate. Schulz was shot in the back of the head by another Gestapo officer as an act of spite aimed at Landau. The town was taken over by Soviet forces in 1945. Landau's house was first abandoned, then reoccupied and the murals were painted over. Drohobycz's corner of Poland became part of Soviet Ukraine.

The paintings in what once had been Landau's house were uncovered by German filmmakers in 2001. The pictures immediately attracted attention, and a commission was struck to decide how best to preserve them. The question became academic, however, when agents acting for the Yad Vashem Memorial Institute in Jerusalem, dedicated to honoring the memory of Jews who died in the Holocaust, spirited all but one of the murals away.

Yad Vashem defends the act as legal and appropriate. It claims to have acted with the full cooperation of municipal authorities and to have negotiated a mutually satisfactory agreement with the current owners of the Landau house. It claims, besides, a moral right to the paintings: "It is a fact from the around 3.5 million Jews who lived in Poland before the Shoah, today there are only a few thousand Jewish inhabitants. Despite the fact that most of the Holocaust survivors live in Israel, the remnants of the vibrant Jewish life and the suffering of the victims and of the survivors are scattered all over Europe. Therefore Yad Vashem has the moral right to the remnants of those fragments sketched by Bruno Schulz."

Not everyone agrees. Twenty-four scholars writing in the *New York Review of Books*, while acknowledging that Yad Vashem "was acting, we trust, with the best of intentions," nevertheless argued that the museum had given expression to "an unconscionable statement of moral and cultural superiority." They continued: "Such a statement is an insult to the people of Central Europe, and to all those who care about the region, and who believe that Ukraine and its neighbors are worthy of giving Bruno Schulz the honor and respect he deserves."

Bruno Schulz, the Jewish writer and artist, was forced by a Nazi
officer to decorate his children's nursery. Schulz's illustrations
included this fragmentary picture of a fairy-tale princess.

THE EXTINCTION
OF HISTORY

"I understood immediately. He didn't want to know anything.
If he knew anything, he didn't want me to know what he knew.
We established an unspoken understanding. We would consciously
avoid knowledge of the history of the vase…"

— Thomas Hoving, *Making the Mummies Dance* (1993)

Third-century BC Hellenistic roundel depicting a maenad or
devotee of Dionysius. Gold repoussée. Stolen from a New York
gallery in fall 2000.

LIKE A WOLF ON THE FOLD

The looting of the National Museum of Iraq in 2003, following the United States' invasion, was a shock. The administrative offices were overrun: papers were strewn everywhere, furniture was stolen, air conditioners lay broken on the floor. Much of the damage appeared to be wanton. The people who tore the place apart weren't profiting from it; they were taking revenge against a hated regime. The motive of those who looted the exhibition halls was another matter. Whole shelves were cleared of their contents. Pedestals that once supported statues were toppled over and smashed. Some newspapers reported that more than 170,000 antiquities had disappeared.

The early reports were exaggerated. The story that emerged later was more complicated than it first appeared, but also less discreditable. Museum staff had taken sensible precautions. Much of the collection had been hidden away, while other pieces were protected, as well as could be managed, by bracing them with sandbags or wrapping them in high-density packing foam. When American forces swept into the city in April, the keepers stayed on as long as they dared. One of them—Adonia George Youkhanna, more familiarly known as "Donny George"—even handed out pistols to his colleagues. But by April 8, when American tanks were within five hundred

yards of the museum, the staff cleared out, and perhaps as many as one hundred members of the Iraqi Republican Guard moved in. From evidence found later, military authorities concluded that American troops had been shot at from the upper floors of the museum. Rather than attack, which would have led to much greater destruction, the Americans fell back. Witnesses reported that Saddam Hussein's soldiers loaded up two vehicles with valuables before they took off. After they left on April 9, the civilian looters moved in.

Thousands of antiquities were scooped up in the spree that followed. Among the missing items were approximately 5,000 cylinder seals. (These are small cylinders, often made of stone, on which intricate and sometimes beautiful images were incised. When rolled across clay they left a decorative impression.) More than 5,500 pieces of jewelry were also lost. Estimates of the total number of pieces taken range from 12,000 to 14,000 or more. While the looting was bad, it could have been much worse. Museum staff courageously threw out the thieves and reoccupied the museum on April 12.

For most people, Iraq brings to mind images of mayhem, bloodshed and war. To church-going Britons in the nineteenth century, the region suggested similar scenes, only set against a biblical backdrop. The Old Testament tells of ancient kings who built vast empires through their cruel

and bloody campaigns. One of the most ruthless and successful was Sennacherib, king of Assyria, who was said to have leveled the cities of ancient Judah and to have come close to capturing Jerusalem. It was he who inspired Byron's powerful stanza, "The Assyrian came down like a wolf on the fold." He met his match when, in the biblical account, the angel of the Lord intervened, killing more than five thousand of his men and causing Sennacherib to withdraw to Nineveh.

Sennacherib and the palace to which he retreated in the seventh century BC were brought vividly to life by Austen Henry Layard, an archaeologist and adventurer whose explorations between 1845 and 1849 were sponsored by the British Museum, among others. Layard uncovered the buried remains of the ancient cities of Nineveh and Nimrud in what was then known as Mesopotamia and is now northern Iraq. He helped himself to substantial works of art from both sites. From Sennacherib's palace he took slabs from the throne room. From Nimrud he took virtually all the narrative bas-reliefs and several dozen objects, including a pair of enormous statues, one of a winged bull with a human face, the other of a lion. Layard was also a dab hand with a pencil, and his drawings of stone bas-reliefs and artifacts were used to illustrate his mid-nineteenth-century bestseller, *Nineveh and Its Remains*.

The wreckage left by looters in the Iraq Museum in Baghdad (above) led to early, exaggerated reports about the extent of the losses. Still, the scene that greeted museum officials on April 12, 2003 was devastating. Objects that weren't stolen were smashed on the floor and the damage was considerable.

One of the museum's treasures, the Warka vase, was attached permanently to its pedestal. Frustrated looters broke it off, leaving the foot behind amid the shattered remains of its glass case. The vase was recovered later.

IN THE GOLDEN AGE

Austen Henry Layard was the British adventurer who first excavated the ancient cities of Nimrud and Nineveh in the late 1840s. Commissioned by the British Museum to send back artifacts, Layard chose a great winged bull with a human face and an equally hefty lion in the palace of the Assyrian king Assurnasirpal II at Nimrud. The region, now northern Iraq, was physically harsh and politically unsettled. Layard had to purchase assistance from among warring tribes while overcoming immense practical problems. Survival was one of these. Figuring out how to shift thousands of pounds of stone across a barren land with only muscle and sinew to provide propulsion was another.

It was an epic operation. Layard ordered trenches to be dug so that logs could be placed beneath the statues. They were then rolled to an embankment and tipped carefully onto a specially constructed cart. Oxen balked at the weight and refused to pull it and so men were enlisted to take their place. Layard rode like a hero on horseback at their head as they hauled the ancient burden to the banks of the Tigris River. From there, he employed an ancient mode of transport: two rafts, one for each statue, that were given buoyancy by inflated sheepskins. (For centuries, nomads had carried these skins with them, blowing them up and then hanging on when they crossed the river. The rafts were the industrial-sized version of the same device.) In this manner, the bull and its leonine companion drifted in stately fashion to the port city of Basra and from there were taken by ship to the other side of the world. The entire venture was a triumph of ingenuity, exploitation and grit. Layard's satisfaction with the outcome is evident in his later thoughts:

> I watched the rafts until they disappeared
> behind a projecting bank forming a distant
> reach of the river. I could not forbear musing
> upon the strange destiny of their burdens;
> which, after adorning the palaces of the
> Assyrian kings, the objects of the wonder,
> and maybe, the worship, of thousands, had
> been buried unknown for centuries beneath
> a soil trodden by Persians under Cyrus, by
> Greeks under Alexander, and by Arabs under
> the first descendants of their prophet. They
> were now to visit India, to cross the most
> distant seas of the southern hemisphere,
> and to be finally placed in the British Museum.
> Who can venture to foretell how their strange
> career will end?

Layard reburied what he didn't take. Both sites were excavated again over the years. Max Mallowan, the second husband of novelist Agatha Christie, explored the region in the 1960s. Teams of Polish and Italian archaeologists made further inroads in the 1970s and 1980s. An Iraqi archeologist, Muzahim Mahmud Hussein, was among the last in line. Through his efforts

at Nineveh, and the work of others at Nimrud, the digs were given roofs and turned into site museums in which the bas-reliefs were stabilized and protected from the elements. An American archaeologist, John Malcolm Russell, visited Nineveh in 1981 and returned for further study in 1989. With assistance from the National Museum's Donny George, he made approximately

Nineveh, once the center of a great empire, sits on the outskirts of Mosul, in northern Iraq.

nine hundred photographs that year and intended to come back for more. The two Gulf wars and the embargo imposed on Iraq between them put an abrupt end to those plans.

Russell and other observers say there was very little looting by Iraqis before the Gulf wars. The country had a first-rate antiquities department, and the public took pride in its cultural inheritance. But the two wars and the ensuing privation took their toll. In the near-anarchy that prevailed in the years after the U.S. invasion, the people,

according to Russell, "squeezed between ruinous inflation and critical shortages of basic necessities, were forced to seek new sources of subsistence income." At the same time, the international market took a renewed interest in Mesopotamian artifacts. Desperation inside the country and willing buyers outside it led inevitably to plunder and smuggling. Russell, and another American archaeologist with whom he sometimes collaborated, Samuel Paley, started to hear of artifacts from protected digs being placed on the market.

Austen Henry Layard drew this picture, *Winged Human-Headed Bull*, when he was excavating the palace at Nimrud, near Mosul, in what now is northern Iraq.

UNBURIED TREASURE

Thousands of Iraqis died in the civil war that followed the American invasion in 2003. With the economy shattered and basic infrastructure either damaged or destroyed, the lives of countless others became tenuous. Outside Baghdad, the privation of the population, the absence of effective policing and the proximity of archaeological sites led to looting on an unprecedented scale. Western scholars, increasingly alarmed by reports of looting in the south of the country, were helpless to act. Satellite pictures and photographs taken from the air by police and security agencies confirmed their worst fears. The photograph above shows looters running away from the site of the ancient city of Isin, now pockmarked by freelance digs. "We're losing an enormous amount," Elizabeth Stone of the State University of New York at Stony Brook told the *Chicago Tribune*. "We look at the sites and say there have to be thousands of objects taken. Perhaps tens of thousands, or hundreds of thousands of objects."

Layard's careful drawings come in handy now, and Russell's photographs have become indispensable. Both resources are imperfect. Layard was sometimes careless in rendering detail and selective in what he chose to draw. Russell's equipment was unsophisticated, his experience was limited, and the conditions in which he worked were challenging. But the drawings and photographs, lovingly created by the two men in visits separated by more than a hundred years, are the authoritative record of what once existed.

Museums, auctioneers and dealers now call Russell and Paley to ask them if the Mesopotamian artifacts that come their way are stolen. Almost invariably, they are. The two men are angered and distressed by the obvious evidence of rampant looting. Thieves are using saws, chisels and even sledgehammers to take apart ancient stone walls. Whole slabs are being destroyed to salvage a single carved figure. Small sections are being squared off so that they can be more easily framed to decorate a living room. The original friezes told a story. The history of an entire military campaign might have been inscribed in the walls of a chamber. This history, in all its suggestive detail, is being lost so that a handful of well-preserved images can be taken to market. So many pieces from Nineveh have found their way to Western dealers, says Paley

This statue in the Iraq Museum, described by archaeologist John M. Russell as depicting "a woman from Hatra," was too big to be taken away by looters. It shows the scars of a botched beheading.

Objects similar to this 2500 BC votive tablet relief, once of interest only to scholars, now appear regularly on the illicit market.

with bitter irony, "that by now the only place where such bas-reliefs are in short supply is in the palace museums."

The destruction in the Iraqi museum focused international attention on the problem of archaeological looting, if only for a while. Within a few months, many of the stolen items had been recovered. Authorities declared an amnesty that led some of the museum's more opportunistic neighbors to return what they had taken "for safe-keeping," as they said invariably. Other objects were picked up when cars were stopped at checkpoints or investigators got tips from informers. In July 2003, the museum was reopened. It seemed that conditions were improving. But they weren't.

Nineveh and Nimrud both are located in northern Iraq, around Mosul, where the largely Kurdish population has been less affected by war than the inhabitants to the south. And yet Nineveh, in particular, has been hard hit by looters. Archaeological sites in the south are experiencing much more serious depredations. From what observers have been able to see, some sites have been wholly destroyed. War, obviously, has been a factor driving the looters. But, above all, it is the combination of a desperately poor population and a rich and eager market for antiquities that leads to uncontrolled plunder. These days, neither the diggers nor the buyers are anywhere in short supply.

GUARDIANS OF THE PAST

"In Search of the Absolute" was an extraordinary show. First mounted in Russia in 1993, it featured four-thousand-year-old sinuous Sumerian busts carved from gypsum, glowing copper-alloy figures from ancient Egypt and evocative Roman frescos cut from the walls of ruined villas. When the exhibition came to England, the 280 antiquities were beautifully displayed in custom-built cases, under banks of theater lights in the high-ceilinged halls of London's Royal Academy of Arts. George Ortiz, the proud owner of these treasures, was born into a family that made its fortune mining tin in South America. He was so keen to share his enthusiasm that he paid for everything—the space, the lights, even the catalogue. In his text for the catalogue, he explained how the collection came into existence. He had lost his religious faith when he was still quite young, he wrote. He became a Marxist, but he was really looking for something more, something that would give meaning to his life. And he found that elusive something on a trip to Greece in 1949 when he was exposed for the first time to classical art. He was ignorant then of ancient history and had no archaeological training, but these shortcomings didn't seem to matter. The artifacts he encountered affected him forcefully on a purely spiritual level.

"Little by little over the past forty-three years," he explained, "the collection has grown more and more into a coherent whole. Objects came my way, and some of them unquestionably because they had to do so. It is as though, imbued with the spirit of their creator, they came to me because they knew I would love them, understand them, would give them back their identity and supply them with a context in keeping with their essence, relating them to their likes."

Ortiz is among the leading collectors of antiquities in the world. There are many others. Some are secretive and reclusive. Others cultivate a public profile: they are among the men and women whose faces appear in society columns and whose views are decisive in civic affairs. Almost all are high-minded idealists whose collections are central to their lives. For all of them, collecting is both a compulsion and a passion.

It is a passion that drives not only those fortunate individuals who have the wherewithal to indulge it, but also museums. Thomas Hoving, the Metropolitan Museum of Art's director in the 1970s, revealed the fire that compelled him to pursue a rare portrait by the seventeenth-century Spanish painter Diego Velázquez. "I was on the verge of discouraging Ted [Rousseau, the curator-in-chief]," he wrote, "when my own passion for acquiring simply exploded. The painting was world-class. The most basic duty of the Metropolitan was to seize such treasures. Not making a major effort would be tantamount to dereliction of duty..."

Fabulous marble friezes from the Parthenon in Athens were appropriated by Lord Elgin in the late nineteenth century. The Greek government has been lobbying for their return for decades.

No museum is ever finished. No collection is ever complete. And the relationship between public museums and the private collectors who share their passion is an intimate one.

The nineteenth-century conception of the great museum—the conception that inspired the builders of the British Museum, the Metropolitan Museum of Art, the Louvre and others—was of an encyclopedic collection that comprehensively illustrated the history of the world's major civilizations. In the age of imperialism, museums often sent their curatorial staff to gather material in far-flung places. Explorers and military expeditions returned with artifacts ranging from botanical specimens to ritual masks and massive architectural ruins. As the representatives and agents of the Great Powers, they simply seized what they wanted from the colonized and vanquished. Or, at best, they came to terms with compliant local overseers before helping themselves, as Lord Elgin did when he consulted Turkish authorities prior to carting off most of the marble friezes from the Parthenon in Greece. Tens of thousands, even millions of objects found their way into museum collections by this means. They were the stuff that made museums possible.

As the imperial age wound down, however, and as nation-states became more assertive, this kind of freebooting appropriation ceased to be either possible or permissible. The appetite for

The charter of the British Museum prohibits it from yielding
any of its collection. An act of Parliament would be required
to bring about the return of the Elgin Marbles to Greece.

acquisition was undiminished, but outright looting gave way to its commercial variant. Both museums and private collectors now purchased their treasures from intermediaries — street hawkers, stall holders, agents, gallery owners and auction houses. Of course, artifacts had been bought and sold long before Western states divested themselves of colonies, but in broad terms there has been a change. Since about the middle of the twentieth century, museums and collectors have competed with one another for the artifacts that sellers make available in cash transactions. Or, as often as not, they have colluded.

It is every museum director's task to cultivate the friendship of significant collectors. Collectors may be invited to join the museum's board of directors or to become members of an exclusive club dedicated to expanding the museum's holdings. Their objectives may diverge: museums strive to fill gaps, while collectors pick pieces they have fallen in love with, but their differences can be minimized. Collectors may come to rely on curatorial advice in making their selections. Curators become diplomats. Sometimes curators arrange to put private collections on show. Not every collector has to do what Ortiz did when he mounted his own exhibition at the Royal Academy of Art. The Met, for example, gave up one of its halls to display antiquities belonging to

Leon Levy and Shelby White in 1990. The J. Paul Getty Museum exhibited Lawrence and Barbara Fleischman's collection four years later.

Lawrence Fleischman, like George Ortiz, was bitten by the collecting bug when he was in Europe in the 1940s. The Fleischmans' interests were wide-ranging: Lawrence collected American art for a time, but he and Barbara increasingly focused their attention on Greek and Roman antiquities. They were guided by their friends in the museum world, first in Detroit, and then in New York and London. In particular, they became friendly with the influential Greek-pottery specialist Dietrich von Bothner, at the Met, and with Brian Cook, the keeper of the Greek and Roman collections at the British Museum. They supported both museums financially and as volunteers. The museums were appropriately grateful. Marion True, as head of antiquities at the Getty, supervised the Fleischman show and coauthored an admiring essay about them. She described their approach to collecting in a way that echoes Ortiz. "They collect on the basis of instantaneous emotional response to the object's aesthetic appeal and its historic interest for them. Later, they reflect on where it fits within the context of their collection," she wrote. A bit later, she added: "Above all, however, it is the universality of the ancient objects that has captured the Fleischmans' devotion. These

objects, which have survived centuries of change and evolution, reflect many of the same desires and emotions that still color our lives."

The Fleischmans were "guardians of the past," wrote True. They saw themselves as the "temporary custodians" of objects that had timeless importance. They always intended to pass this custodial role on to a museum before they died. In 1996, a couple of years after True's essay was published in the catalogue accompanying the exhibition, the Fleischmans handed over their collection to the Getty. This was a huge coup for True, who had been competing for the honor with the Met. But she and her colleagues had worked hard for the prize. "We were struck by the installation, creativity, skills, and educational outreach of Dr. True and her staff," explained Barbara Fleischman later. Since the East Coast museums were already well endowed, she and her husband decided "it might be more fun to enrich a fine but smaller collection on the West Coast."

Museums are the institutional equivalent of the compulsive private collector: their hunger for acquisition is unending and insatiable. This particular acquisition was made official at a time when the Getty was completing work on the new Richard Meier–designed Getty Center in Los Angeles and just embarking on the renovation of the Getty Villa in Malibu, which was

The museum world was severely shaken when Marion True, curator of antiquities at the Getty, was charged with conspiring to smuggle antiquities out of Italy.

intended in the future to house only antiquities. So the acquisition of the Fleischman collection was timely as well as satisfying from the point of view of the curator whose job it was to fill that fabulous, hilltop space. If it had been fun for the Fleischmans, however, as Barbara Fleischman claimed, the fun was just beginning for the Getty.

MR. TOAD'S PERFORMANCE

The Ortiz exhibition precipitated an academic firestorm. The man behind the show must have wondered what hit him. He was doing only what collectors had been doing for decades. And for all those decades, as often as not, they had been quietly honored for their luxurious and innocuous-seeming hobby. But times were changing. Not only were archaeologists increasingly alarmed by the looting of ancient ruins, but a criminal case that would expose the dark underside of the antiquities trade as never before was also pending in Italy. It was just bad timing on Ortiz's part.

The article in the *Guardian* by the eminent archaeologist and British peer Andrew Colin Renfrew was the opening volley in what would turn into a sustained barrage. The Ortiz exhibition, he wrote mildly, "delights the eye, but it also raises troubling questions for the visitor. Perhaps it should for the Royal Academy as well."

The questions Renfrew had in mind had to do with where the artifacts came from. The catalogue, he noted, was almost always vague on the subject, suggesting that "most of them fall under the suspicion of having once been looted—of having come from clandestine excavations—and of subsequently being exported illegally from their country of origin." It's not that Ortiz had broken any law in acquiring his collection, said Renfrew. He had bought the objects legally, either in England or Switzerland. But it's not enough to avoid breaking the law. Collectors have a responsibility to respect and preserve an object's history or the story of where it came from and what it meant. This, said Renfrew, was the point of the 1970 UNESCO convention that made it illegal for nations (at least those that signed on) to import clandestinely excavated antiquities. "Since 1970," he wrote, "collectors have been aware that when they buy antiquities without provenance and with 'no questions asked' they are funding, whether directly or indirectly, the vandals who loot ancient sites."

The Oxford don, poet and art critic James Fenton, writing in the British newspaper *The Independent*, picked up on Renfrew's themes while dispensing with his mild tone. In a reference to the children's classic *The Wind in the*

George Ortiz used his inherited wealth to build a fabulous
collection of antiquities. He put them on show at London's
Royal Academy of Art in January 1994.

Willows, he called the exhibition in which Ortiz did everything, from the design and lighting to providing the props, a "Mr. Toad performance, in which the collector plays all available roles." Fenton mocked Ortiz's claims that the antiquities came to him because they somehow knew the collector would restore their identity and supply them with a context "relating to their likes." "Supplying the art with meaning," wrote Fenton scathingly, "is just one of those things Mr. Toad does well."

The issue of provenance was at the heart of Fenton's critique. After doing the math, he contended that just forty objects in the show came from named collections. "Of the first 100 entries in the exhibition," he wrote, "about 10 percent have a usually skimpy provenance, 40 percent are allegedlies (as in 'allegedly from the region of Troy') and the remaining 50 percent give the provenance as 'no indication.'" Unprovenanced collections such as this, both Fenton and Renfrew argued, robbed the objects of their historical context. Ortiz wanted visitors to believe that he was giving his finds a new, aesthetic context in which different cultures and times could be compared. But the enterprise, in the archaeologists' view, was subjective, largely bogus and no substitute for history. And it was all a cover for the illicit origins of the material. Fenton, finally, took a swipe at John Boardman, another eminent archaeologist and a noted expert on Greek pottery, who had written a preface to Ortiz's catalogue. He was brought in, Fenton suggested, merely to add respectability to a dubious show.

"The world cannot afford many more collectors with a passion for antiquities," wrote Ricardo Elia of Boston University in *The Art Newspaper.* He was writing not about Ortiz but about the Fleischman collection on view at the Getty a few months later. Like Fenton, Elia took a close look at the catalogue and, like Fenton, he didn't like what he found. "Out of 295 catalogued entries (some representing more than one object), not one has an archaeological provenance and only three (1 percent) are described as coming from a specific location. More than 85 percent have surfaced with no provenance at all. Eight percent are identified as previously held in another collection, and 4 percent are 'said to be from' a place ('said by,' one supposes, the looter)."

Elia wondered how the history of the pieces could be of so little concern to either the owners or the curators. He speculated that the Fleischmans relied on the word of reputable dealers to vouch for the legitimacy of their purchases. But "reputable dealer," Elia wrote cuttingly, "is an oxymoron.... Dealers," he continued, "operate under a jealously guarded code of silence that protects their sources; the typical excuse is that the dealer is protecting the privacy of an

WEARY HERAKLES

Patrimonial laws—that is, the laws enacted by governments claiming newly discovered antiquities as the property of the state—generally go back a long way. Italy's law, for example, was passed in 1939; Turkey's in 1906. So when dealers claim that an object was found before the relevant law of patrimony went into effect, they must also make the claim, at least implicitly, that the object has somehow been hidden for all those years. The usual story is that the object has been in a "private collection." The story is more easily sustained when the item is small and uninteresting. Larger, more substantial pieces almost always attract notice. The proposition that a big, beautifully carved statue has been completely unknown for a hundred years is bound to raise eyebrows.

In 1980, the director in charge of an archaeological site near the Turkish town of Antalya heard rumors that something significant had been stolen. Later the same year, numerous statues were uncovered, including the bottom half of a statue of Herakles, or Hercules. In 1981, it was learned that the New York collector Leon Levy had acquired what appeared to be the top half of the same statue. Plaster casts were made showing that the two halves were a perfect fit. Levy gave a half interest in the statue, known as *Weary Herakles*, to the Boston Museum of Fine Art (MFA), where it can now be seen.

The affair, taken at face value, requires observers to accept a remarkable coincidence. The bottom half of the statue came to public notice because it was freshly dug out of the ground. The top half came to be known because, less than a year later, it was sold

PHOTOGRAPH © APRIL 2008 MUSEUM OF FINE ARTS, BOSTON.

by a dealer to a prominent collector. We must infer the top half was discovered perhaps a hundred years ago and kept somewhere in a private collection, unknown to experts or other collectors, until its sale to Levy. We have to believe this because otherwise, if it was shipped out of Turkey anytime after 1906, it was taken illegally.

A spokesperson for the MFA said in mid-2007 that "the museum continues to believe that the *Weary Herakles* was legally and properly acquired. The *Weary Herakles* is currently on display in the Art of the Ancient World galleries, and is also accessible on our website, mfa.org, making it available to researchers, archaeologists and the general public world-wide." The provenance given in the website indicates that the statue was purchased from a dealer in Frankfurt in 1981, "said to be from his mother's collection and before that from a dealer in Germany about 1950."

impoverished lord who is forced to liquidate his art collection. But the practice of non-disclosure effectively shelters the illicit network of criminals who traffic with the dealer."

The relationship among dealers, collectors and curators was singularly self-serving, Elia and other critics suggested. Collectors basked in the glory that was showered on them when their collections were shown in great museums. Their holdings became more valuable simply by being catalogued and displayed. The museums used the opportunity to flatter the collectors and perhaps acquire their pieces at some time in the future. And the dealers, of course, got rich. Only history suffered.

THE REAL LOOTERS

Archaeologists chart the history of civilizations that have often left only the barest traces of their rise, reign and fall. They are the crime-scene investigators of lost worlds: like the men and women at CSI, they insist that the remains of the past be left untouched while they go about their business. Everything—every chipped stone, clay shard and broken bone—must remain where it was found until it has been logged, numbered, described and photographed. Everything has meaning in the eyes of archaeologists going about their field studies. And everything is valuable. A beautiful pot is precisely as interesting as a plain one: either one may yield an insight into the way its vanished owners lived. But neither a beautiful nor a plain pot has meaning once it has been taken from its place of origin. Just as the matchbook cover becomes a useful clue only if it is found next to the murderer's victim, so, too, the clay pot gives up its story only when it can be studied in the remnants of the home of the woman who used it for storage.

Unhappily for archaeologists, the CSI metaphor is all too apt. Archaeological sites have become crime scenes all over the world. From Southeast Asia to Africa and the Middle East, looters have plundered the past. In Italy, they are called *tombaroli* or tomb robbers. In parts of South America, the looters are known as *haqueros*. At the lowest level, they are the poorest of the poor: Chinese peasants or West African villagers subsisting on less than a dollar a day. Between them and the dealers are intermediaries, either bandits or disreputable businesspeople, who make their living through organized looting. Above them are the few who make fortunes.

The cumulative extent of the damage is catastrophic. Several organizations including UNESCO, the International Foundation for Art Research and the Illicit Antiquities Research Centre have compiled reports from archaeologists

Rare Eastern Roman bronze representing Isis and Serapis, dating from the second or third century, stolen from the Museo Nazionale in Rome in January 1980. It was discovered in a Christie's antiquities sale twenty years later.

Small bronze sculpture of a boar, Gallo-Roman period. Only 1 in. tall, it was stolen from a museum in Nantes, France, in 1998.

Roman Imperial white-marble carving of a two-faced head of Janus (far left and left), from the second or third century. Stolen from a private collection in Italy in 1983.

Two Ekpu Oron ancestral figures. Wood. Stolen from a museum in Nigeria in October 2000.

and others all over the world. Neil Brodie, the former head of the Illicit Antiquities Research Centre, says it is no exaggeration to talk of the "extinction of archaeology." Whole areas of study are being lost.

This is true of widely separated regions of the world. Some of the worst examples are in the most poverty-stricken parts of Africa. A touring international exhibition of antiquities from Niger, mounted between 1993 and 1998, was intended to draw attention to the cultural riches of the nearly destitute West African state. It succeeded too well, creating a market among collectors for terracotta and stone statuettes that previously had been overlooked. The sudden demand for these objects precipitated an orgy of illicit excavation, leading to "a catastrophe," according to Boubé Gado of the university in Niamey, the country's capital. In southwest Niger, "the ancient history of the region, and especially its ancient art, has been lost forever."

In contrast, the flow of antiquities from Central and South America to the United States has a longer, if equally dishonorable, history. Daniel Schávelzon, an Argentinean scholar based in Buenos Aires, has written of his country's role as a conduit for antiquities from Bolivia, Ecuador, Colombia and Peru to North American collectors. "There are no controls," he says, "or they are rudimentary at best."

Roman ocher limestone stele, stolen from an open-air museum
in Manavgat-side, Antalya, Turkey, in 1997.

War and other forms of civil violence often form the background against which antiquities are stolen. The looting that has taken place in Iraq has already been noted. In Somalia, the civil war that reduced the capital city of Mogadishu to a state of nearly total anarchy also led to the complete destruction of the National Museum, where everything was taken, including the doors and windows.

Years of war in Cambodia have been nearly as devastating. The country suffered terribly under the communist Khmer Rouge regime and in the years following its collapse. In 1993, three hundred armed bandits surrounded the conservation compound of the Angkor Wat temple complex, Cambodia's most famous historical site and a major tourist destination. They used hand grenades and a rocket launcher to blow open the entrance to a warehouse where valuable statues had been stored for safekeeping. Ten disappeared and were never recovered.

Since then, Angkor Wat has been somewhat better protected, while hundreds of other sites have been neglected. Among the others is Banteay Chmar in the northwest corner of the country, a ruin famous for its fabulous bas-reliefs and statuary. In late 1998, a Cambodian army unit moved into the area, scared away local residents and then used heavy equipment to gut the site.

Army trucks hauled away the artwork. Some was recovered in Bangkok, Thailand, and ultimately returned. Much was not. In the following year, more than twenty tons of antiquities were found in the headquarters of the last Khmer Rouge commander.

War begets one form of anarchy while an untrammeled free market can give rise to another. By all accounts, the political and economic opening of China in the early 1990s was accompanied by the large-scale destruction of archaeological sites. It was said that well-thumbed copies of Sotheby's *The Art Market Review* could be found even in poor regions of the country. More seriously, local authorities on their own initiative established auction houses devoted to antiquities. By 1995, between 150 and 200 had already been set up. He Shuzong, of the National Administration on Cultural Heritage in Beijing, described a raid that occurred in 1997 in which five men used high explosives to blow open an ancient mausoleum in Hebei Province. They removed over five hundred bronze, gold and jade objects, about half of which were shipped through Hong Kong to London, and the other half sent to Canada. Some of the antiquities were later returned, but much of the historical, artistic and scientific value of the site was destroyed. According to He Shuzong, this incident was only one of many.

When the statuary is too massive to move, looters hack away at
the heads: signs of recent looting at Banteay Chmar, Cambodia.

PILLAGE IN ANGKOR

The photograph above, taken in spring 2002, shows headless statues of Buddha and Buddha deities at Angkor Wat, Cambodia. The temple complex, which dates from the eleventh to the seventeenth centuries, has been damaged and looted sporadically since the country descended into anarchy in the early 1970s.

Angkor Wat and other Cambodian archaeological sites have been the focus of major restoration and conservation efforts by UNESCO and the International Council of Museums (ICOM) in recent years. In 1993, the organizations combined to publish *One Hundred Missing Objects: Pillage in Angkor*. The slim paperback showed photographs and carried descriptions of some of the thousands of objects that have disappeared over the years. The publication has not been without effect: half a dozen antiquities were quickly identified because of the book and returned to their country of origin. Among the objects recovered was a tenth-century head of Shiva that was on display in the Metropolitan Museum of Art. It was discovered by the Met's curator of South and Southeast Asian art, Martin Lerner, who told a *New York Times* reporter that he was horrified by the revelation. He sent the head back to the Cambodian government in 1997 at the Met's expense.

ICOM has since published a revised version of the Angkor book together with three other titles in the same series, one each for Latin America, Africa and Europe.

The potential for looting in China is astonishing: the country has an estimated four hundred thousand archaeological sites. Only a fraction of that number is protected and, even then, the effectiveness of the protection is doubtful. Corruption is widespread. The story is told of a Western scholar who noticed while visiting a Chinese museum that the gift shop offered items for sale that were nearly identical to those in the museum itself. When he enquired about this, he was told that they were, indeed, authentic and of comparable quality. The shop was owned by the museum's director. Across the street was another shop that also sold museum-quality antiquities, only this shop was owned by the assistant director, whose lesser status didn't permit him to locate within the museum.

India, too, has a wonderfully rich archaeological history and an economic environment that encourages free-market initiatives. Historically, it has also been tainted by corruption. According to one official report, in a single year in the late 1990s, three thousand artifacts were smuggled out of the country, with less than a third ever recovered. This number almost certainly underestimates the scale of the illicit trade.

In his 1997 book *Sotheby's: The Inside Story*, British journalist Peter Watson revealed that the auction house had developed a close relationship with an Indian antiquities dealer, Vaman Narayan Ghiya. Among the extra services Sotheby's provided to Ghiya, along with a handful of other privileged suppliers, was a bank account under an invented name that he could use as a personal slush fund. These and other revelations led Sotheby's to close its London antiquities department.

Ghiya was arrested in India in 2003. Apparently, the loss of Sotheby's London as an outlet didn't hinder his operation. He simply redirected the flow of looted antiquities to auction houses in New York. (Both Christie's and Sotheby's denied knowingly dealing with him.) He had been in the business for thirty-odd years and maintained a network of companies in Mumbai, Delhi and Switzerland. Three companies in Zurich laundered the artifacts he funneled through Switzerland's duty-free zone by selling them to one another. The artifacts would then be sold on through New York under the camouflage of a corporate name.

Ghiya was very rich and very successful. Indian police finally recovered about nine hundred unsold stolen antiquities from his various hiding places—enough to fill a small museum. In fact, a building in Jaipur has now been designated for that purpose, since it would be impractical to return the objects to their original homes. But first, as Patrick Radden Keefe noted

in a *New Yorker* article, the future museum needs a burglar alarm. At the time of writing, it was lamentably insecure.

Scattered, anecdotal evidence like this makes it obvious that the trade in illegal antiquities is big business. Figuring out just how big is a problem. In 2002, the British government's Illicit Trade Advisory Panel estimated the trade's value at between £15 and £20 million a year within the United Kingdom and around £100 million worldwide. But, as Brodie noted, these estimates were based on figures supplied by auction houses and dealers that have a vested interest in minimizing the problem. According to him, their figures seem to be deliberately designed to encourage public confidence in the antiquities trade and to discourage interference in the way the business is conducted. Brodie's own estimate for the United Kingdom alone, which he regards as conservative, is around £50 million.

The numbers have significance because collectors and their allies base their defense in part on the assumption that the archaeologists' complaints are exaggerated. Ortiz has claimed that most of the items appearing on the antiquities market are "chance finds." That is, most ancient treasures are discovered, not in archaeological digs, but in farmers' fields when they are struck by a plow or in road-building and other construction projects when laborers stumble upon them.

The point was taken up by John Boardman, who was stung by the criticisms flung his way by James Fenton and others for his alleged role as apologist for George Ortiz. Boardman recalled a time when he was traveling in central Greece and a farmer gave him some classical clay figurines he had found in his fields and kept for his children. "Most new antiquities on any market are come by through accident, not design," argued Boardman, "and a great many are virtually heirlooms, whether documented or not."

If the "chance find" argument is true, it follows that collectors provide a valuable service by purchasing items that otherwise would be lost forever. Brodie agrees that the farmer's plow and the developer's shovel have destroyed innumerable antiquities while saving a few. He acknowledges that a handful of studies have shown that, in specific regions and over limited periods, agriculture and construction have damaged more artifacts than has looting. But, he argues, these studies are skewed in various ways so that they miss the reality. "Those who benefit from the illicit trade—the dealers and collectors—are in a state of denial," he says. "The scale of the trade is often played down and the damage it causes is discounted." The nature of the business—the fact that it is illegal—makes it impossible to measure accurately how widespread it really is. This being the case, eye-witness testimony becomes

invaluable. What can be seen on the ground tells its own, often devastating, story, whether in West Africa, Bolivia or southern Iraq. In a sense, the archaeologists say, they know what they know.

Between the looted tomb and the dealer's showroom there is a criminal conspiracy, its workings usually concealed from view. The momentous exposure of a smuggling ring in Italy in the mid-1990s, and the blockbuster trials that followed, have swung the argument in favor of archaeologists. In the aftermath of these revelations, the collectors, and especially museums, are fighting a defensive, rearguard action against their critics.

HOVING'S HOT POT

In the summer of 2005, when the Getty was becoming mired in scandal, Thomas Hoving rather mischievously volunteered for the job of director. As a self-confessed former "bad boy" of the museum world, he reckoned he was well positioned to make the reforms that would help pull the beleaguered museum out of the mud.

Hoving's bad-boy credentials were sketched out in detail in *Making the Mummies Dance*, the entertaining memoir of his time as director of the Metropolitan Museum of Art. There he recalled how, in the 1960s and 1970s, he routinely placed

Thomas Hoving fell in love with the Euphronios krater, the ancient wine vessel that took its name from the Greek artist who decorated it. Hoving's infatuation led him to overlook its dubious provenance.

As director of the Metropolitan Museum of Art in New York in the 1960s and 1970s, Thomas Hoving set out to acquire major works of art, sometimes at considerable expense, and occasionally with scant regard for laws designed to protect the cultural patrimony of other nations.

antiquities that had been purchased illicitly in Europe into the hands of smugglers who, for the "usual 4 percent commission," delivered them promptly, efficiently and secretly to New York. In those days, he suggested, a familiarity with smugglers was a requirement of the job, and many curators relished the frisson of intrigue that went with it.

There were indications, even then, that governments were becoming more sensitive about their cultural property. Hoving admiringly acknowledged the work of the Met's in-house lawyer, Dudley Easby, who negotiated an agreement with the Mexican government to exchange exhibits. The agreement meant that, instead of making questionable acquisitions in Central America, the Met would lend the Mexicans objects they didn't have—American paintings, Egyptian antiquities and the like—and get to borrow in return unlimited quantities from Mexico's storehouse of antiquities. Hoving also recalled his participation in the UNESCO conference in 1970, which led to his dawning awareness that the freebooting days of buying and smuggling were coming to an end. The UNESCO experience did not, however, deter him from purchasing the Euphronios krater.

The decorated bowl—technically described as a red-figure Calyx krater from the sixth century BC—soon became better known as the

Met's "hot pot." It was the work of the Greek potter Euxitheos and the painter Euphronios, both regarded by experts as unrivaled masters of their respective arts. Von Bothner, the Met's classical art specialist, declared it a masterpiece and had no difficulty persuading Hoving that the museum had to have it. Hoving, in turn, persuaded the museum's board to come up with $1 million, which in 1971 was an unheard-of sum for an ancient Greek bowl. The money was to be handed over to the seller, Robert Hecht.

Hecht was an American, the heir to a department-store fortune who studied classics and archaeology in Italy after World War I. He was multilingual, cosmopolitan and erudite. Von Bothner, according to Hoving, regarded Hecht as "an honorable fellow, a genuine scholar and an invaluable art dealer." Hecht had run into some trouble a few years earlier when a member of the cabin crew on a plane bound for Turkey noticed that the American seated in her section was examining a pile of what appeared to be ancient coins. She alerted the captain and, on landing, Hecht was met by Turkish Customs officials. He wasn't charged with any crime, but he was barred from the country for a number of years. Apparently, the incident did not damage his reputation as a dealer.

Hecht told Hoving a wonderfully unlikely story to the effect that the krater had languished in pieces in a shoebox in Beirut for the preceding seventy-five years. According to Hecht, its owner, who was a dealer, had inherited the shards from his father. Beirut, Hoving noted, was the "cliché provenance for any smuggled antiquity out of Italy or Turkey," but by tacit agreement, neither he nor von Bothner challenged the tale. Nor did they examine too closely the letters attesting to its provenance that Hecht supplied. Hoving and the krater were featured in *The New York Times Magazine*, and the krater itself became the centerpiece of the Met's Greek collection. Within weeks of its installation, the story of its origins was disputed by reporters in a series of articles in the same newspaper that had celebrated its arrival in New York. Italian investigators, alerted by the reports, claimed that the krater had been dug out of the ground at a site near Rome. Hoving, however, was unmoved by these developments. The allegations about the krater's origins remained unproved, and the "hot pot" attracted crowds of the curious to the Met.

After his departure as the Met's director, Hoving stepped into a new role as the editor of *Connoisseur*. He became an enthusiastic critic of his unreformed former colleagues. In particular, he targeted the Getty.

Meanwhile, Robert Hecht was barred from Italy. He moved to France.

UNITING AGAINST THE UNSCRUPULOUS

By Lyndel Prott, Former Director,
UNESCO Division of Cultural Heritage

The mandate of the United Nations Educational, Scientific and Cultural Organization (UNESCO) is to assist its member states to protect the cultural heritage of humanity. Defending that heritage against theft is a major part of that work. While the job of detection and punishment is the function of the police, UNESCO works to try to deter thieves from stealing cultural heritage items. It does not have a mandate to protect private property rights—that belongs to nation-states—but it does promote international collaboration to ensure the return to its owners of wrongfully taken cultural property. The better that cooperation, the less the incentive there is for thieves to steal.

In pursuit of these objectives, UNESCO is responsible for several international treaties on the return of stolen cultural objects. These include the Hague Convention for the Protection of Cultural Property in the Event of Armed Conflict 1954 and its protocols; the Convention on the Means of Prohibiting and Preventing the Illicit Import, Export and Transfer of Ownership of Cultural Property 1970; and the Convention on the Protection of the Underwater Cultural Heritage 2001. The first deals with cultural objects stolen in times of conflict, the second with those stolen in peacetime; and the third with items unlawfully taken from shipwrecks.

Since most stolen cultural property is taken out of the country from which it was stolen within twelve hours, it is essential to have an agreement among states for cooperation on its return. It has been traditional in the art trade for sellers not to reveal their source of ownership, and this has enabled thieves and receivers to easily pass an object into the licit market. However, as a result of increasing cooperation among states, more and more information on provenance is available, and buyers are better able to protect themselves against acquiring illicitly trafficked objects.

An important addition to these international laws is the UNIDROIT Convention on Stolen or Illegally Exported Cultural Objects 1995. Differing rules in the diverse systems of national law concerning protection of the good-faith purchaser have been an impediment to recovery. While some systems, such as Italy's, offered protection to good-faith purchasers immediately, and others in a short time (in France, for example, the period was three years), still others preferred the rights of the original owners. Thieves became adept at exploiting these differences to launder stolen objects and prevent the hapless owners from recovering them. The 1995 convention goes some way toward foiling the thieves by providing quite simply that "a stolen cultural object shall be returned." Nevertheless, the position of the good-faith purchaser is taken into account. A state may provide that, where he or she has made the appropriate inquiries, compensation will be available.

Of course, the effectiveness of these agreements depends on the number of states that are party to them. The 1970 UNESCO Convention includes 115 of the 193 states in the international community. The UNIDROIT 1995 Convention so far has 28. The provisions only take effect among the states that

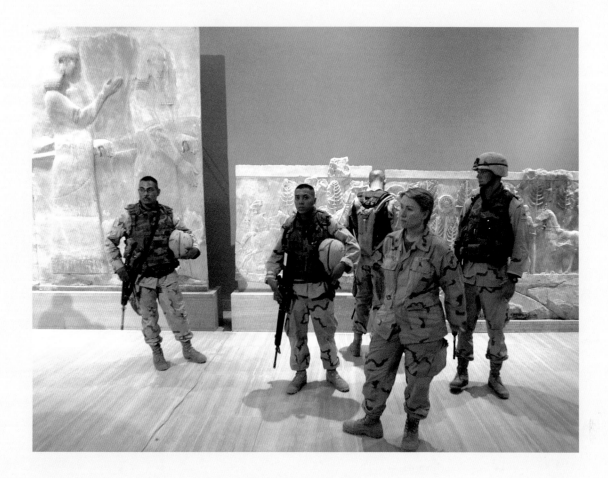

parties to the agreement, and they apply only from the date on which the state ratifies. Consequently, none of these conventions applies to objects stolen before the date of the convention, and generally none applies to objects stolen from a state before that state became a party to the treaty. It is a common misconception that the 1970 convention, for example, would apply to the Parthenon marbles taken by Lord Elgin from the Acropolis and now in the British Museum. This is not the case.

It is striking, however, how attitudes have changed since 1970. The International Council of Museums has, since 1978, promoted a Code of Ethics which requires museums not to acquire or display objects of dubious provenance. The subtance and diversity of existing national rules favouring the good faith purchaser have facilitated the transit of stolen objects into the licit trade. Broad acceptance that this was a problem led to the much more precise rules now included in the 1995 Convention. Courts in various states have noted these developments and been influenced by them, even where their state has not become a party to any or all of the conventions.

American soldiers secure the Iraq Museum in Baghdad, spring 2003.

TRUE STORIES

The American oil tycoon John Paul Getty Jr. died in 1976. He left everything to the Getty Trust, and nothing to his sons, who sued. By the time the lawsuits were settled, his legacy was worth nearly $2 billion. Thirty years later, it had grown to nearly five times that sum. Pots of money, a billion dollars in fact, went into the new museum in Los Angeles. And lots of money went into refurbishing the Getty Villa, which became the home of the Getty's Greek and Roman collection. Spending all that money has been hard work.

Part of the challenge stemmed from the fact that, for all its cash, when it came to its inventory of ancient relics, the Getty was starting pretty much from scratch.

The old, established American museums (never mind the European ones) had a century-long head start. They had the advantage, too, of having formed their core collections when collecting was easy. The Met, Boston's Museum of Fine Arts, even the University of Pennsylvania's Museum of Archaeology and Anthropology were replete with archaeological treasures. The Getty in comparison was cash rich but collection poor. The pressure was on its staff to rectify the imbalance. In the circumstances, they were bound to make mistakes.

Jiří Frel was working at the Met (and reporting to Hoving) when he was offered the job of curator of antiquities by the Getty's founder, John Paul Getty himself. Frel was tireless, knowledgeable and charismatic, and he was ingenious in devising strategies to add to the Getty's holdings. In one of his schemes, he encouraged supporters to donate items for which he personally provided a valuation that could be turned into tax relief. Hoving, in his role as scourge of the unscrupulous, reported in *Connoisseur* that in 1978 one donor purchased a "damaged Roman head" at Christie's for $892. When he gave it to the Getty a year later, its full market value as reckoned by Frel had risen amazingly to $45,000. This case was unusual for its extravagance: the value Frel or his surrogates assigned for tax purposes was usually only double or quadruple the real market price. By the time Hoving and Geraldine Norman, a correspondent for the *London Times*, exposed the scam in 1987, Frel had already been quietly demoted for "donations violations" and exiled to Paris (a dire fate!). Soon after, he resigned.

Frel was succeeded as curator by Arthur Houghton Jr. It was later shown that Houghton disapproved of the Getty's acquisition policies. He described the museum's approach in one internal memo as "curatorial avarice" and accused other staff members of knowingly making purchases

The Getty kouros—a statue of a male athlete—turned out to be a
contentious acquisition. It appears to blend styles associated with
different periods, leading some experts to believe it is a forgery.

from criminals. Houghton didn't last long. He was replaced by Marion True.

Frel had purchased scores of Greek and Roman antiquities over the years from Hecht. Among the other dealers he associated with were Giacomo Medici, Gianfranco Becchina and Robin Symes. Several of his purchases from these sources would prove controversial. One, a marble statue of a naked youth, or *kouros*, was offered for sale by Becchina. Frel, not yet publicly disgraced, wanted it for the Getty, and it was duly purchased in 1983 for around $9 million. Experts outside the museum were immediately dubious about its authenticity. Houghton, following Frel's departure, pointed out that one of the documents attesting to its provenance was obviously forged. (The letter dated in the early 1950s claimed the statue had been part of a Swiss collection but gave an address with a postal code that didn't exist for another twenty years.) In 1990, another nearly identical but smaller statue, apparently by the same artist, appeared on the market. The new *kouros* was said to be the work of a forger, which caused observers to look at the original statue with renewed suspicion. True later contended that the new one was manufactured at the request of Becchina's chief rival, Medici, in an effort to discredit him. Whatever the effect on Becchina, it certainly embarrassed the Getty: the original *kouros* now is described in the Getty guidebook as "Greek, circa 530 BC or modern forgery." The detailed entry that follows acknowledges that the statue mixes stylistic features normally associated with different periods, but pleads touchingly that "the apparent anomalies ... may indicate our limited knowledge of Archaic Greek sculpture rather than be evidence of a forger's mistakes."

The purchase of the *kouros* was, in the estimation of many observers, an expensive error. A huge stone statue, acquired from Symes in 1988, was by any reckoning a more grievous mistake. The price, reportedly $18 million, was the highest ever paid for an antiquity, and the controversy it precipitated went on damagingly for years.

The piece was monumental—more than seven feet tall—and constructed of a combination of materials. The body was limestone, while the head, hands and a foot were made of marble. It might have represented one of several goddesses, but experts believed that it was most likely meant to be Aphrodite. Its size suggested that it was a cult statue commissioned for a temple built in her honor.

True first laid eyes on it in 1986 in a warehouse owned by Symes. She must have been affected by it in much the same way that Hoving was affected by the Euphronios krater. It would be, she wrote, "the single greatest piece of ancient art in our collection; it would be the greatest piece of classical sculpture in this country and any country outside

of Greece and Great Britain." With these superlatives in mind, she was bound to pursue it ardently. The procedure she followed was not dissimilar to Hoving's in his pursuit of the krater: she had documents and a story provided by the seller. When the story was questioned, she and the Getty just toughed it out.

Symes, of course, assured True that he had clear title to the statue. He had purchased it, he said, from Renzo Canavesi, a Swiss dealer whose affidavit he was happy to provide. True had photographs of the piece sent to the Italian Ministry of Culture along with a letter asking if there was any record of the theft of the statue. The ministry replied there was none. This type of exchange is part of a formal procedure that Colin Renfrew calls "the Catch 22 pertaining to all illicit antiquities." If an object was dug up in secret and then smuggled out of the country, obviously the government would have no record of its existence. But museums have pretended for years that a formal enquiry, followed by official notification that an item is unknown, is grounds for believing it legitimate. This pretence drives archaeologists wild.

The Aphrodite was shipped to the Getty in 1987 and examined by experts. Newspaper reports later suggested that museum staff disagreed about the advisability of buying it. A senior member of the conservation department, according

An enormous statue, presumed to be of the goddess Aphrodite, was controversial from the moment it was acquired by the Getty in 1988.

to the *Los Angeles Times*, noticed dirt in the folds in the statue's garments and recent cracks in the statue itself. The dirt implied that it had been recently excavated, while the cracks suggested that it had been broken up for easy shipment and then put back together again. When asked to explain why these warnings were ignored, the Getty said that this particular conservation expert often sent "alarmist notes," and it claimed that any reservations expressed by staff members were not serious enough to nullify the case for proceeding.

There was one last hitch. A rumor was circulated that tomb robbers had dug up the statue in the late 1970s in Morgantina, an archaeological site near the town of Aidone, Sicily. The Getty contacted an American archaeologist who had worked on the excavations. He said that he had no reason to think the statue had been found there. The Getty courteously told the Italian authorities of the rumor, and the American archaeologist scrupulously got in touch with the woman in charge of the dig. At just about the same moment in July 1988 when the museum was completing the paperwork with Symes, signing enormous checks and offering champagne toasts to Aphrodite, the art unit of the Carabinieri launched its investigation into the reported illicit digging in Morgantina. It thoughtfully dropped the Getty a line to let the museum know. The Getty continued to ignore

the controversy: it was dead set on keeping the statue, while the Italian Ministry of Culture and the Carabinieri were equally determined to get it back. Although set on a collision course, both parties observed the courtesies with almost comic-opera punctiliousness. This exchange was the diplomatic version of chicken, and it would go on for years.

The Carabinieri brought charges of looting and smuggling against three *tombaroli* who allegedly dug up the Aphrodite. The charges were dropped in 1992 for lack of evidence, and the case stalled. But the pressure on both collectors and museums continued to build. There was the fuss over the Ortiz show, followed by the flak aimed at the Getty when it first exhibited and then acquired the Fleischman collection. Feeling the heat, True announced a new policy on antiquities in 1995. "Now we would only consider buying from an established collection that is known to the world," she said, "so that we do not have the issue of undocumented provenance." Critics cynically noted that the new policy would take effect only after the Fleischman gift was tucked safely inside the Getty's vaults. Ricardo Elia was singularly unimpressed. "The term 'well-documented provenance' refers to an object's ownership history," he said, "and should not be confused with archaeological 'provenance,' the findspot of an object." The archaeological community

was becoming both more focused and more militant. It argued that it wasn't enough to show that someone else had owned an item: the purchaser had to say where it originally came from.

And then, in the mid-1990s, the Carabinieri scored a remarkable breakthrough. The case has been thoroughly documented by Peter Watson in his book *The Medici Conspiracy*. Aspects of the investigation have also been reported in the pages of the *Los Angeles Times* and elsewhere. A raid on the home of a tomb robber resulted in the discovery of a remarkable handwritten document. The handwriting was that of a looter and smuggler of antiquities, Pasquale Camera, and it sketched out a kind of organizational chart, but instead of showing the reporting structure of a legitimate business, leading from the shop floor to the office of the president, this one revealed the relationship among criminals. At the lowest level were the *tombaroli*. At the next level, instead of middle management, the chart named regional captains who bought from the diggers and sold on to their bosses. The most significant of these bosses within Italy were Giacomo Medici and his rival—Gianfranco Becchina. Medici, according to the chart, had two international associates, dealers in illicit antiquities with contacts at the highest levels in Britain and the United States. The associates were Robin Symes and Robert Hecht. Both Symes and Hecht publicly denied the allegations.

In 1995, Italian and Swiss authorities acting together mounted a raid on Medici's warehouse in Geneva. What they found was the antiquities equivalent of an Aladdin's cave: thousands of clay pots, bronze and marble figures, mosaics and architectural fragments. Marble capstones taken from ancient Roman columns were arranged in front of Medici's desk to serve as seats for clients. The police also discovered thousands of photographs, some of which showed objects in their found state, covered in dirt, and others that showed the same pieces cleaned up and in museum collections. Equally damning were the tags: scores of the antiquities found in the warehouse had auction-house labels attached to them. What these and the photographs reflected was the process by which antiquities were laundered: Medici, using front companies and accomplices, often bought the items he himself had put up for sale. This created a history: the fact that an object had been catalogued and sold made it respectable. The sale at auction also established a market price. For the Carabinieri, the tags, photographs and catalogue histories provided more hard data than it had ever before laid its hands on. Italian prosecutors gleefully settled in to analyze the information, using the photographs and paperwork to trace individual items from illicit excavations to private and institutional display cases. Their plan was to start by charging those

Robert Hecht was a multilingual scholar, the heir to a fortune, and a trusted dealer in ancient coins and antiquities. It was he who sold the Euphronios krater to the Met.

at the bottom of the chart and then use the accumulating evidence and testimony to work their way up to the top. The prosecutors had plenty of experience with this approach: they had used it often over the years to send mafiosi to jail.

Revelations from the early trials soon gave the Italians the evidence they needed to press the case for the return of looted items. In early 1999, True took back to Italy three of the Getty's most prized antiquities, including a highly regarded fifth-century Greek drinking cup, or *kylix*, painted by Euphronios, and a Roman head from the Fleischman collection. In her remarks to *The Art Newspaper* at the time, True adopted a conciliatory tone. "In general," she said, "museums are more defensive and cautious about what they're willing to take on. There's no point in buying trouble. There's a growing awareness of international laws and the imposition of those laws in a more forceful way. We're encouraging international dialogue …"

The trend was a worrisome one for museum directors. Philippe de Montebello, Hoving's successor as the director of the Met, offered what amounted to a defense of unprovenanced acquisitions at about this time. "I feel that if an object is of great and artistic value, and there is not specific knowledge of its origin, that the responsible thing to do is to put it in a museum, not leave it languishing in the limbo of the market, or in some unknown collection where it cannot be studied.

Better, obviously, to have a work of art, albeit of uncertain origin, displayed, studied, available to scholars, loved and cherished, than thrown back like some worthless chattel into the maw of the vast and all-swallowing unknown. The latter, incidentally, is not equivalent to a magical restitution to some unknown dig's stratum awaiting a licensed archaeologist." The plaintive tone and the barb aimed at the more militant archaeologists reflected an unfamiliar defensiveness by the usually poised and confident museum head.

In August 2001, Canavesi, the Swiss citizen who had supplied the affidavit asserting his ownership of the Aphrodite before it was acquired by Symes, was tried in Italy for his role in spiriting the statue out of the country. He was found guilty, sentenced to two years in prison and ordered to pay a fine of £12.7 million. The sentence was voided when it was determined that the limitation period had expired, but the finding inevitably damaged the Getty's claim. Worse was to come.

With the cooperation of the French police, the Carabinieri raided Hecht's Paris apartment in 2001 and came up with something even better than Medici's organizational chart. For years, investigators had heard rumors that Hecht was writing a memoir in which he described illicit transactions and named names. Just the hint that the document existed had kept rivals and subordinates in line for years.

But it was hard to believe: any memoir that incriminated others was almost certain to incriminate its author. The police hoped it might be true, but at the same time doubted that it could be. Their mixed emotions of disbelief and delight when they seized the handwritten manuscript in Hecht's apartment were, accordingly, boundless.

Medici was found guilty of buying and selling stolen artifacts in 2005. He was sentenced to ten years and fined $13 million. True and Hecht were charged jointly with conspiring to excavate and export artifacts illegally from Italy shortly after Medici's trial ended. Both pleaded not guilty.

GUILTY PLEASURES

The year 2006 should have been the best of times for the Getty. The refurbished Villa was reopened to glowing reviews. (Martin Filler, writing in *The New York Review of Books*, called it a "strange, seductive, and undeniably entrancing environment, the guiltiest pleasure in the modern museum world.") The Aphrodite, of course, occupied pride of place. The demand for tickets to the Villa was so great that would-be visitors had to make reservations weeks or even months in advance.

INTERVIEW WITH A TOMB ROBBER

Pietro Casasanta was a tomb robber all his life. Until recently, he told a reporter, he went about his business with relatively little interference from authorities. "No one bothered us, starting with the police," he said. "For fifty years we were experts in archaeology, and then, from one day to the next, we became common thieves."

Casasanta got his start by selling his finds from a stall in the streets of Rome. He had little formal

education, but he became fascinated by the antiquities that he uncovered, and he started to teach himself about the past by buying and reading second-hand books. "Archaeology is a sickness," he told a reporter for the Associated Press. "Once you feel the beauty and fascination of an ancient marble, you're hooked. It's like falling in love with a woman, it's hopeless."

As he gained experience, his finds brought in more money, and he could employ technology as well as his growing knowledge in the hunt for artifacts. Sometimes he scouted new territory from the air, in the seat of a friend's glider; more often he conducted his searches on the ground. He became adept at spotting likely humps and mounds, which he excavated using a bulldozer and hired hands. There was no need to be secretive, he said. "I always worked during the day, with the same hours as construction crews, because at night it was easier to get noticed and make mistakes."

Casasanta made millions over the years. His most fabulous discovery was an ivory carving of the head of Apollo later valued by experts at $50 million. It found its way into a warehouse owned by Robin Symes where the journalist Peter Watson, in another investigative coup, had a hand in its recovery.

Casasanta lost virtually as much as he earned, either to police seizures or bad habits. He was arrested several times and spent about nine years in jail. He was philosophical about his changing fortunes. Conditions recently had been tough for *tombaroli*, he said, but added, "The interest in archaeology never fades. We'll be back."

It should have been the best of years, yet it was anything but. True's arraignment shook everyone. She was facing both criminal and civil charges over the museum's purchase of a list of named antiquities. At least in theory, she could end up in jail. It seemed incredible that a woman in such a position could find herself in the dock on such serious charges. The trial dragged on, with interruptions and delays, for endless, wearying months.

At the same time, Italy's Ministry of Culture was engaged in high-level negotiations for the return of its allegedly looted antiquities. Drawing on information supplied by prosecutors, who continued to sift through data yielded by police investigations, the ministry kept adding to its list. The initial demand for forty items in the Getty collection increased incrementally to more than fifty. Meanwhile, an investigation conducted by the California attorney general's office into the extravagant expenses of the Getty's director finally led to his resignation. Barry Munitz, the Getty Trust's president since 1997, repaid $250,000 in cash to the Getty and forfeited more than $2 million in expected benefits as part of his exit agreement. As if this wasn't humiliation enough, Barbara Fleischman had to resign from the board of directors. It turned out that she had loaned some $400,000 to True for the purchase of a holiday home on the Greek island of Paros. In light of the financial negotiations between True and the Fleischmans leading to the donation of their antiquities to the museum, some observers might have interpreted the loan as a conflict of interest. The Getty Trust, which had supported True in her legal predicament in Italy, dismissed her over the matter of the loan. However you looked at it, in its dealings with the Italians, the museum was negotiating from a weak position.

The Italians, in their ferocious pursuit of the Getty, had not forgotten Hoving's hot pot. De Montebello, the Met's urbane director, found himself engaged in tough negotiations in late 2005. He had, if he thought about it, the example of Dudley Easby and the deal struck years earlier between the Met and the Mexican government to guide him. That civilized exchange of materials between countries offered perhaps the best available model for restitution and cooperation. The unpalatable alternative was being enacted in a courtroom in Rome. The discussions were conducted with all the passionate pyrotechnics to be expected in a highly charged and profoundly political debate. The Italians issued ultimatums, made provocative public statements and periodically stalked out—at least partly for the benefit of an approving electorate back home. It was rumored that de Montebello broke out in shingles as the negotiations sputtered back and forth. An agreement was finally struck, however, in February 2006. The Italians, with some justification, claimed victory: the Met was to

return twenty-one looted artifacts in exchange for the loan of equivalent treasures. The Euphronios krater was going home.

In August 2007, the Getty bowed to the inevitable and negotiated a similar agreement with the Italian Ministry of Culture. The bill for the California trust was longer: forty antiquities, including items from the Fleischman collection, were to be sent to Italy. For its part, Italy offered future material exchanges and withdrew civil charges against True for the items that were being returned. One of those items, inevitably, was the Aphrodite. It, too, was going home.

WE ARE ALL ROMANS NOW

"The golden age of the museum has come to an end," writes one observer in a sober legal journal. There's no doubt that both museums and collectors are being forced to change their ways.

Government officials in Greece are frank about their admiration of Italy's achievement in getting back looted artifacts. "The Italians are very well organized—very, very well organized," Culture Minister George Voulgarakis told a reporter in December 2006. The Greeks hope that by emulating the Italian approach they can achieve similar results. They have built a state-of-the-art museum in Athens with space specifically set aside to display the Elgin Marbles. There has been no public indication yet that the British Museum will yield up the splendid friezes. In fact, it can't: the museum's charter specifically prohibits it from letting anything go. It would take a change in British law to make it happen, and that pushes the issue into the political sphere.

Politicians and courts have ignored the strict requirements of law and restored Holocaust art to the families and descendants of victims. The same could happen with antiquities. Not everyone would be made happy by the result. The American historian and critic Garry Wills has argued that the pressure to restore treasures such as the Elgin Marbles to their country of origin is an attempt to rewrite history. He calls this feckless. "Are today's Greeks actually the descendants of ancient Athenians? For that matter, the Athenians themselves believed that the proper owner of works on the Parthenon was [the goddess] Athena—and she has been missing in action for some time now. As far as she is still alive, she is in the brains of all the people who read and love Homer.… The legacy of Greece is everywhere, not just in Athens and Rome."

Wills's remarks came in a review of a just-opened wing devoted to Greek and Roman civilization at the Metropolitan Museum of Art. It was a glowing review that ended on a decidedly

SPOILS OF WAR

While a lot of international attention was focused on the war in Iraq and its grievous consequences, the devastation of the National Museum in Kabul, Afghanistan, received much less attention. Yet the Kabul museum contained a fabulous array of items reflecting the trappings of civilization at one of the world's great cultural crossroads. Conflict and the fanatical iconoclasm of the Taliban regime gutted the museum. By the end of the 1990s, only about a quarter to a third of its exhibits survived, and most of these were scattered to storage depots around the city.

Among the thousands of items lost were the stone carvings and the ivory lion shown here. The lion reportedly was recovered when it was purchased from dealers in Pakistan in 1998. In recent years, the British Museum has led an initiative supported by other museums to help repair the building and begin the process of restoration, but much remains to be done, and conditions in the country remain chaotic.

The Greek government has optimistically built a state-of-the-art museum below the Acropolis in which space has been set aside for the yet-to-be-returned Elgin Marbles.

hopeful note. The display, Wills suggested, was about the qualities we share rather than those that divide us. "We are all Greeks," he wrote. "We are all Romans."

Wills may be right and the spirit of universal collegiality may yet triumph. Meanwhile, the Getty and the Met, arguably the two most powerful American museums, both have returned a pile of items of cultural significance to the countries they came from. Other museums have made less dramatic concessions, sometimes with less prompting. In 1998, Glasgow city councilors voted to return a "ghost dance shirt" and other artifacts to the Lakota Sioux. The items, once part of Bill Cody's Wild West Show, had been exhibited in the Kelvingrove Art Gallery and Museum since the 1890s. The move to return them was widely applauded.

If museums are prevailed on by source-country governments to divest themselves of some of their prizes and by outraged archaeologists to examine more closely the source of new acquisitions, then it may be that a golden age has ended. At the same time, museums appear to be reinventing themselves in a form that assures their survival. The Met, after thirty years under de Montebello's guidance, is doing just fine. The British Museum is overrun by visitors. The Louvre has franchised its name for use on a futuristic museum in Abu Dhabi. Their format

is changing: museums no longer exist primarily to put together comprehensive, encyclopedic collections for the benefit of researchers, as their nineteenth-century predecessors did. Loans and exchanges with museums and galleries in other countries are taking the place of the kinds of purchases that make headlines. Consequently, the compulsion to acquire carelessly is fading.

The new museums are designed to distract rather than educate the public. Architectural adventurism has contributed to the trend. Philosopher and critic Mark Kingwell observes that "museums have been for two decades the most important sites of architectural experiment on the planet." As a result, "the interiors of museums have lately mattered less, or anyway have received less attention, than exteriors. Museums as artifacts–the Guggenheim Bilbao, of course, and anything trying to emulate it including [Daniel] Libeskind's own Jewish Museum in Berlin — have overpowered artifacts themselves."

When museums do attract attention for something other than the structures they occupy, it is as likely to be for a touring blockbuster exhibition as for its permanent collection. The lavishly advertised exhibition of Chinese antiquities, "The First Emperor: China's Terracotta Army," at the British Museum in 2007, was trumpeted as a once-in-a-lifetime opportunity to see items that might never again come to Britain. Across town, the King Tutankhamen exhibition — a spruced-up version of a blockbuster show originally organized more than forty years previously by Thomas Hoving at the Met — was drawing appreciative crowds at another architectural folly, the former Millennium Dome. Clearly, something has changed.

Alfred Taubman, a former chairman of Sotheby's, may have put his finger on it when he described the renovations he made to the venerable auction house. Among the problems he set out to rectify was the problem of flow, or how people moved through the building. The London premises of Sotheby's were awkward: too many staircases, too many levels, too many small rooms. "Real estate, art, whatever. It's the same experience," he told *The Sunday Times*. "It's entertainment. It makes the customer feel better. You don't know exactly why, but it gives you a high." He might just as easily have been talking about museums — or about many other aspects of the contemporary art scene. They are all about creating a sensation. And they are all about money.

When sensation and money take the place of contemplation and scholarship the nature of the institution undergoes a fundamental change. The new museums and galleries are attracting a different kind of customer. Some of them are discovering a world that is new to them. And a few of them are thieves.

LORD NORTHAMPTON'S TREASURE

The Sevso silver is the stuff of fairy tales—a fabulous treasure. And like fairy-tale treasure, it has brought to those who touched it almost nothing but grief. It was discovered by a poor Hungarian youth who was murdered because of what he found. Many others played a part in the story. Some were scoundrels; others did their level best to set things right. Its present holder is a British lord who was betrayed by friends. He wants desperately to unload the silver, but can't.

ACT 1: IN THE QUARRY

Jozsef Sumegh lived with his parents in the village of Polgárdi, Hungary. Sometime in 1978, he was working alone in a nearby quarry when his shovel struck something hard. He dug carefully around it and gradually unearthed an enormous copper cauldron containing fourteen silver dishes of extraordinary craftsmanship and beauty. On one of the silver plates was an inscription bearing the name Sevso. Sumegh could not have known just what he had found, but it was obviously valuable, and he was careful to keep it out of sight.

Sumegh quit his job and went to Budapest, taking three pieces of the silver with him. Hungary was still under Communist rule, but there was a market in the capital where almost anything could be bought and sold. It was here that the youth found a purchaser for his samples. In 1979, he left the city to do his army service. Before he went away, he buried the remaining silver under the floor of a wine cellar near his home in Polgárdi.

Two men came to visit him at home after he was discharged from the army in 1980. They accompanied him to the wine cellar, where he was found later, apparently having committed suicide by hanging himself. In the weeks that followed, two of Sumegh's friends were murdered. The treasure, of course, was gone.

ACT 2: IN THE BAZAAR

Precisely how the silver found its way to a Serbian coin dealer, Anton Tkalec, and a merchant trading in Lebanese antiquities, Halim Korban, is not known. Both were based in Vienna when they set out to find a buyer for the horde.

They found one in London. In November 1980, Rainer Zietz, a dealer, and Peter Wilson, the innovative director of Sotheby's, took the first proffered piece of silver to experts at the British Museum. The piece was authentic—late Roman silver crafted around AD 350 to 450—and absolutely stunning. Encouraged, Wilson, Zietz and a lawyer, Peter Mimpriss, formed a consortium, The Art Consultancy, and bought more.

Tkalec and Korban's sales technique was straight from the bazaar. They doled out one piece at a time, always promising another one, and always pushing up the price. Wilson and company kept buying, but they knew they needed a partner with more cash. They drew up a prospectus and showed it to the Marquis of Northampton. The prospectus said the silver had been found by farm workers in Lebanon. Lord Northampton believed them and joined the club.

In 1983, The Art Consultancy approached the richest museum in the world with an offer to sell. Arthur Houghton at the Getty took one look at the documents that guaranteed title and turned them down flat. Peter Mimpriss, undeterred, hit Lord Northampton for another £500,000 and got new papers. Northampton, by now, was accustomed to

shelling out money. The fourteen pieces of silver cost him between £10 million and £16 million. He and his associates were certain the set could be sold for a £100 million or more.

ACT 3: IN THE COURTROOM

The forthcoming sale of the Sevso silver was announced with maximum fanfare by Sotheby's Zurich in February 1990. To make sure potential buyers could see it for themselves, it was sent on tour. At the first stop, New York, it was seized by the courts. First one, then two, then finally three countries claimed the Sevso silver had been stolen from their sovereign lands.

Lebanon's claim reflected the consortium's attribution but was obviously flimsy and soon abandoned. Yugoslavia's claim arose from a newspaper report that was probably planted with intent to confuse. (The report imaginatively implicated the family of Balkans' strongman Josip Tito.) Hungary's claim, by far the most plausible, cited, among other things, a comparable piece of silver found within its borders. Police had also been investigating the hanging of Jozsef Sumegh, which they now said was murder.

Scotland Yard's Richard Ellis started looking into the case in 1991. "It was our introduction into what was clearly a very murky market," he said. It appeared to Ellis that criminal offences may have been committed in England. The prospectus falsely asserted that the consortium held title to the silver and that it could be "sold anywhere in the world." Peter Wilson had died, so attention focused first on Lord Northampton. Peter Mimpriss's law firm parted company with Northampton at this juncture, saying that it acted for the trust, not for him. "Lord Northampton,

if you like, was left holding the baby," said Ellis. "We investigated him and actually exonerated him." Ellis continued with his investigation for some time but no charges were laid.

Lord Northampton's lawyers in New York proved to be more adroit than their opponents. The New York Supreme Court decided in November 1993 that Hungary and Yugoslavia had failed to establish their claims. This was not quite the same as saying that Northampton's claim was valid. He got to keep the silver, but it would be tough for him to sell it. There was always the chance that Hungary would again intervene. So he sued Peter Mimpriss and his law firm instead.

Northampton claimed damages for fraud, deceit, wrongful interference with business interests, negligence, fraudulent misrepresentation, breach of contract, breach of trust and breach of fiduciary duties. It took a long time for the parties to come to terms. In 1999, the action came to an end when Mimpriss and his firm paid the ill-used marquis a sum that has been variously estimated at between £15 million and £25 million.

ACT 4: IN LIMBO

The silver languished in a Channel Isles' bank vault for years. In late 2006, it was dusted, polished and put on show at Bonhams auction house in London. It drew an admiring crowd but no offers. Although no one has successfully challenged Northcliffe's claim to the silver, Hungary continues to insist that the treasure was taken illicitly from within its borders. The fabulous silver, which would easily become the principal attraction in any museum of antiquities, has been returned to its vault.

THE UNBREAKABLE
ART BUBBLE

"I like money on the wall. Say you were going to buy
a $200,000 painting. I think you should take that money,
tie it up, and hang it on the wall."

— Andy Warhol

Mark Rothko (1903–1970), *White Center*. Oil on canvas. In the
late 1940s, influential art dealer Betty Parsons, who championed
the abstract expressionists, struggled to get patrons of her New
York gallery to look at a Rothko. Fifty years later, this one sold at
auction for more than $72 million.

Tobias Meyer, head of contemporary art, presides over the Sotheby's auction in June 2007. Behind him, about to be hammered down for millions of pounds, is a Francis Bacon self-portrait.

MORE RECORDS ARE BROKEN

The popular press—and not just the art media—is full of reports from the art world in the week leading up to the sale at Sotheby's in London in June 2007. New York receipts in the preceding month set new records. Warhols did especially well. Three silkscreen prints—*Orange Marilyn, Sixteen Jackies* and a *Chairman Mao* from 1972—all sold for between $15 and $17 million apiece. This was startling enough, but then *Green Car Crash I* established a new benchmark for Warhol's work by making $71.7 million. And it wasn't just Warhol: almost everything on offer attracted feverish bidding. The Christie's post-war and contemporary sale set nineteen records in the course of selling sixty-four works of art for a total of $240 million. A Clifford Still abstract from 1947 tripled its high estimate when it sold for $21 million. Mark Rothko's *White Center* fetched $72.8 million. Even comparatively small works attracted astonishing prices: a diminutive Willem de Kooning charcoal, oil and graphite drawing on paper sold for $9.6 million. Altogether, the spring art sales in New York conducted by the three main houses, Sotheby's, Christie's and Phillips de Pury, did $870.7 million worth of business, another record. It seems unlikely that London can match these totals, but the works the auction houses have to offer are enticing, and the anticipation is keen.

Christie's leads off the week with a sale of twentieth-century art that includes one of Monet's London paintings, *Waterloo Bridge*, from 1904. Estimated to sell for between £6 and £8 million, it makes £17.9. This is promising. The next night Sotheby's offers one of the few Monet pictures of water lilies still in private hands. Estimated to sell for between £10 and £12 million, *Nymphéas* sells for £18.5 million. Obviously, Impressionist paintings are holding their own. On Wednesday, June 20, Christie's holds its sale of postwar and contemporary art. Once again, the hot market has drawn some notable works into the auction room. The star is a sympathetic full-length portrait by Lucien Freud of his friend and drinking companion Bruce Bernard. It goes for £7.9 million—almost £3 million more than its high-end estimate—making Freud the most expensive living European artist. The Sotheby's sale of contemporary art is coming up next, on June 21, and with it Warhol's *30 Colored Maos*.

A PIECE OF THE PIE

Museums, auction houses, dealers and collectors all have had a hand in driving up the price of art. Visionary museum directors like Thomas Hoving and Nicholas Serota reinterpreted the role of their institutions. Instead of being quiet refuges dedicated to contemplation and research, they became venues for popular entertainment. Crowds streamed in (and paid a premium) to see Inca gold, the treasure of the pharaohs, and terracotta armies from China. Before leaving, they were encouraged to visit the vastly expanded gift shops and stock up on souvenirs. These same museums soon found themselves competing with one another to purchase works of art as they came on the market and then shelling out ever-greater prices for them. The sums that were paid became the attraction. Hoving never balked at the asking price for the Euphronios krater. Without doubt, he believed that it was worth the $1 million that the Met paid for it, but he also shrewdly broadcast the price. It was enough to merit a cover story in *The New York Times Magazine*, and, following the hype, people with no knowledge of Greek antiquities lined up to see it. For those whose salaries were a small fraction of the sum, a million-dollar clay pot was worth a detour.

Auction houses had a lot to do with the rise in prices. Peter Wilson, as chairman of Sotheby's in the 1960 and 1970s, is widely credited with the innovations that enticed celebrities and well-heeled private collectors into the salesroom and infused the old-fashioned art auction with new glamor and excitement. His successors have consolidated the gains he made, and art now is

The actress Elizabeth Taylor is among the many celebrities who own great art. Among her prized pieces is this van Gogh, *View of the Asylum and Chapel at Saint-Remy*, painted shortly before his death. Her title to the painting was challenged by descendants of a Jewish collector living in Germany who, they claimed, had sold the work under duress in 1939. Successive court actions have denied the claim.

regarded as high-status ornamentation, suitable for home and office, as well as a viable financial instrument. Art dealers were pushed briefly to the margins of the business but recovered handily by reinventing the art fair. The effect of these innovations by museums, auction houses and art dealers was to expand both the number of participants and the quantity of money that changed hands. The art pie became bigger and richer.

Art has its own seductions, of course, but the price of art gives it an added allure that corrupts the susceptible. Peter Wilson, after retiring from Sotheby's, was at the center of a consortium that purchased the smuggled antiquities known as the Sevso Silver. Alfred Taubman, perhaps unwittingly, colluded with his counterparts at Christie's to fix commissions. Others inside the art business have engaged in similarly dubious or underhanded practices. This is clearly the case when it comes to the smuggling of antiquities, in which some dealers, museums and private collectors have been more or less complicit. At the very least, buyers have avoided asking sellers hard questions about where their purchases came from. They have also done their best to drive up the value of their purchases. Museums enhance the value of private collections simply by cataloguing and putting them on show. The prices they pay for new acquisitions establish benchmarks that reinforce one another, keeping the market strong.

One of Peter Watson's many revelations was that smugglers like Medici bought the antiquities that they themselves had put up for auction to establish their price and to fortify their provenance. But the interests of the smugglers were identical to those of the people they sold to. High prices suit everyone.

If the money sloshing around the art world has corrupted some of the inhabitants, it is hardly surprising that it also has attracted professional crooks. It was never suggested before World War II that art theft ranked among the most serious crimes confronting law enforcement agencies. Now, although firm figures are hard to come by, no one doubts its importance. And while police agencies report some success in solving the most notorious crimes, the everyday thefts from small galleries and people's homes flummox investigators more often than not. The villains have achieved some proficiency in moving their swag.

Three varieties of art crime have been featured in these pages: straight theft by criminals from public and private collections, the theft of art from Jewish owners by the Nazis in the period from 1933 to 1945, and the looting of archaeological sites by tomb robbers. The features that make them different are obvious. What is interesting, and significant from the point of view of law enforcement, are the features that make them the same.

First, thieves tend to move stolen art across borders, both to evade the police where the crime was committed and to take advantage of laws in different jurisdictions. The astonishing mobility of the criminal underworld can be seen in relatively trivial crimes where, for example, stolen garden statuary is routinely spirited from one jurisdiction to another within days of the crime. The more valuable the work, the more likely it is that the item will be moved long distances.

Second, stolen art disappears for long periods. This is less likely to be true of artifacts, which often are robbed from archaeological sites without the knowledge of the authorities. But, in all cases where an item is known to have been stolen, the thief is likely to keep it out of sight for years. Limitation laws may be brought into play, and thieves may also count on official forgetfulness. In some cases the art is put to illicit use in drug or arms deals while it is out of sight.

Finally, stolen art reappears. Sooner or later, its possessor is almost certain to slip it back into the market. The lure of rising prices and the temptation to assume that pursuers have given up and moved on are ultimately irresistible. And when the art reemerges, it finds its way to market by predictable channels. That is, if it is to attain its true market value, it has to be offered eventually to an art dealer or auctioneer.

The problem of jurisdictional differences regarding Holocaust art and archaeological artifacts has been tentatively addressed through a variety of legal mechanisms. Neither the Washington Principles nor the UNESCO convention is a definitive solution to these challenges, but both have had an effect. The Washington Principles have led, directly or indirectly, to the return of Holocaust art or compensation in lieu. And 1970, the year the UNESCO convention was passed, has become an accepted benchmark for determining whether or not antiquities have been looted. Differences in limitation periods are a trickier challenge, but there is, at least, a wide awareness of the problem.

No solution is perfect. Julian Radcliffe's Art Loss Register, however, responds to a number of the traits peculiar to art theft. The ALR is international and accessible to individuals and institutions all over the world. It is permanent and therefore patient: the passage of years does not dim its memory. Records of items stolen in the 1930s can be located just as readily as those entered yesterday. And because art can be reintroduced to the legitimate market only through reputable dealers and auction houses, their participation severely limits a thief's options. With broad participation by the mainstream players, stolen art gets pushed to the margins, to dodgy dealers and suspect internet websites. Or it gets sold off the back of a truck.

HEAD OF A WOMAN

A Bond Street dealer asked the Art Loss Register to check up on a Roman artifact. He sent them pictures that showed the damaged marble head of a woman, which he dated from the late second or early third century BC and valued at more than £10,000. Staff at the ALR found a match with a marble head taken from a museum in Sfax, Tunisia, in October 1998. They promptly notified Scotland Yard's Art and Antiquities unit, and within hours a police inspector was in Bond Street.

The London dealer told the policeman that the Paris vendor said that the object was in Switzerland. (For thieves, the more borders between them and their pursuers, the better.) If this was true, the inspector could intercede only if the Tunisian authorities asked him to pursue the matter. Meanwhile, the investigation was in the hands of Interpol and the French police. The vendor's story didn't hold up under questioning, however, and Paris police passed on information that led Scotland Yard to conduct a raid in London. The art squad recovered the head, which was turned over to the Tunisian consulate in December 1999.

Thousands of items are added to the ALR's database each year. Their worth, as reflected in sales at auction, in galleries and through art fairs, is on a seemingly endless upward trajectory. History suggests that the climb will end. One day the bubble will be deflated. But the huge expansion of the art world will not be instantly undone. And the appeal art holds both for speculators and criminals alike will remain intact.

QUITE A GOOD WARHOL

Radcliffe arrives at Sotheby's shortly before the auction is to begin. The salesroom is full, the seats are taken and about as many people as are seated are standing at the rear. There must be four hundred people in attendance. Beautiful women in short dresses are accompanied by sleek men in open shirts. Wealth is informal in June. Radcliffe, as restless as always, lingers at the back with a few members of his staff. He has little to say about his expectations. He is optimistic, he says, that the evening will go well.

Tobias Meyer, Sotheby's head of contemporary art, steps up to the podium at 8 PM exactly. He is surprisingly young, very elegant, and has wonderfully expressive hands. Over the course of the next hour and a half, as sixty or so pieces

of art are auctioned off, his hands conduct proceedings as if they were drawing music from musicians. Sometimes they are emphatic, pointing decisively at the leading bidder; at other times they hover, as if unable to make up their mind. They can beckon, wait patiently and fall feather-like to the podium in acknowledgement of defeat. Tonight, defeats are rare.

First on the block are five works donated by British artists, the proceeds to go to charity. Meyer's hands point like a conjuror's to his right, and one of the contributors, artist Tracey Emin, materializes out of the crowd. She waves—not shyly but like the celebrity she is—and then withdraws. The five pieces, including a Damien Hirst spin painting, are sold in short order.

A nattering buzz fills the salesroom, as softly insistent as the sounds of an Eastern bazaar. Cell phones call out like songbirds in cages, and glass bottles of water that have been handed out by Sotheby's staff tinkle against the metal feet of people's chairs.

Pie Face, a spoof portrait by the graffiti artist Banksy, goes for £160,000, well above its estimate. The bids are shown as soon as they are called on a big scoreboard in the corner of the room, not just in British pounds, but also in dollars, euros, yen and rubles. The Russian currency has just been added in recognition of the growing presence of buyers from the East. The next few

paintings sell mostly within their estimates, and then a Francis Bacon self-portrait, estimated at between £8 and £12 million, comes up. The chattering subsides.

Bacon painted himself, he once explained, because he ran out of sitters. The bids rise swiftly—£10, £12, £14 million. It is knocked down, to applause, for more than £19 million. The sounds of the bazaar swiftly resume.

Lot number 22 is *30 Colored Maos*. There are only two bidders, and one drops out quickly. Meyer's wonderful hands point once, twice, then make a fist and bang it down for £1.1 million. "This is quite a good Warhol," Radcliffe had said. The price is stupendous when you think about it. More than £1 million! But this evening, in this remarkable week in London, a million pounds is only to be expected. The auctioneer moves briskly on.

The auction has several standout moments. Chief among them is the sale of Hirst's *Lullaby Spring*. The roughly six-by-eight-foot steel cabinet with its six thousand colored pills more than doubles its estimate. The winning bidder pays £8.6 million. Lucien Freud was Europe's most expensive living artist for just twenty-four hours. The title now belongs to Hirst.

A Jean-Michel Basquiat sells for £2.5 million. A Gerhard Richter sells for £1.9 million. Another Warhol, this time a painting of a dollar sign, sells for £1.5 million.

Meyer's hands are mesmerizing to the end. The conclusion of the sale has a final few surprises. A handful of works by contemporary Chinese artists elicit strong bids. One in particular, *The Pope* by Yue Minjun, brings in £1.9 million, more than double the anticipated price. The talk in the newspapers the next morning, apart from the achievements of Bacon and Hirst, is about the influx of money from the East. London has been home to Arab sheiks for decades, but the arrival of Russian and Chinese billionaires is new. London, the reporters enthuse, is displacing New York as the art world's center because of the new power of the East.

Radcliffe leaves Sotheby's as soon as *30 Colored Maos* is knocked down. The price is excellent as far as he is concerned. There will be a press release in the morning hailing both the sale and the recovery of the stolen print. This is all good news for the ALR. Even though it is getting late, Radcliffe heads back to the office. He has work to do, and he is traveling to India the next day. He checks his messages when he gets there, of course. Reports come in all the time. You never know what stolen work of art will turn up next.

A GALLERY
OF STOLEN ART

"Bereavement is a good word to use. I think Harry has been
deeply hurt by this robbery. He loved those things."

— Chapman Pincher, a neighbor of Harry Hyams,
after the robbery of Ramsbury Manor

Kleber Hall's *Portrait of Sarah Doyle* disappeared from Sayles Hall at Brown University
in Providence, Rhode Island, in August 1997. Doyle occupied an important place in
the university's history because of her role in opening its doors to women students in
the 1890s. The robbery didn't qualify as art theft, according the university's curator,
"because it's not a good picture. I would put it in the category of vandalism." The
university commissioned an artist to make a copy of another portrait of Doyle to
replace the missing painting.

Any robbery comes as a shock to the victim. Property is tied up with our sense of identity. An intrusion by uninvited strangers who make off with things that we see and use every day, things that are part of our lives, is almost always felt as a violation. When the items stolen are part of an art collection, the sense of violation is even more acute. Art is chosen, purchased and displayed because it has special meaning to its possessor. The owner of stolen artwork, like the millionaire collector Harry Hyams, often grieves as if bereaved.

The art thefts that most often come to public attention are the big ones: the theft of Edvard Munch's *The Scream* from a museum in Oslo; the disappearance of more than a dozen works, including irreplaceable masterpieces by Vermeer and Rembrandt, from the Gardner Museum in Boston; the heist of a pair of Picasso paintings from the artist's granddaughter's house in Paris. Both the fame of the artists and the monetary value of the art can give these robberies a patina of glamor. But there is nothing glamorous about the thieves and their callousness is often evident in the destruction they leave behind.

The overwhelming majority of art thefts are just theft like any other. They are no different, from the criminal's point of view, from the theft of a car or a corner-store holdup. The thieves take what catches their eye and can be more-or-less easily carried away. It's only in the eyes of those who appreciate art that these thefts take on a different meaning. The items illustrated in these pages — all of which have been listed as missing at one time or another — vary widely in their monetary value. But all reflect the rich imagination and technical skill of their creators. And their value to their original owners is simply incalculable.

Note that the quality of these pictures, often the property of private collectors, varies widely. The only available photographs may be from snapshots or pictures taken for insurance purposes rather than commercial reproductions.

Edvard Munch (1863–1944), *Madonna*. This painting was stolen from Oslo's Munch Museum, along with the more famous *Scream*, in August 2004. Two years later the two paintings were recovered but were in poor condition due to rough handling by the thieves. The Munch Museum's conservationists worked for two years to restore the paintings to something approaching their original state. They went on permanent display again—with vastly improved security—in 2008.

Egon Schiele (1890–1918), *Wise, Kirche und Hauser.*
The small oil-on-panel painting, dated 1912, was stolen
from a museum in the Czech Republic in September 2001.

Paul Cézanne, *Auvers-sur-Oise* (c.1880). While revelers celebrated the beginning of a new millennium, thieves clambered across the tops of neighboring buildings to reach the roof of the Ashmolean Museum in Oxford, England. They broke through a skylight to enter the museum and then made off with this landscape, valued at about $2 million. The director of the museum described the theft as a "shattering blow."

Following page: **Antione-Felix Boisselier** (1870–1957), *Entrance of the Convent of San Benedetto Sublaro.* Oil on paper. Stolen from a gallery in New York City in the Summer of 2000.

Vincent van Gogh (1853–1890), *Congregation Leaving the Reformed Church in Neunen*. One of two immensely valuable and important paintings stolen from the Van Gogh Museum in Amsterdam, the Netherlands, in December 2002. The other was *View of the Sea at Scheveningen*. Two men were convicted of the robbery two years later but neither painting has been recovered.

Jean-François Raffaëlli (1850–1924), *Place de la Trinité*.
Oil on canvas. Its present whereabouts is unknown.

Franz Richard Unterberger (1838–1902), *Pont de Londres*. In the summer of 1999, an elderly Derbyshire resident handed this painting over for a pittance to an individual who came to the door claiming to be an art dealer. The victim's family notified the police and the item was listed with the Art Loss Register. A few months later, the painting was identified when a provincial auction house checked it out with the ALR. The seller was arrested but the painting was not recovered.

Elisabeth Seldron (c.1690–1735), *Market Scene*. In May 1974, fifty-five paintings were stolen from an art dealer in Zurich. Thirty-six were recovered almost immediately but the remaining nineteen disappeared. This one turned up in an auction of Old Masters in London, in 1994.

Walter Laurent Palmer (1854–1932), *Woodland Stream*.
This work, pastel on paper laid on canvas, was stolen from
a gallery in New York in early 2002.

Andrew Wyeth (1917–), *A Bridge, Race Gate*, 1984, watercolor on paper. This is one of four paintings stolen from a private residence in Houston, Texas in December 1999 that have yet to be recovered. The others are Joaquin Sorolla Y Bastida (1863–1923), *Playa de Biarritz*, 1906, oil on board (opposite top); Mary Cassatt (1844–1926), *Margot Wearing a Large Bonnet, Seated in Armchair*, 1904, drypoint; and Hildegard Lehnert (1857–1943), *Blooming Azaleas Along the River*, oil on canvas.

Deux Vieillards et Voilier, c. 1934.

Cinésias et Myrrhine, c. 1934.

Picasso

Of the twenty-five most valuable paintings ever sold, according to one observer's calculations, nine were Picassos. His reputation is unparalleled and, consequently, he is often targeted by crooks. The Art Loss Register currently lists as either stolen or missing more than four hundred works by Picasso. These include paintings, ceramics, sketches and prints. In one recent year, another sixteen works were added to the database. The three copper etchings shown here were stolen from an art-book dealer in New York in September 2000. All three were signed by the artist in the lower left margin, and numbered 95/150 in the lower right margin.

Couple et Enfant, c. 1934.

Romare Bearden (1914–1988), *The Blue Girl*.
The African-American Harlem Renaissance artist
created this watercolor-and-collage work, which
was stolen from a New York gallery in 2000.

189

Therèse-Marthe-Françoise Cotard-Dupré (1877–1920), *Feeding the Chickens.* Stolen in transit between New York and Beverly Hills, August 2000.

T. Lunvold, *Black and White Terriers Looking into a Rabbit Hole.*
These two paintings by the nineteenth-century artist were stolen
from a private residence in Dorset, England in 2004.

Amedeo Modigliani (1884–1920), *Carytid*. A gouache-and-pencil on paper drawing, reported missing from a warehouse in New York in 2005.

Pablo Picasso (1881–1973), *Nude Before a Mirror*. This
painting, valued at more than $12 million, was stolen from
the California home of a retired ophthalmologist in 1992,
and recovered five years later in a storage locker in Cleveland.

Fernandez Arman (1928–2005), *Small Liberties*. The ten-foot-tall bronze sculpture was reported missing in New York City in January 2004.

Georges Petit de Chemellier (1835–1907), *La Famille*. The bronze sculpture, stolen in Angers in the Loire region of France, weighed more than 300 pounds. In recent years, similar metal sculptures have been taken sometimes for their value not as art, but as scrap metal.

Benin culture, Nigeria. This black, cast-brass ring depicting a royal ritual was stolen in Cleveland, Ohio.

Henry Moore (1898–1986), *3-Piece Reclining Figure: Maquette No. 4.* The small bronze, numbered 2 of 9, was stolen from a New York gallery in 2001.

George Carlson (1940–), *Mind, Body, Spirit.* Bronze statue
numbered 8 of 21. Stolen from a shop in Los Angeles, in 2001.

Anders Zorn (1860–1910), *Nude Woman at Seaside.*
Oil on canvas. The early twentieth-century oil painting
by the Swedish painter was stolen from a private collection
in Nassjo, Sweden in 1999.

Jean Fautrier (1898–1964), *Petit nu*. The theft of this painting from a residence in France was reported to police in 1994. It was purchased six years later in Vienna, Austria from a dealer who bought it from crooks in Tel Aviv, Israel. It was finally returned to its original owner in the summer of 2006 after it was identified in a consignment bound for auction in London.

KPM Berlin manufactured these missing porcelain plates c. 1832–36. Now missing, they featured a floral pattern on a black background with a gold rim.

Jan Elmy (twentieth century), *Harbenaro Peppers*. This diminutive (4 in. by 6 in.) oil painting was stolen from a gallery in Philadelphia, Pennsylvania in September 2001.

Johan Laurentz Jensen (1800–1856), *Vase of Flowers*. The painting by this Danish artist disappeared after a residence in New York State was burgled in early 1980. When the owner registered the loss with the ALR she provided a snapshot showing it hanging on her living room wall. Staff at the ALR were able to identify the painting from the snapshot when it turned up in a Christie's, New York auction in 2000.

French octagonal gold box with miniatures of various women on each side. An inscribed plaque says the box belonged to M. de Maurepas, Minister of Louis XV.

Waddesdon Robbery

Country estates in Great Britain have been targeted by increasingly aggressive thieves in recent years. At about 2 AM on 10 June 2003 robbers broke into Waddesdon Manor in Buckinghamshire, England. The house, built for Baron Ferdinand de Rothschild in the late nineteenth century, is open to the public under the auspices of the National Trust. It contains many important works of art as well as collections of porcelain and antique furniture. But the thieves on this occasion targeted the James A. Rothschild collection of more than a hundred snuffboxes and other precious small objects. At the time of writing, none of the stolen items had been recovered.

French rectangular container, gold with green enamel, bearing an oval miniature of a young woman and the words "*Souvenir*" and "*d'Amitié*" in diamonds.

French oval varicolored gold snuffbox, c. 1765. The cover, walls, and base depict scenes from domestic life in the manner of Greuze and Boucher.

French Louis XVI urn-shaped potpourri vase, 1774–1793. Ormolu-mounted, engraved rock crystal bowl and domed cover.

English rectangular box, c. 1770, in gray agate with gold cagework. Decoration in gold, agate, mother-of-pearl and tortoiseshell.

The Master of Moulins (c. 1480–1500), *The Lady of Moulins.*
This oil-on-panel painting was stolen from a private residence
in Los Angeles in September 2001.

Antonio Paretana (sixteenth century), *Portrait of a Young Girl*.
Oil on canvas. One of three European paintings stolen in Texas
in 1999.

Anna Hyatt Huntington (1876–1973), *Bear Playing on Its Back*. This small (3½ by 4¾ in.) bronze was stolen from a Madison Avenue gallery just before Christmas 2000.

James Fitzgerald (1899–1991), *Oxen Logging.*
Watercolor painting stolen from a private residence
in Dover, Massachusetts, spring 2000.

Etienne Parrocel (1696–1775), *Saint Augustine and Saint Bernard* (attributed). This oil-on-canvas painting was listed as an historical monument before thieves took it from a church in Carpentras, France, in February 1998.

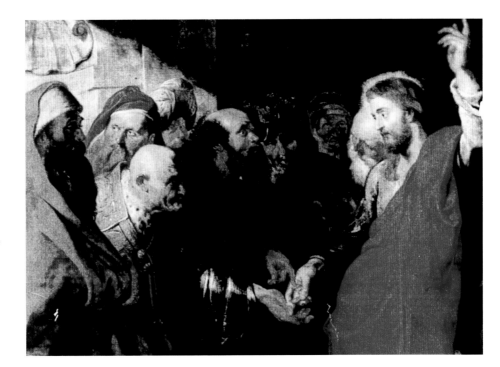

This seventeenth-century oil-on-wood painting attributed to the School of Rubens, *Christ with the Pharisees*, was stolen from a private residence in Warsaw, Poland in August 1996.

Churches often contain fabulous art and they are especially vulnerable to thieves. Like museums, they are open to the public, but they are not nearly as well guarded. These three fifteenth-century wood statues were stolen from a church in Lemgow, Lower Saxony. The central figure, portraying John the Baptist, was nearly three feet tall.

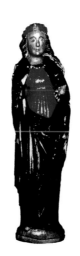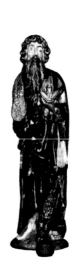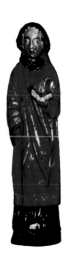

Not your everyday clock: it dates from the time of the Sun King, Louis IV of France. The dial and movement were made (and signed) by Isaac Thuret, Clockmaker to the King. The case—ebony and red tortoiseshell, inlaid with pewter and brass stringing, and fitted with bronze mounts—is attributed to the Gobelins Workshop, c. 1705. It was stolen in New York in 1998.

This antique clock was stolen in the United Kingdom in 1993. It came to the attention of the Art Loss Register when it was offered at auction in the summer of 2001. The original owners had marked the clock with an ultraviolet pen, which helped to nail the identification. They got the clock back.

This striking twentieth-century pyramid-shaped desk clock was just five inches tall. Made by the jeweler Asprey, using 18-carat gold, amethysts, pink coral and nephrite. The clock is set on one face, with frames for photographs on the other two. It disappeared in Beverly Hills, California in 1999.

William Aiken Walker (1838–1921), *The Sharecroppers*. Oil on board. Disappeared from a Chicago location in 1998.

213

Ming dynasty jade carving, *The Three Teachings*. All the
carved objects on this and the following two pages were
stolen from a gallery in San Francisco in June 2001.

Ming dynasty (seventeenth century) jade mandarin duck. The wings are finely feathered and the webbed feet are fitted to the underside of the body.

Seventeenth- or eighteenth-century jade floating log in the form of a pine tree with two figures, one apparently holding a fan.

Han dynasty (206 BC–220 AD) pendant of a coiled dragon and its young.

Qing dynasty (eighteenth century) Chinese ivory figure holding flowers (left) and Meiji period (1868–1912) Japanese ivory carving of a mother and child hunting for shells (right). Both were stolen from a gallery in San Francisco in June 2001.

John Absolon (1815–1895), *Two Young Women in Forest*.
This painting by the English artist was lost in transit in
Florida in 2004.

Susan H. MacDowell (1928–1987), *Portrait of Walter G. MacDowell.* A diminutive (7 by 4 in.) oil-on-board painting, stolen from a residence in the state of Virginia.

Frederic Remington (1861–1909), *Cow Pony Pathos.*
Oil on canvas. This painting by the revered American
artist of Western scenes was one of nine stolen from
a private residence in Texas in 1974.

Maria Louisa Campoy's bronze sculpture of a horse and rider, *Jinete*, was stolen in New York in January 1998.

Jacob Lawrence (1917–2000), *The Life of John Brown.*
Serigraph print. Stolen in Los Angeles, September 2001.

Sigmar Polke (1941–). A gallery owner in Germany was persuaded to loan these two mixed-media works by the contemporary German artist to a man who represented himself as a dealer with a potential purchaser waiting in the wings. The dealer turned out to have a string of criminal convictions in his past and he neither returned nor paid for the artworks he had "borrowed." In 2001, Munich police and the ALR picked up his trail and mounted a sting operation in which an ALR staff member posed as a private collector. The fake dealer was arrested and the paintings were recovered.

Picasso. A relatively late painting of a female nude which was stolen in Lisbon, Portugal, in 1982, and recovered in the United States in 1998.

Fernand Léger (1881–1955), *The Dancers.*
Oil on canvas. Stolen in New York in 1997.

Vase, one of Gallé's famous dragonfly goblets.

Small vase, *Forme Soldanelle des Alpes*, c. 1889. Glass decorated with engraving, enamel, gold and silver.

Two-handled vase, *Glycine*, c. 1889. Double-layered glass with glass inlays and bronze base.

Vase, *Liseron d'octobre*, c. 1891. Double-layered crystal.

Gallé

Thirteen decorative glass objects by French artist Emile Gallé (1846–1904) were stolen from the Musée de la Fondation Neumann in Gingins, Switzerland in October 2004. Among them were the three items shown here, and the dragonfly goblet opposite.

Claude Monet, *The Cliffs of Dieppe*. The five armed thieves chose the one Sunday of the month when admission is free to enter the Jules Cherest Museum in Nice and make off with four valuable paintings. They chose the Monet (above), and Alfred Sisley, *The Alley of the Poplars* (facing page), as well as two paintings by Jan Breughel the Elder. Both the Monet and the Sisley had been stolen previously, in 1998, in a heist for which the then-curator of the museum was jailed.

Peter Breughel the Elder, *The Temptations of St. Anthony.* Seventeen valuable artworks were stolen from the Madrid mansion owned by the daughter of a construction magnate in August 2001. Almost a year later, Spanish police and FBI agents combined in an elaborate sting operation to capture the criminals and recover the art. A meeting was arranged at a Madrid hotel. An FBI agent posed as an art expert whose role was to authenticate the paintings, while scores of police surrounded the building. The thieves showed the agent this Breughel as proof of their bona fides. Ten paintings were recovered and three men were arrested and charged.

Petrarch's illuminated manuscript. Professor Melnikas's colleagues were appalled by the theft. "It's a colossal thing, just remarkable," said antiquarian book dealer Bruce Ferrini. "You don't cut up Petrarch's copy. You don't do that with something you love." The copy he referred to was this priceless illuminated manuscript once owned by the fourteenth-century Italian poet properly known as Francesco Petrarca. It was currently held by the Vatican Library. And it was cut up by an Ohio State University professor whose seniority had earned him special privileges when he visited the Vatican for research purposes. The illustration shows one of three pages Professor Anthony Melnikas razored out of the handmade book and attempted to sell to Ferrini – who sounded the alarm.

Berlin Break-in

Nine paintings were stolen from the Brücke Museum in Berlin on April 20, 2002 (shown here and on the following five pages). All were by the Brücke (Bridge) group of German Expressionists whose members included Erich Heckel, Ernst Ludwig Kirchner, Max Pechstein and Emil Nolde. Just about one month after the theft, eight and one-half paintings were found in a Berlin apartment, stuffed into a black suitcase. The mutilated painting was Max Pechstein's *Junges Maedchen* (Young Girl), above. Observers speculated that the missing half was sent to a prospective buyer as proof that the paintings were real.

Emil Nolde, *Herr Sch. (Gustav Schiefer).*

Erich Heckel, *Portrait of a Man.*

233

Erich Heckel, *Irrer Soldat.* **Erich Heckel,** *Roquarirol.*

Erich Heckel, *Roemisches Stilleben.*

Erich Heckel, *Tuebingen.*

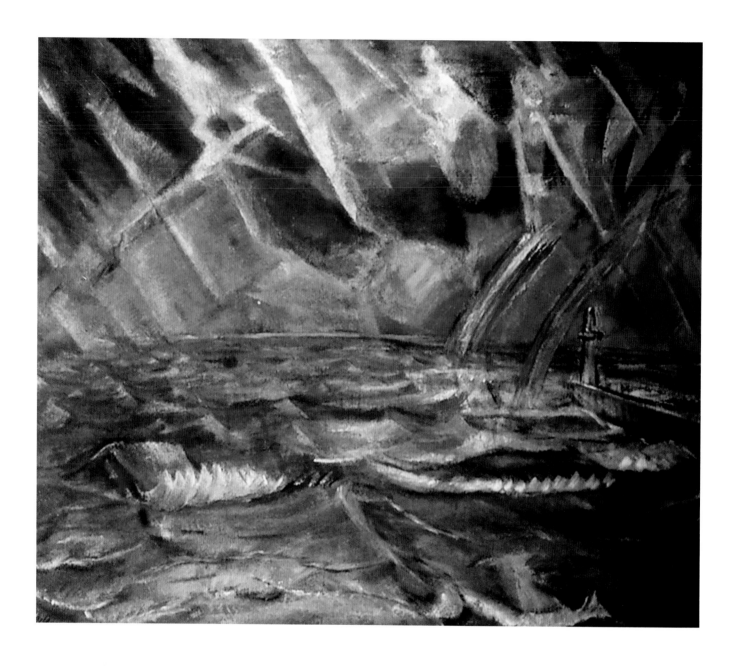

Erich Heckel, *Nordsee.*

Ernst Ludwig Kirchner, *Tiergarten Berlin.*

Albrecht Dürer, *The Dead Christ,* is now owned by the Cleveland Museum of Art. The museum owns a third Dürer drawing, *Head of a Man in a Cap* (not shown) which, like the others, once belonged to Prince Lubomirski.

Drawing Fire

In 1866, when Prince Heinrich Lubomirski deposited his wonderful collection of drawings by Albrecht Dürer in the Lubomirski Museum in Lviv, Lviv was part of the Austro-Hungarian Empire. World War I put an end to that empire, however, and Lviv became part of Poland following passage of the Treaty of Versailles. In 1939, the Soviet Union invaded Poland and made Lviv part of the Ukrainian Soviet Socialist Republic. Two years later, Germany turned against its erstwhile ally and occupied the city. A Nazi official promptly appropriated the Dürer drawings on orders from Hermann Göring. According to one published account, Göring gave the drawings to Hitler, who liked them so much that he took them with him on his travels.

After the war, the drawings were found in a salt mine in southern Germany by officers of the Monuments, Fine Arts and Archives division of the U.S. Army, who sent them to the Munich collection point. There, the MFA&A responded to the claim made by Georg Lubomirski, a descendant of the original prince, by handing the drawings over to him. Lubomirski sold the drawings through dealers in London and New York and used the proceeds to live comfortably on the French Riviera for the rest of his life.

The drawings are now widely dispersed. Among the buyers were the British Museum, the Courtauld Institute, the National Gallery of Canada, the Metropolitan Museum of Art, the Art Institute of Chicago, the Museum of Fine Arts, Boston, the National Gallery of Art in Washington, and the Cleveland Museum of Art.

Over the years, both Poland and the Soviet Union have made more or less strenuous claims for the return of the drawings. The MFA&A broke with its own established policy when it handed the trove over to an individual rather than a country back in 1950. But the American Association of Art Directors has defended the action. James Cuno, speaking for the association, noted in testimony to a Congressional sub-committee in 2006, that "the U.S. State Department has reviewed its 1950 decision to restitute the drawings to Prince Lubomirski as the rightful owner, and has concluded that its 'prudent' decision was processed 'with due diligence, deliberation, and care.'

Albrecht Dürer, *The Ascension*, is one of a collection of more than two dozen drawings that were seized by the Nazis during World War II. It was purchased after the war from a New York art dealer by the Cleveland Museum of Art.

The Marmottan Robbery

Claude Monet (1840–1926), *Impression, Sunrise*. Oil on canvas.
One Sunday in October 1985, two men paid the entrance fee to
the Marmottan Museum in Paris. Once inside, they drew guns and
held the unarmed staff and about forty visitors at bay, while their
colleagues helped themselves to nine Impressionist paintings, including
Monet's *Impression, Sunrise* of 1872. This was the painting that gave
Impressionism its name.

 The robbery was notable because it was one of the first in which
armed thieves invaded a public gallery during opening hours, a modus
operandi that has since become common. It was said to be the work
of the same gang that had taken five paintings by Camille Corot from
a museum in Semur-en-Auxois two years earlier. The Corots were
recovered in Japan in 1987. The Monet was found in a barman's attic
in Corsica in 1991.

Page references in *italics* indicate the presence of an illustration.

PICTURE CREDITS

Every effort has been made to correctly attribute all material reproduced in this book. If errors have unwittingly occurred, we will be happy to correct them in future editions.

1: *Impression, Sunrise* by Claude Monet. Image © Corbis.

2: *Boulloire et fruits* by Paul Cézanne. Image courtesy of the Art Loss Register.

INTRODUCTION

6: Self Portrait, 1630 (oil on copper) by Rembrandt Harmensz van Rijn (1606–69) © Nationalmuseum, Stockholm, Sweden/The Bridgeman Art Library Nationality/copyright status: Dutch/out of copyright.

9: © Associated Press.

THE CASE OF THE MISSING WARHOL

10: Courtesy of the Art Loss Register.

15: Courtesy of the Art Loss Register.

17: © David Levenson/Alamy.

ART CRIMES

18: © Associated Press.

21: Isabella Stewart Gardner Museum, Boston, MA, U.S.A./Bridgeman Art Library.

22: Erich Lessing/Art Resource, NY.

23: © Getty Images.

24: © Associated Press.

25: © Associated Press.

27: © Associated Press.

28: © Associated Press.

29: © Associated Press.

30: Both images © Associated Press.

31: Courtesy of the Art Loss Register.

33: Both images courtesy of the Art Loss Register.

35: © Associated Press.

37: Courtesy of the Art Loss Register.

38: © Associated Press.

40: Four images courtesy of the Byzantine Museum and Art Galleries of the Archbishop Makarios III Foundation.

41: Both images courtesy of the Byzantine Museum and Art Galleries of the Archbishop Makarios III Foundation.

43: Courtesy of the Art Loss Register.

44: Julian Radcliffe, chairman of the Art Loss Register, photographed at the Victoria & Albert Library, London, where he conducts much of his research. Copyright photograph by Graham Trott © 2006.

46: © Associated Press.

48: Three images courtesy of the Art Loss Register.

51: © Associated Press.

52: Both images courtesy of the Art Loss Register.

53: Courtesy of the Art Loss Register.

54: © Associated Press.

56: Courtesy of the Art Loss Register.

59: Courtesy of the Art Loss Register.

60: Courtesy of the Art Loss Register.

63: John Tlumacki/*Boston Globe* staff.

TAINTED LEGACY

64: © Getty Images.

67: © Getty Images.

68: © Associated Press.

69: © Getty Images.

71: © Corbis.

73: (Top) © Getty Images. (Bottom) © Corbis.

74–75: © Associated Press.

77: © Corbis.

78: © Associated Press.

80: Both images © Associated Press.

81: © Associated Press.

83: © Associated Press.

84:	© Corbis.
85:	© Courtesy of the Art Loss Register.
86:	© Associated Press.
89:	© Associated Press.
90:	© Associated Press.
93:	© Associated Press.
94:	© Associated Press.
97:	© Associated Press.
98:	© Associated Press.
101:	© Erich Lessing/Art Resource, NY.
104:	Tate, London 2007.
108:	© by Ingeborg & Dr. Wolfgang Henze-Ketterer, Wichtrach/Bern; Digital image © Erich Lessing/ Art Resource, NY.
111:	Still of the documentary film *Finding Pictures* about the rediscovery and loss of the Bruno Schulz murals, © 2001 Benjamin Geissler Filmproduktion — www.benjamingeissler.de.

THE EXTINCTION OF HISTORY

112:	Courtesy of the Art Loss Register.
115:	(Top) © Corbis. (Bottom) © John Russell.
116:	Drawing by Austen Henry Layard.
117:	© Getty Images.
118:	Drawing by Austen Henry Layard.
119:	Drawing by Austen Henry Layard.
120:	© John Russell.
121:	© John Russell.
122:	© Corbis.
124:	(Top) © Linda Gustafson. (Bottom) © Getty Images.
125:	© Getty.
127:	© Associated Press.
129:	© Royal Academy of Arts, London.
131:	Photograph © April 2008 Museum of Fine Arts, Boston.
133:	Four images courtesy of the Art Loss Register.
134:	Both images courtesy of the Art Loss Register.
135:	Courtesy of the Art Loss Register.

137:	© Etienne Clement.
138:	© Getty Images.
141:	© Associated Press.
142:	© Associated Press.
145:	© Associated Press.
147:	© Rodolfo Arpia/Alamy.
149:	© Rodolfo Arpia/Alamy.
152:	© 2006 Ed Alcock.
154:	© Associated Press.
157:	Three images courtesy of the Art Loss Register.
158:	© Getty Images.

THE UNBREAKABLE ART BUBBLE

162:	© Getty Images.
164:	© 2007 Linda Nylind.
166:	© Associated Press.
169:	Both images courtesy of the Art Loss Register.

A GALLERY OF STOLEN ART

172:	© Associated Press.
175:	© Getty Images.
176:	Courtesy of the Art Loss Register.
177:	© Associated Press.
178–179:	Courtesy of the Art Loss Register.
180:	Courtesy of the Art Loss Register.
181:	Courtesy of the Art Loss Register.
182:	Both images courtesy of the Art Loss Register.
183:	Courtesy of the Art Loss Register.
184:	Courtesy of the Art Loss Register.
185:	Courtesy of the Art Loss Register.
186:	Both images courtesy of the Art Loss Register.
187:	Courtesy of the Art Loss Register.
188–189:	Courtesy of the Art Loss Register.
190:	Courtesy of the Art Loss Register.
191:	Both images courtesy of the Art Loss Register.
182:	Courtesy of the Art Loss Register.
193:	© Associated Press.
194:	Courtesy of the Art Loss Register.
195:	Both images courtesy of the Art Loss Register.

196:	Courtesy of the Art Loss Register.
197:	Courtesy of the Art Loss Register.
198:	Courtesy of the Art Loss Register.
199:	Courtesy of the Art Loss Register.
200:	Courtesy of the Art Loss Register.
201:	Both images courtesy of the Art Loss Register.
202:	Courtesy of the Art Loss Register.
203:	Four images courtesy of the Art Loss Register.
204:	Courtesy of the Art Loss Register.
205:	Courtesy of the Art Loss Register.
206:	Courtesy of the Art Loss Register.
207:	Courtesy of the Art Loss Register.
208:	Courtesy of the Art Loss Register.
209:	Four images courtesy of the Art Loss Register.
210:	Courtesy of the Art Loss Register.
211:	Both images courtesy of the Art Loss Register.
212–213:	Courtesy of the Art Loss Register.
214:	Courtesy of the Art Loss Register.
215:	Three images courtesy of the Art Loss Register.
216:	Both images courtesy of the Art Loss Register.
217:	Courtesy of the Art Loss Register.
218:	Courtesy of the Art Loss Register.
219:	Courtesy of the Art Loss Register.
220:	Courtesy of the Art Loss Register.
221:	Courtesy of the Art Loss Register.
222:	Courtesy of the Art Loss Register.
223:	Courtesy of the Art Loss Register.
224:	Courtesy of the Art Loss Register.
225:	Courtesy of the Art Loss Register.
226:	© Associated Press.
227:	Three images courtesy of the Art Loss Register.
228:	© Associated Press.
229:	© Associated Press.
230:	© Associated Press.
231:	© Associated Press.
232:	© Associated Press.
233:	(Left) © Erich Lessing/Art Resource, NY. (Right) © Bildarchiv Preussischer Kulturbesitz/ Art Resource, NY.

234:	Both images © Associated Press.
235:	Both images © Associated Press.
236:	© Associated Press.
237:	© Associated Press.
238:	© Associated Press.
239:	© Associated Press.
240–241:	© Corbis.
256:	Courtesy of the Art Loss Register.

NOTES ON SOURCES

Almost everywhere my researches took me, I found that British journalist Peter Watson had been there first. His history, *From Manet to Manhattan: The Rise of the Modern Art Market* (London: Vintage, 1992), is an entertaining overview of the subject. More relevant to the present enterprise are his two muck-raking books: *Sotheby's: The Inside Story* (London: Bloomsbury, 1997) and (with Cecilia Todeschini) *The Medici Conspiracy: The Illicit Journey of Looted Antiquities From Italy's Tomb Raiders to the World's Greatest Museums* (New York: Public Affairs, 2006). Watson is always worth reading. For background about art theft in general, Simon Houpt, *The Museum of the Missing: The High Stakes of Art Crime* (Toronto: Madison, 2006) is intelligent and wide-ranging.

In addition to the specific sources cited below, I drew on magazines and newspapers. Especially useful were the on-line archives of *The New York Times*, *The Times* (London), *The Los Angeles Times*, and *The Art Newspaper*.

THE CASE OF THE MISSING WARHOL

The story of the *30 Colored Mao* draws on background information provided by the ALR and interviews with Julian Radcliffe, June 2007.

ART CRIMES

Charles Hill, "But when it comes to great works of art," interview, June 2007. Vernon Rapley on police investigations, email to author, August 2007. Bonnie Magness-Gardiner quote, "This kind of material requires special expertise," telephone interview, September 2007. Robert Wittman quote, "We've worked hard," FBI Press Release, "The Good Earth Unearthed," June 27, 2007. The story of Martin Cahill is told by Matthew Hart, *The Irish Game: A True Story of Crime and Art* (Toronto: Viking, 2004). Art used "to provide venture capital for [drug] trafficking," Charles Hill, "Money Laundering Methodology," *Journal of International Banking and Financial Law*, April 1995.

The story of the Fishing Line Theft is recounted by Jonathan Wood, "Cross-Border Issues Affecting Stolen Art," paper presented at the AXA Conference, Rogues Gallery: An Investigation into Art Theft, 2005. *Autocephalous Greek Orthodox Church of Cyprus v. Goldberg & Feldman Fine Arts Inc.* has been described in a number of articles. See for example: Andrew Kenyon, "Don't Tell Me About the Limitations: The Law on Stolen Art Recovery," paper presented at the Australian Registrars Committee Conference, October 9, 2001; and Charles Palmer, "Recovering Stolen Art," *Michigan Bar Journal*, June 2003. "Most developments in the modern world favor

the criminal," Raymond Kendall, "The Role of the Police," unpublished article made available to the author. Pierre Valentin, "Art law as a discipline doesn't really exist," interview, June 2007.

The story of the Argentine theft relies on background provided by the ALR and interviews with Julian Radcliffe. On officially sanctioned theft under the junta, see Daniel Schávelzon, "What's Going on Around the Corner? Illegal Trade of Art and Antiquities in Argentina," Neil Brodie and Kathryn Walker Tubb (eds.), *Illicit Antiquities: The Theft of Culture and the Extinction of Archaeology* (London: Routledge, 2002). On the murder of dissidents by the Argentine junta see, for example, Horacio Verbitsky, *The Flight: Confessions of an Argentine Dirty Warrior* (New York: New Press, 1996). Regarding the role played by the Williams, see Simon Worrall, "Art for Arms Sake," *The Independent*, September 13, 2006. The story of the Bakwin robbery relies on information provided by the ALR. The case also has been covered extensively in the press, especially by Stephen Kurkjian in the *Boston Globe*. See for example, Kurkjian, "Lost and Found," *Boston Globe* magazine, December 17, 2000, and "Lawyer Surrenders in '78 Stolen Art Case," Boston Globe, February 14, 2007. Jack Flaherty quote, "It was not your run-of-the-mill, everyday theft," Ellen G. Lahr, *Berkshire Eagle*, February 2, 2006. Julian Radcliffe quote,

"These were still stolen works," Georgina Adam, *The Art Newspaper*, No. 163, November 2005. Robert Mardirosian, "I know some things don't look good here," Stephen Kurkjian, *Boston Globe*, February 1, 2006. On legal issues in the Bakwin case, see Pierre Valentin, "The Bakwin Paintings: A Tale of Fraud and Deceit," *Art and Cultural Assets*, Summer 2007, published by Withers LLP.

TAINTED LEGACY

The primary source for background on the Nazi thefts is Lynn H. Nicholas's magisterial history, *The Rape of Europa: The Fate of Europe's Treasures in the Third Reich and the Second World War* (New York: Vintage, 1994). Also useful: Hector Feliciano, *The Lost Museum: The Nazi Conspiracy to Steal the World's Greatest Works of Art* (New York: Basic Books, 1995); Elizabeth Simpson (ed.), *The Spoils of War: World War II and Its Aftermath: The Loss, Reappearance, and Recovery of Cultural Property* (New York: Harry N. Abrams, 1997); Richard Z. Chesnoff, *Pack of Thieves: How Hitler and Europe Plundered the Jews and Committed the Greatest Theft in History* (New York: Anchor Books, 1999).

Bernard Taper relates the story about Göring's train in "Investigating Art Looting for the MFA&A," Simpson, *Spoils of War* (as above). The statistics relating to the quantity of Holocaust art turned over to the French state are

from Marie Hamon, "Spoliation and Recovery of Cultural Property in France, 1940-94," also in Simpson, *Spoils of War*. On Russian art appropriations, see Konstantin Akinsha and Grigorii Koslov, "Spoils of War: The Soviet Union's Hidden Art Treasures," *Art News*, April 1991, and "The Soviets' War Treasures: A Growing Controversy," *Art News*, September 1991. On the Washington Conference, "It's basically one of those sex education guides," David D'Arcy, "Much Piety and Hot Air," *The Art Newspaper*, No. 88, January 1999. James Cuno statement to the Subcommittee on Domestic and International Monetary Policy, Trade and Technology, of the Committee on Banking and Financial Services, United States House of Representatives, July 27, 2006, available online.

The Gotha case received extensive press coverage. The judgment in the High Court (England and Wales) *City of Gotha and Federal Republic of Germany v. Sotheby's and Cobert Finance S.A.* is available online. For astute legal commentary on this and other Holocaust-related cases, see Norman Palmer, "Memory and Morality: Museum Policy and Holocaust Cultural Assets," *Art, Antiquity and Law*, Vol. 6, No. 3, September 2001. See also Will Bennett, "High Court Sends Looted Old Master Back to Germany," *Daily Telegraph* (London), September 12, 1998. The seizure of the Egon Schiele paintings was covered comprehensively in the press. See especially,

Martha Lufkin, "How Do I Sue Thee? Let Me Count the Ways," *The Art Newspaper*, No. 97, November 1999. See also Anna O'Connell, "Immunity from Seizure: An Overview," *Art, Antiquity and Law*, Vol. XI, No. 1, March 2006. "For a statute designed to deflect litigation," Norman Palmer, "Memory and Morality" (as above).

The story of the Dunedin's misadventure is told by John Timmins, "The Macchiaioli Affair: Lost and Found in Italy," *Art, Antiquity and Law*, Vol. VII, No. 2, June 2002. The Adam Williams case received wide press attention. See for example: Souren Melikian, "The Mystery of the Looted Portrait," *International Herald Tribune*, September 1, 2001; Charles Bremner, "Dealer Accused Over Painting Stolen by Nazis," *The Times* (London), May 17, 2001. See also: Leila Anglade, "The Portrait of Pastor Adrianus Tegularius by Franz Hals," *Art, Antiquity and Law*, Vol. VIII, No. 1, March 2003. On the Griffier case, see *Report of the Spoliation Advisory Panel in Respect of a Painting Now in Possession of the Tate Gallery*, January 18, 2001, available online. See also Neil Mackay, "It Took a Jewish Family 61 Years to Win Justice," *Sunday Herald* (Glascow), June 3, 2001. On the Rosenberg Matisse, see Hector Feliciano, *The Lost Museum* (as above), and numerous press articles including David D'Arcy, "From Seattle to Paris to Budapest to New Zealand," *The Art Newspaper*, No. 97, November 1999, and

Martha Lufkin, "US Dealers and Seattle Museum Settle over Matisse Lawsuit," *The Art Newspaper*, No. 108, November 2000. On the Kirchner case, see Matthias Weller, "The Return of Ernst Ludwig Kirchner's *Berliner Strassenszene* – A Case Study," *Art, Antiquity and Law*, Vol. XII, No. 1, March 2007. See also Associated Press, "Neue Galerie in New York Shows Second Major Work Acquired through Restitution," July 27, 2007.

Feature, "The Art Commandos," draws on press reports. Letters were published in *The New York Review of Books*, November 29, 2001 and May 23, 2002. Yad Vashem's Press Release, "Yad Vashem's Statement Regarding the Sketches by Bruno Schulz," is available online at http://yadvashem.org.il.

Source for the feature, "The Problem of Provenance," is Testimony of Gilbert S. Edelson before the Subcommittee on Domestic and International Monetary Policy, Trade and Technology, of the House Committee on Financial Services, United States Congress.

THE EXTINCTION OF HISTORY

The story of the marines and the Baghdad museum is told by Matthew Bogdanos with William Patrick, *Thieves of Baghdad: One Marine's Passion for Ancient Civilizations and the Journey to Recover the World's Greatest Treasures* (New York: Bloomsbury, 2005). Austen Henry Layard told his own story in *Nineveh and Its Remains*, Vol. 2 (New York: George P. Putnam, 1849). On the plundering of archeological digs in Iraq, see: John Malcolm Russell, "The Modern Sack of Nineveh and Nimrud," *Culture Without Context*, No. 1, Autumn 1997; and Russell, *The Final Sack of Nineveh: The Discovery, Documentation, and Destruction of King Sennacherib's Throne Room at Nineveh, Iraq* (New Haven: Yale University Press, 1998). "The only place where such bas-reliefs are in short supply," Samuel Paley, "Nimrud and Nineveh Again: Documented Bas-Reliefs from Iraq Offered in the West," IFAR *Reports*, Vol. 18, No. 6, June 1997. See also: Paley, "More Published and Documented Bas-Reliefs from Nimrud Offered on the Antiquities Market, IFAR Journal, Vol. 2, No. 3, Summer 1999; and Paley, "Nimrud, the War and the Antiquities Markets," IFAR Journal, Vol. 6, No. 3, 2003.

"Little by little over the past forty-three years," George Ortiz, "In Search of the Absolute," available on-line at www.georgeoritz.com. "I was on the verge of discouraging," Thomas Hoving, *Making the Mummies Dance* (New York: Simon & Schuster, 1993). "They collect on the basis of instantaneous emotional response," Marion True and Arielle Kozloff, "Barbara and Lawrence Fleischman: Guardians of the Past," *A Passion for Antiquities: Ancient Art from the Collection of Barbara and Lawrence Fleischman* (Los Angeles: Getty Publications,

1994). "We were struck by the installation," Barbara Fleischman, "The Fleischman Collection and the Getty," letter to the editor, *The New York Review of Books*, September 21, 2006.

"[The exhibition] delights the eye," Colin Renfrew, "Justifying an Interest in the Past," *The Guardian* (UK), January 26, 1994. "A Mr. Toad performance," James Fenton, "A Collection Robbed of Its True History," *The Independent* (London), January 31, 1994. "The world cannot afford," Ricardo Elia, *The Art Newspaper*, No. 41, October 1994. The looting of antiquities has been widely reported by archaeologists. I have drawn in particular on papers published following a symposium held under the auspices of the Illicit Antiquities Research Centre of the McDonald Institute at Cambridge University. Neil Brodie and Kathryn Walter Tubb, *Illicit Antiquities: The Theft of Culture and the Extinction of Archaeology* (London: Routledge, 2002). See especially: Boubé Gado, "The Republic of Niger"; Daniel Schávelzon, "What's Going on Around the Corner? Illegal Trade of Art and Antiquities in Argentina"; Rachanie Thosarat, "The Destruction of the Cultural Heritage of Thailand and Cambodia"; He Shuzhong, "Illicit Excavation in Contemporary China." Some other sources: Melvin Soudign and Edgar Tijhuis, "Some Perspectives on the Illicit Antiquities Trade in China," *Art, Antiquity and Law*, Vol. VIII, No. 2,

June 2003; Gitanjali Deb, "Stealing Gods: Illegal Trade in Indian Antiquities," *Art, Antiquity and Law*, Vol. x, No. 1, March 2005; H. Bhisham Pal, *The Plunder of Art* (New Delhi: Abhinav Publications, 1992), etc. The Ghiya case has been extensively reported. See especially Patrick Radden Keefe, "The Idol Thief," *The New Yorker*, May 7, 2007; Antony Barnett, "Sotheby's Faces Probe," *The Observer* (London), July 6, 2003. On the scale of the illicit trade in antiquities see United Kingdom Government, Department for Culture, Media and Sport, Ministerial Advisory Panel on Illicit Trade, *Report*, December 2000.

"Most new antiquities on any market," John Boardman, "Don't Just Berate the Thieves," *The Art Newspaper*, No. 54, December 1995. See also George Ortiz, "Unidroit is a potential Disaster," *The Art Newspaper*, No. 67, February 1997; and Ortiz, "The Cross-Border Movement of Art: Can and Should It Be Stemmed?" *Art, Antiquity and Law*, Vol. 3, No. 1, March 1998.

For astute commentary on the Getty's tribulations, see Martin Filler, "The Getty: For Better and Worse," *The New York Review of Books*, November 16, 2006. Some of Thomas Hoving's critique of the Getty is contained in the articles: "My Eye: The Getty Scandals (Part One)," *Connoisseur*, April 1987; and "My Eye: Who Says a Great Museum Has to Be a Staid, Serious Place?" *Connoisseur*, February 1991. Getty *kouros* described

as "Greek, circa 530 B.C. or modern fake," J.Paul Getty Museum, *Handbook of the Collection* (Los Angeles, Getty Publications, 2002). Marion True on Aphrodite becoming "the single greatest piece of ancient art" quoted in Ralph Frammolino and Jason Felch, "The Getty's Troubled Goddess," *Los Angeles Times*, January 3, 2007. "The Catch 22 pertaining to all illicit antiquities," Colin Renfrew, *Loot, Legitimacy and Ownership: The Ethical Crisis in Archaeology* (London: Duckworth, 2000). Marion True announcement, "Now we would only consider buying," and Ricardo Elia response, "The term 'well-documented provenance,'" both quoted in Mark Rose, "The Getty's Mea Culpa," *The Courier* (UNESCO), April 2001. Marion True, "In general, museums are more defensive," and Philippe de Montebello, "I feel that if an object is of great and artistic value," quoted by Jason Kaufman, "To the Greater Glory of Antiquity?" *The Art Newspaper*, No. 92, May 1999.

The observer who wrote, "The golden age of the museum has come to an end," is Katherine Jane Hurst, "The Emptying Museum," *Art, Antiquity and Law*, Vol. XI, No. 1, March 2006. Voulgarakis quote, "The Italians are very well organized," Hugh Eakin, "Greece and Italy Team up to Reclaim Lost Art," *International Herald Tribune*, December 11, 2006. "Are today's Greeks actually the descendants," Garry Wills, "We Are All Romans Now," *The New York Review of Books*, May 31, 2007." Mark Kingwell, "Museums have been for two decades…" email to the author, September 3, 2007. Alfred Taubman, "Real Estate, art, whatever," quoted by Rosie Millard, "To the Slammer by Gulfstream Jet," *The Sunday Times*, June 24, 2007.

Feature, "Interview with a Tomb Robber," draws on interviews given by Casasanta to: Ben MacIntyre, "Saga of the 'Stolen' Gold Wreath Could Loosen British Hold on Elgin Marbles," *The Times* (London), March 31, 2007; Associated Press, "Italy's Crackdown on Art Looting Keeps Plunderers in Check for Now," July 5, 2007; and Peter Watson and Cecilia Todeschini, *The Medici Conspiracy* (as above).

The story of the "Weary Herakles" has been the subject of many newspaper reports. See for example Anne E. Kornblut, "Getting to the Bottom of Split Statue," *Boston Globe*, December 27, 1998. Colin Renfrew also discusses it in *Loot, Legitimacy and Ownership* (cited above).

Feature, "Lord Northampton's Treasure," draws on an interview with Dick Ellis, June 2007, and numerous press reports including Christina Ruiz, "The Silver Missing from the Sevso Hoard?" *The Art Newspaper*, No. 178, March 2007. See also Colin Renfrew, *Loot, Legitimacy and Ownership* (as above). An entertaining tangent is explored by Peter Landesman, "The Curse of the Sevso Silver," *The Atlantic Monthly*, November 2001.

ACKNOWLEDGEMENTS

Julian Radcliffe's generous cooperation was indispensable. The staff in the London office of the Art Loss Register went out of their way to be helpful. Maja Pertot Bernard responded patiently to all requests. Sarah Jackson and William Webber submitted to interviews, and Hugo Gorst-Williams dug deep into the ALR's files to provide details of thefts and recoveries. This book was made possible through their efforts.

Jeffrey Robinson shared contacts and extended courtesies far more generously than I reasonably could have expected. Julius Melnitzer took the time to read parts of the manuscript and gave shrewd advice. Simon Houpt also made time to review the manuscript and provided encouragement.

Silvia Langford graciously made her London home available to me. Signe Hoffos wined and dined me in London and kept me company on the night at Sotheby's. My sister Judith Madore provided expert assistance in tracking down articles at the library and archives in Ottawa.

A number of people neglected more important business to answer my questions. My thanks to Neil Brodie, Richard Ellis, Annabel Fell-Clark, Charley Hill, Mark Kingwell, Samuel Paley and Pierre Valentin. Ricardo Elia permitted me to quote him at length. John M. Russell, Etienne Clement, and the Byzantine Museum and Art Galleries of the Archbishop Makarios III Foundation were generous in providing photographs. Raymond Kendall and Lyndel Prott kindly made their unpublished articles available.

Oliver Salzmann, publisher and proprietor at Madison, is just terrific. The staff at Madison, like the staff at so many publishing houses, is dedicated, talented, and seriously overworked. The efforts of Alison Maclean, Susan Barrable, Sandra Hall, Greg Thorogood, Diana Sullada, Kelvin Kong, and Hannah Draper all contributed to this book. Linda Gustafson and Peter Ross at Counterpunch contrive to be both creative and serene under pressure. Diane Young's editing was intelligent and sensitive.

I was a stinker to live with when I was writing this. Vivian, Nora, Harry, and Madeleine inexplicably put up with me. Thank you all.

—J.W.

EDITOR
Diane Young

COPYEDITOR
Judy Phillips

PROOFREADER
Charis Cotter

INDEX
Ruth Pincoe

DESIGN
Counterpunch

PRODUCED BY MADISON PRESS BOOKS

PROJECT EDITOR
Hannah Draper

ART DIRECTOR
Diana Sullada

PRODUCTION MANAGER
Sandra L. Hall

VICE PRESIDENT, FINANCE AND PRODUCTION
Susan Barrable

ASSOCIATE PUBLISHER
Alison Maclean

PRESIDENT AND PUBLISHER
Oliver Salzmann

Color Separation, Proofing, Printing and Binding
by Oceanic Graphic Printing, China